Ξų ·

~The Best of~ BBCCHURE DESIGN

~The Best of~ BROCHURE BROCHURE BROCHURE

Copyright © 1999 by Rockport Publishers, Inc.

All rights reserved. No part of this book may be reproduced in any form without written permission of the copyright owners. All images in this book have been reproduced with the knowledge and prior consent of the artists concerned and no responsibility is accepted by producer, publisher, or printer for any infringement of copyright or otherwise, arising from the contents of this publication. Every effort has been made to ensure that credits accurately comply with information supplied.

FIRST PUBLISHED IN THE UNITED STATES OF AMERICA BY: Rockport Publishers, Inc. 33 Commercial Street Gloucester, Massachusetts 01930-5089 Telephone: (978) 282-9590 Facsimile: (978) 283-2742

ISBN 1-56496-592-9

10 9 8 7 6 5 4 3

DESIGNER | Stoltze Design COVER IMAGE | Nesnadny + Schwartz *The Progressive Corporation*, 1997 Annual Report (Detail) *see page 55*

Printed in China

業務架構日益完備。從第

water is for a fish, timely a

in separates. And the sta

OPEN OR IGNORE

"When you receive a **BROCHURE** in the mail, or see one on a store countertop, those are your basic option And whether you like it or not, the graphic designer who mac brochure has a huge **Impact** on that dec

My senior year of high school, I remember receiving BROCHURES from about a million different colleges, from everywher the face of the Earth. They came unsolicited, and having that "future will figure in out" attitude, I had little interest in looking at them. Even so, there were a that I just could not resist. They so completely captured my attention 1 I couldn't help but peruse their large, glossy pages; revealing scen of a college life that I could only imagine; telling anecdotes of amazing things that occurred on campus. These brochures w purely seductive, and I found myself browsing through them and again. With my trusty "yes" pile, I was convinced tha needed to know nothing more than what was in that brock And sometimes, the brochure was really all the informat really had with which to make my decision. In those cas would carefully read all the text, trying to absorb what college could offer me. But I read it on another level a Consciously or subconsciously, the feel of the brochu the colors, the papers, the fonts-these details were I used to distill the essence of the college. Was it a conservative place? Were the students there wild? W college known for its innovative teaching? I allowed se thing as basic as the color palette to discern that for m

nd it is that level of the design that makes the graphic designer's b so difficult and so gratifying. Good designers know clever ways fit enormous amounts of text into a specified format, to work ithin a tight budget, to appease a difficult client. Don't get me rong—those are very difficult tasks. But beyond that, the designrs only have the use of the tools of the basic elements of design capture the feeling, the essence of the client. And good designrs, with an endless number of ideas, amazing innovations, and a tle bit of luck, can really do that. the end, my decision on where to attend college was not solely used on the brochure. But truth be known, there sure were a lot places that I didn't even consider because

heir brochure just did not ell me to "open."

—ALDEN ROY, DESIGNER

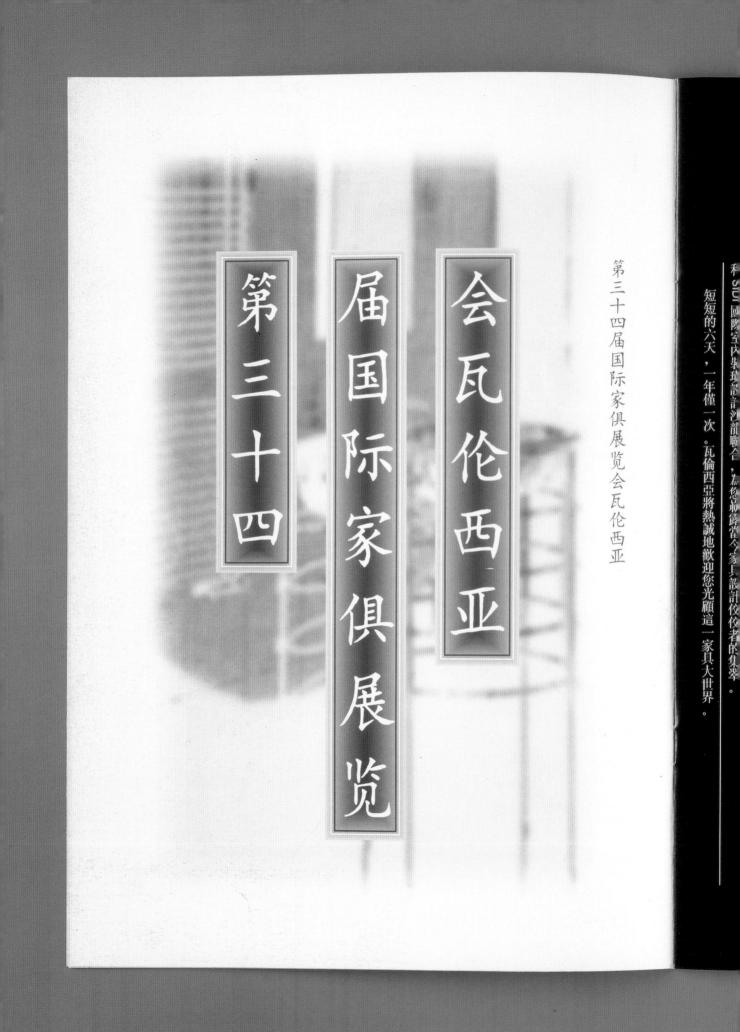

舉行,有一百多個國家和地區前來參加。巨大的展覽館其總面積為 180,000 平方米將容納世界家具市場應有盡 個完整的商業視野,您所期望的各種貿易良機隨時有機會出現。 第三十四屆瓦倫西亞國際家具展覽會,于一九九七年九月二十二日至九月二十七日在西班牙,瓦倫西亞市

估量的,它很可能使您在整年之余坐享其成。就在同一地點,您可以飽覽一個壯觀的當今家具世界,可以獲得 每年只有一次,而每次只持續六天。盡管如此,如果您是一位具有簽賞能力的商人,這六天時間將是無法

母年一度

羔 悠 扶 伊 英 幸 臣 彬

4	際	來	
K	家	Í	
	.貝.	歐	時
あぶ是共住葬りと幾	展	來 自歐洲,	E C
Ê	嶞	,	為
卖	會	亞	六
匀	將	亞洲	天
Į	為	和	•
後	您	羙	來
	展	洲	訪
	示	0	者
	,	就	達
	當	在	<u>h</u> .
	今	這	禺
	世	and a	以
	界	•	Ŀ
	家	П	•
	具	M	
	的	西	+
	新	班	3
	動	牙	個
	態	•	参 ##
	,	凡	質ハ
	新	倫	公司
	際家具展覽會將為您展示,當今世界家具的新動態,新產品,	和美洲。就在這里, FIM 西班牙 - 瓦倫西亞國	間為六天,來訪者達五萬以上,一千多個參贊公司分:
	品	517. 1-181	分加
	;	些	別

BROCHURES

DESIGN FIRM | Pepe Gimeno, S.L. DESIGNER | Pepe Gimeno CLIENT | Feria Internacional del Mueble de Valencia Tools | Macromedia FreeHand, Adobe Photoshop PRINTING PROCESS | Offset

This is the program given out at the International Furniture Fair in Valencia. The brochure had to be designed in five different languages.

DESIGN FIRM | Q DESIGN ART DIRECTORS | Thilo Von Debschitz, Laurenz | DESIGNER | Roman Holt CLIENT | VKE TOOLS | QuarkXPress, Adobe Photoshop PAPER | Akylux & Polyart PRINTING PROCESS | Ultraviolet, four-color Pante

Annual Report for VKE (association of plastic cessing industries). Text and cover is all synt paper, therefore UV-printing was used.

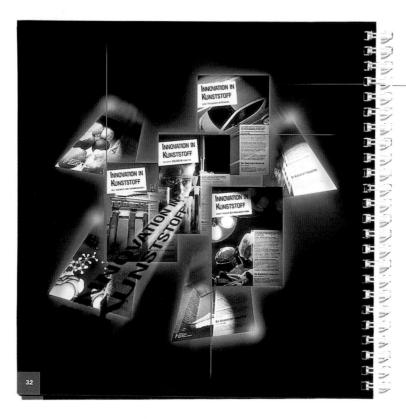

Geschäftsbereich

<u>ÖFFENTLICHKEIT</u>SARBEIT

Seit dem Frühsommer 1997

Der VKE sucht auch in seiner Öffentlichkeitsarbeit die Zusammenarbeit mit anderen europäischen Verbänden, wo immer sich eine Möglichkeit dazu ergibt. So wurde im vergangenen Jahr auf Initiative des VKE ein gemeinsames, einheitliches europäisches Logo für Kunststoff auf den Weg gebracht. Es soll als Siegel für den innovativen, vielseitigen Werkstoff der Zukunft stehen und für alle Europäer leicht verständlich sein. Gerade im Bereich der Kommunikation macht multinationale Zusammenarbeit besonderen Sinn: Internationaler Handel und ungehinderter, reger Informationsaustausch auf verschiedensten Kommunikationskanälen haben längst auch die Massenkommunikation internationalisiert.

Das gilt im besonderem Maß fürs Internet. Der Datenhighway kennt keine Ländergrenzen.

zeigt auch der VKE mit professionell gestalteten, eigenen Seiten im Internet Flagge. Unter "www.vke.de" finden sich Basisinformationen rund um Kunststoff und die Kunststoff-Industrie ebenso wie aktuelle News aus der Welt der Polymere - selbstverständlich auf deutsch und auf englisch. Zahlreiche Links, also per Mausklick herstellbare, direkte Verbindungen, runden das Angebot ab. Von der VKE-Homepage gelangt man problemlos zu den Mitgliedsfirmen, zu Organisationen und anderen Kunststoff-Verbänden. auch im europäischen Ausland und sogar in Übersee. Und die Nutzungsstatistik zeigt, daß gerade die europäischen Nachbarn eifrige Websurfer sind. Nur etwas über die Hälfte der Homepage-Besucher kam aus Deutschland.

Ein Highlight auf den Webseiten war im vergangenen Jahr die europäische Online-Regatta. ein gemeinsam mit den europäischen Kunststoff-Erzeugern entwickeltes Spiel im Internet. Die User konnten von der VKE-Seite zu verschiedenen großen Kunststoff-Anwendern surfen, Fragen zu Kunststoff beantworten und damit attraktive Preise gewinnen. Hauptgewinn war ein Segeltörn mit Wibke Bülle und Nicola Birkner, den Seglerinnen der 470er Olympia-Crew, die unter dem Motto "Innovation in Kunststoff" an den Start gehen.

Sponsoring: Sport und Kultur

Denn auch das 1996 begonnene Sponsoring der Seglerinnen der 470er Klasse und des deutschen Frauen-Nationalachters wird fortgesetzt. Die Partnerschaft

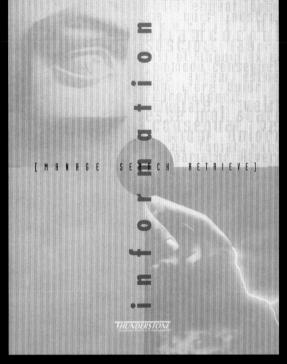

DESIGN FIRM | Zylstra Design and Denise Kemper Design (collaboration) ART DIRECTORS | Melinda Zylstra, Denise Kemper DESIGNERS | Melinda Zylstra, Denise Kemper PHOTOGRAPHER | Stock COPYWRITER | Thunderstone CLIENT | Thunderstone TOOLS | QuarkXPress PAPER | Neenah Environment Mesa White, UV Ultra II Columns PRINTING PROCESS | Three-color offset lithography

The design firm's goal was to create a unique brochure that stands out from the crowd and reflects the client's non-traditional outlook. With this goal in mind, they designed the project using unusual page layout, paper stock, and photographic images.

G

THUNDERSTONE?

Thandestone is an independent R&D company thet provides high-end software to manage, retrieve, filter and electronically publich information content constituting of text and multimedia. Over the last 17 years Thandestone has sold more than 400,000 endyset icenses to corporations, softwaye developers, content providers and government entities. Privately hald, Thandestoen analtations a constant commitment to excellence and innovation within diverse areas of information management and entired. Its focus constant technical advancement provides its customers with the ability to spacifically addeas the demands of their user bose without componitor.

THE THUNDERSTONE DIFFERENCE

Large organizations generally have specific information retrieval and management needs that can only be met by a combination of several unrelated products, but this type of integration is time consuming and error prone. Other retrieval vendors just index text and provide the ubiquitous list of answers. Thunderstone will realize and implement the entirety of the application exactly as envisioned; rapidly and maintainably. Our Texis RDBMS is fully capable of managing text and multimedia objects out of the box without the need to resort to loosely coupled "Data-Blade" programs. The Thunderstone infrastructure can meet the diverse and unique needs for almost any internet opplication.

The marketplace for internetworked information monagement/united systems is regular expending. Loss represents a crucial port of the information relaximent by symmetrically merging objects; validation data, and full test retrieval. Thandestate has been a pioneer since 1964 with the first cancept based network product on the market. No other product can make this delin, and no integration of other products can easily replicate loss' functionality.

www.thunderstone.com

DESIGN FIRM | Stoltze Design ART DIRECTOR | Clifford Stoltze DESIGNERS | Clifford Stoltze, Dina Radeka PHOTOGRAPHER | William Huber CLIENT | New England Investment Company PAPER | Mohawk 50/10, Champion Benefit Oyster 80 lb. text, Gilclear Medium 28 lb. PRINTING PROCESS | Cover: 4 PMS plus varnish; front section: 5 PMS plus varnish; financials: 1 PMS Invest.

INVEST

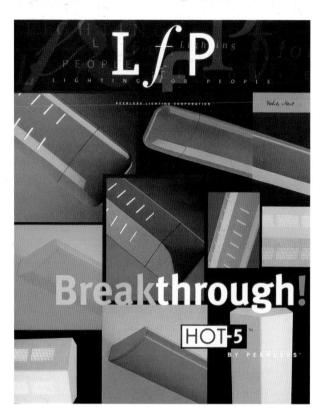

DESIGN FIRM | JD Thomas Company DESIGNER | Clive Piercey PHOTOGRAPHERS | Various/Stock COPYWRITER | Jim Thomas CLIENT | Peerless Lighting Corporation TOOLS | QuarkXPress, Adobe Photoshop PAPER | French-Construction 100 lb. cover PRINTING PROCESS | Four-color offset

This quarterly publication was created to announce new technologies and products. The distinctive design is meant to appeal to interior designers and architects.

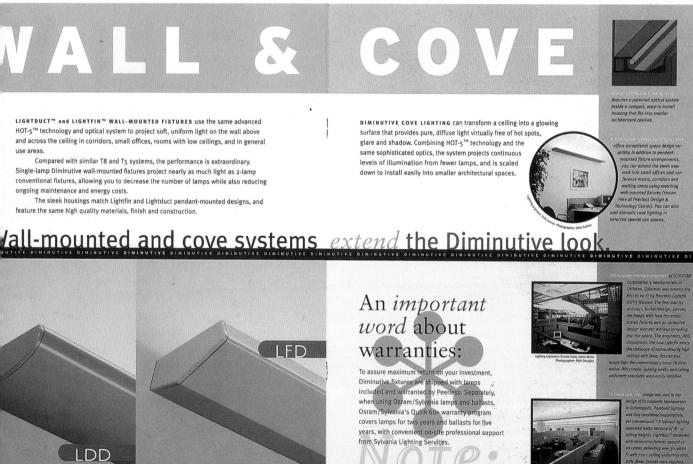

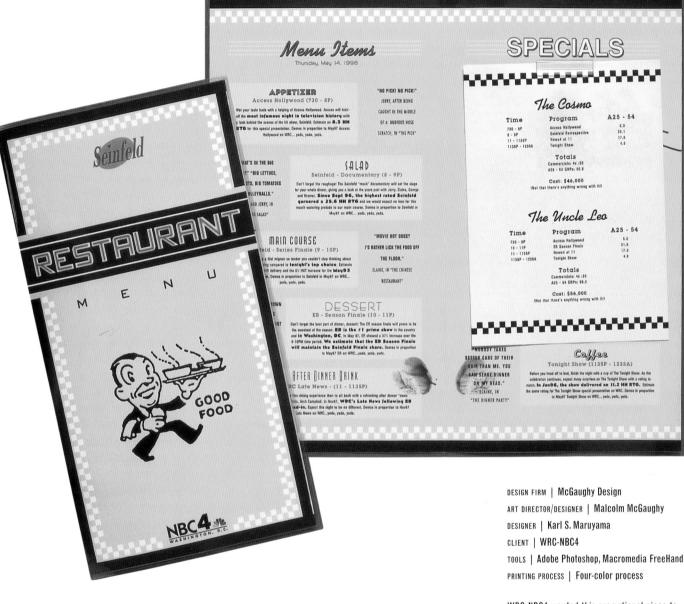

WRC-NBC4 wanted this promotional piece to be something their clients could save as a collector's item.

DESIGN FIRM | Morgan Design Studio, Inc. ART DIRECTOR/DESIGNER | Michael Morgan PHOTOGRAPHER | Dan Weiss COPYWRITER | Jennifer Jiles CLIENT | 100 Black Men of America Inc. TOOLS | QuarkXPress PAPER | Proterra/Georgia-Pacific Natural PRINTING PROCESS | Four-color plus metallic, satin varnish

The client wished to convey how "Four for the Future" helps to mentor inner-city children. Editorial shots highlight the support, the power, and the elements of the mentoring program. Successful design techniques included intricate folding and color usage. The organization is non-profit, so the brochure was designed to be printed as a workin-turn, which allowed Morgan Design to stay within their limited budget.

100's Overview

Every east ago, Philip Thompson was a shy, introverted, nine-year old-boy. The small Perry Homes' resident was burdened with low self-esteem and failing grades. Yet, somehow, young Philip found the courage to approach a man he did not know very well and ask him, "Would you be my mentor?"

That man was Archibald Hill, director of the Atlanta Partneship office of Fannie Mae and vice president of programs for the 100 Black Men of Atlanta, inc. That day was the beginning of a freeyear relationship that has challenged, transformed and rewarded both of them. Largely due to his relationship with Hill, Philips if the schanged greatly.

Today, the 14-year-old is on the honor roll, has learned how to set goals and overcome challenges that before may have overwheimed him. Philip often spends weekends and attends church with Hill and his family. Hill is now mentoring Philip's younger sister. The reality is that the 100 does not just mentor a child, we mentor a family.

Archibald Hill and Phillip Thompson embody the mission of the 100 Black Men of America, Inc. This is just one example of the literally thousands of successful mentor-mentee relationships. Our mentoring programs have possitively impacted the lives of young people and their families.

Throughout our 34-year history, our mission has been to improve the quality of life for children and communities. Today, our effort to reach this goal is strengthened by our "Four For the Future" initiative.

Our focus continues to be on youth development through mentoring. Through our "Mentoring the 100 Way" programs, we have touched the lives of over 120,000 children, positivi impacting families, communities, and the nation.

Realizing that economic prosperity and self-esteem are tied together, our economic development program is poised to take our organization and those we serve to new heights. The 100 is taking a new direction in helping our community reach economic self-sufficiency and empowerment.

Education is also key to self-esteem and empowerment. The 100's educational initiatives include business ownership, college scholarships, teaching self-sufficiency and the importance of community service.

In 1997, the 100 expanded its health & wellness program to include areas that have a major act on our community. While maintaining our focus on anti-violence, we are also addressing state cancer in African-American men, diabetes and HIV/AIDS awareness.

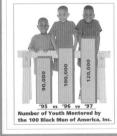

cessful, or even possible, without our 77 chapters. Chapters are the engines of the 100. The national organization applauds their dedication, contributions and service.

Increasing Gyr, toollary, studie and using goemment laaders, community laaders deciand other key corporate and business decision makers are ablo recognizing the efforts and individual investors are expansing their support, a further testament to the success of the 100 Black Men of America, inc. as one of the nation's leading non-profit organizations.

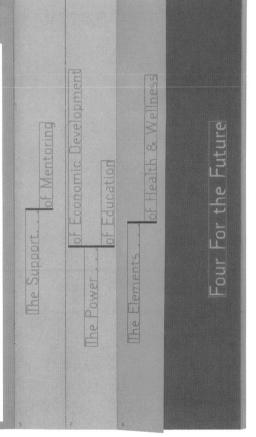

行 史

簡

總行 申與銀行的前身是一九零五年清朝政 府成立的戶部銀行,一九零八年改務 大清銀行。一九一二年一月、泰孫中 山縣時大總統論、改銀為中國祭行、 同年二月在上海陶業。一九四九年十 一月、中國銀行總管理處遷往北京。 一九五三年中央人民政府指定中政级 行為國家特許的外國專業還行。一九 七九年國務院批准中國銀行為國務院 直履機構·專門行使國家外額外質專 業銀行的職能。 ● 端著國家經濟體制改革及對外開放政

策的技术深入,中國銀行進入了新的 歷史發展時期,並以其維厚的實力、 卓著的信誉、杨健的综合、跨入了世 界大銀行的臺列,並逐步朝向國有商 紫銀行轉化。

根據英國《銀行家》兼誌一九九七年 公佈的全球一千家大銀行中·以核心 资本排名、中國銀行列世界第十五 位、國內第一位:以總資產到世界第 二十四位。世界著名雑誌《歐洲货 幣>連續三年詳中調銀行為最佳國內 銀行。

1943年建成的上現中國最后大來 許某題 The A----mking hall of our Shanghas in 1943 實發行總行大陸 Zheng Turn, Beanch Manager the lead in accepting Beijing 1950年3月 乾隆加川府為 8週 中國銀行大厦 8 章 Mr. Zheng Tieng uliferation iating the

ORIGIN OF BANK OF CHINA

HEAD OFFICE

© Rank of China's predecessor in the Oing Dynasty was the Treasury Bank, which was established by the government in 1905 and subsequently rena ned as the Baok of Great Qing in 1908. In January 1912, under the sanction of Dr. Sun Yat-sen, the Interim President, Bank of Great Qing was reorganized with its name changed to Bank of China. The Bank commenced its business in Shanghat in February, 1912. In November 1949, the Head Office of Bank of China was relocated to Beijing. In 1953, the Central People's Government issued a decree designating Bank of China as the state's foreign exchange bank. In 1979, the State Council decided that the Bank should be under its direct jurisdiction with specific functions of a state bank specialiaing in foreign exchange and foreign trade.

Ohina's reform and open policy has directed the Bank of China to a new historical era. With its solid foundation, fine reputation and prudent operation, the Bank has come one of the leading banks in the world, and is gradually being transformed into a state-owned commercial bank.

According to "The Banker" of July 1997, Bank of China was ranked 15th among the world's 1,000 largest banks in terms of core capital, and the first in China, With respect to total assets, the Bank was the 24th in the world. "Euromoney" also selected Bank of China as the best domestic bank in China for cutive years.

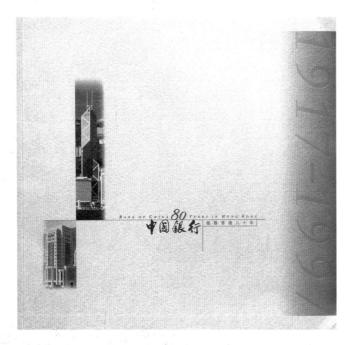

DESIGN FIRM | Kan & Lau Design Consultants ART DIRECTORS | Kan Tai-Keung, Lau Sin Hong DESIGNER | Cheung Lai Sheung CLIENT | Bank of China, Hong Kong PAPER | Cover: Hiap Moh F961-304 320 gsm; text: 151 gsm Artpaper and Heiwa Ultrafelt 118 gsm

The contrast between the new and old buildings of the Bank of China expresses the bank's progress over its eighty-year history.

DESIGN FIRM | The Creative Response Company, Inc. ART DIRECTOR/ILLUSTRATOR | Sandy Salurio DESIGNERS | Sandy Salurio, Arne Sarmiento COPYWRITER | Fides Bernardo CLIENT | Fil-Estate Group of Companies TOOLS | Adobe Photoshop and PageMaker, Macromedia FreeHand PAPER | C2S 220 Ib. PRINTING PROCESS | Offset

This interactive sales kit includes a movable wheel that shows the titles of the four districts within the park. Bright, playful colors in solid blocks readily create a feeling of outdoor fun and excitement, clearly establishing that life in Southwoods Ecocentrum is an everyday adventure.

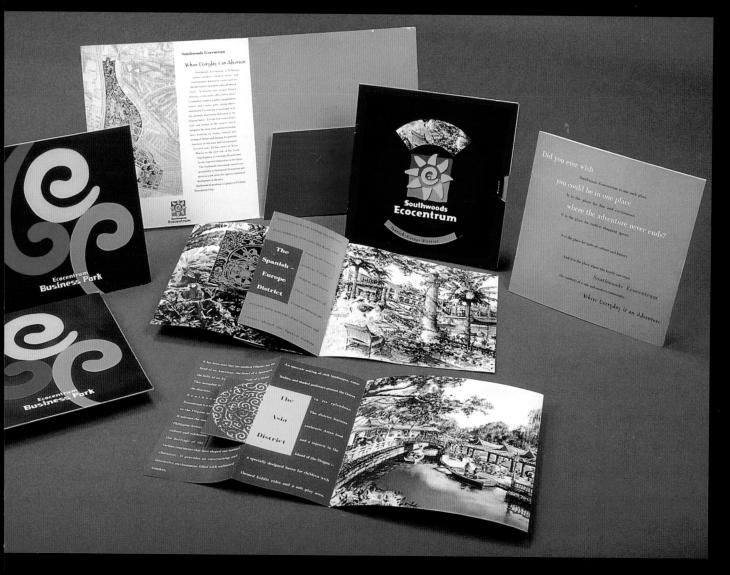

Caring for and managing our land

Land was at the heart of the congressional discussions about the Alaska Native Claims Settlement Act when it was passed in 1971. Land also provides an incredibly strong tie to our heritage for those of us who live in Southeast Alaska and for those of us who left but who still

trace our ancestry to the region. For such reasons, our maturing corporation is devoting considerable time and attention to how we care for and manage our land. Sealaska is structuring its resource

management program to perpetuate our cultural identity and e subsire

New policies at work In 1982, Sealaska took an important step toward its stewardship mission, with the implementation of its first environmental policy. Ultimately, changing times and new laws called for a positive step ahead, tesulting in even stronger policies and programs that were adopted by the corporation late last year. Sealaska's new environmental policies require the corporation to aggressively assume responsibility.

Sealaska is responsible for balancing conservation and environmental considerations with sharehol

60 8

> DESIGN FIRM | Hornall Anderson Design Works, Inc. ART DIRECTORS | Jack Anderson, Katha Dalton DESIGNERS | Katha Dalton, Heidi Favour, Nicole Blo Michael Brugman ILLUSTRATOR | Sealaska archive COPYWRITER | Michael E. Dederer CLIENT | Sealaska Corporation TOOLS | Adobe PageMaker, QuarkXPress

PAPER | Quest Green, Cougar Natural, Speckletone Cougar Opaque, Quest Moss, Gilbert Voice

The client needed a piece that would serve not an annual report, but would also celebrate the 25th anniversary. The Hornall Anderson team c clean design, incorporating earthy colors and a art references. Their biggest challenge was pr Pantone colors on uncoated, colored paper sto required multiple drawdowns.

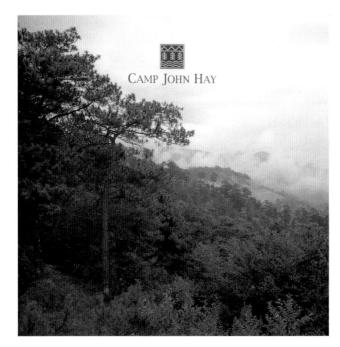

DESIGN FIRM | The Creative Response Company, Inc. ART DIRECTOR/DESIGNER | Arne Sarmiento PHOTOGRAPHER | Francis Abraham COPYWRITER | Pia Gutierrez CLIENT | CJH Development Corporation TOOLS | Adobe Photoshop and PageMaker, Macromedia FreeHand PAPER | C2S 229 Ib., Matte 100 Ib. PRINTING PROCESS | Offset

To distinguish Camp John Hay from among other land developments, a fictional character was created whose poignant diary entries show the personal significance of living in Baguio, the summer capital of the Philippines.

DESIGN FIRM | The Creative Response Company, Inc. ALL DESIGN | Sanady Salurio PHOTOGRAPHER | Francis Abraham COPYWRITER | Creative Copy Team CLIENT | Philippine National Oil Company (PNOC) TOOLS | Adobe Photoshop and PageMaker, Macromedia FreeHand PAPER | C2S 220, Matte 80 lb. PRINTING PROCESS | Offset

The challenge for PNOC's 1995-1996 annual report was to create a divergent approach to the usual technical presentation common to petroleum companies, while conveying their adaptation and responsiveness to ever-changing environments. The strategy of using oil pastel renditions successfully met this challenge and strengthened the company's position as a responsible leader in the petroleum industry.

o be a Group of world-class people guided by managerial excellence. To use our resources wisely, responsibly To explore, develop, and manage existi and potential energy sources, whenever, wherever All these that the country wou better place to live in And that prosperity would br envelop the lar This is, this shall, for The Philippine Nation Going boldly where Changins, sill life World has eve

PNOC

1994

ANNUAI REFORT

Vition Store

As information technology advance we're evolving to help you succee W are beginning a new dagter in the Ancorone to U you've bene following the story, you how us an company with three decedes of experience provide information delivery solutions, a company with the soreds of catemars who rely on us as they face the d lenges of the information age, forthinged on near pro-

0

ANACOMP: THE NEET CHAPTE

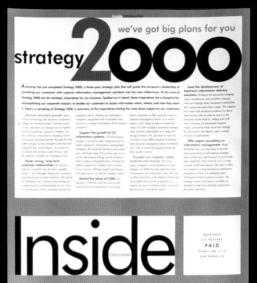

DESIGN FIRM | Mires Design ART DIRECTOR | John Ball DESIGNER | Deborah Hom ILLUSTRATOR | Tracy Sabin PHOTOGRAPHER | John Still, Michael Campos stock COPYWRITERS | Danniel White, Steve Miller CLIENT | Anacomp PRINTING PROCESS | Six-color offset

Anacomp's *Inside Information* newsletter was designed to re-introduce a revitalized company to its customer base. A new logo, new products, and a new focus were created, accompanied by industry-trend stories that reinforce Anacomp's leadership position.

Look inside for new ideas on managing your information.

0

With a national 30 MHz licence to operate PCS in the 1.9 GHz range, Microcell Connexions is the only Canadian company to deploy, operate and market an open wireless telecommunications network based on the GSM standard. In addition, Connexions wholesales its network, making it available to service providers and entrepreneurs who wish to enter the wireless market and offer their own services.

Microcell's GSM network serves five regions, and currently offers digital coverage to nearly 40% of the Canadian population, and by the end of 1998, it will cover the majority of the population. Roaming on AMPS networks increases coverage to 94% of the Canadian population.

The approach is simple:

Adopt a well-proven technology that is on the leading edge in terms of costs and product development and is a world standard.

Build out a cost-effective network to support the economics of a mass-market approach build in densely populated areas where people live, work and spend their leisure time, offer roaming on the cellular analog network between cities and in remote areas; offer worldwide coverage through roaming on the networks of its CSM counterparts.

Design an open network and offer it to other providers on a wholesale basis, to quickly leverage the network investment, and capitalize on the opportunities created by additional niche and full-service operators entering this market. In the first half of 1998, Microcell expects that the netw will be rolled out progressively to an additional 3.7 mill Canadians rapidly increasing the overall population cove Networks will be launched in areas such as Victoria, Edmo Calgary and Barrie. Microcell is also working towards additi roaming services in other centres in the U.S. and overseas

THE GSM ADVANTAGE

CSM (GLOBAL SYSTEM FOR MOBILE COMMUNICATIONS) IS THE WORLD'S LEADING WIRELESS DIGITAL TECHNOLOGY, WITH INTWORKS OPERATING IN 109 COUNTERS, SLEWING 66 MILLION SUBSCRIBLS AT THE END OF 1997. TWO MILLION NEW CSM CUSTOMERS ARE ADDID EVERY MONTH WORLDWIDE, CSM NOW MORTH WORLDWIDE, CSM NOW TOTAL WIRELESS MARKET. O GSM HANDSETS USE A SM CARD, CONTAINING THE CUSTOMER'S INDIVIDUAL NUTHENTCATION KEY, PESE IDENTIFICATION AND SEEN PROFILE INFORMATION. G DFFEBS SUPPEROR VOICE Q CALL PRIVACY AND THE DOVANTAGES OF NATIONAL INTERNATIONAL ROAMING.

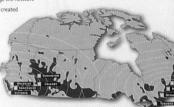

CURRENT FIDO PCS COVERAGE AREA

DESIGN FIRM | Goodhue & Associés Design Communication CREATIVE DIRECTOR | Lise Charbonneau ART DIRECTOR | Paulo Correia DESIGNERS | Josée Barsalo, Aube Savard ILLUSTRATOR | Daniel Huot PHOTOGRAPHER | Jean-Francois Berube COPYWRITER | Microcell Solutions Language Services CLIENT | Microcell Telecommunications Inc. TOOLS | QuarkXPress, Macromedia FreeHand, Infini D PRINTING PROCESS | Offset

During 1997, the client revolutionized personal communications and experienced outstanding growth. They wished to emphasize the personnel responsible, hence the use of vibrant-yellow, humar figures on the cover, and staff photos inside.

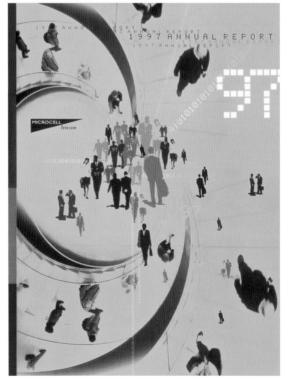

The Beresford process starts with an exam

nation of your coarting applications and architecture—your departments, users' requirements, software requirements and the like—and compares them against the Beresford Model. From here, Bereaford cost-effectively provides Design, Project

MODELS CREATE THE ULTIMATE SOLUTION

datagement, and Professional Skills to a successful implementation. Although impleneutration may differ from customer to customer, the Beresford approach will tailor the system exactly to meet your needs, while maintaining a package. You may require a funct implementation, for example, learing some legacy systems in place while eplacing others. — Bensford is a powerful system that enables you to see your loan, case and credit card business while it is in process. The movement and flow of information can be managed throughout the day, at any moment and from any location, egundless of where it orignates. —

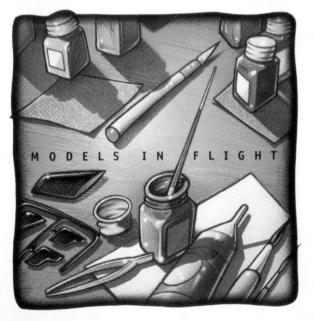

BERESFORD

DESIGN FIRM | ZGraphics, Ltd. ART DIRECTOR | Joe Zeller DESIGNER | Renee Clark ILLUSTRATOR | Paul Turnbaugh CLIENT | Beresford

Beresford has created a comprehensive loan, lease, and credit-card system adaptable every part of any finance company. They achieve this adaptability by producing models that are customized to the target business. The concept of airplane model-building helps to convey Beresford's strategy while focusing on their theme: models in flight.

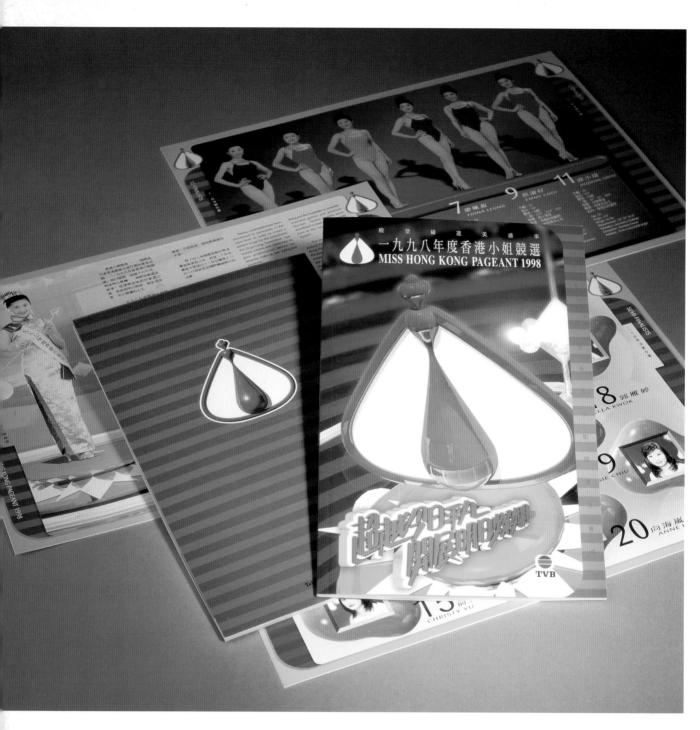

DESIGN FIRM | Television Broadcasts Limited ART DIRECTOR | Alice Yuen-wan Wong PRINCIPAL DESIGNER | Andrew Pong-yee Chen DESIGNER | Tom Shu-wai Cheung CLIENT | Miss Hong Kong Pageant 1998 TOOLS | Adobe Illustrator and Photoshop, Macromedia FreeHand PAPER | 150 gsm art paper PRINTING PROCESS | Four-color plus one Pantone on cover; four-color inside

To convey the pageant is "as glamorous as a crystal palace," the designers created a three-dimensional environment and gave the pageant's logo a magical appearance.

mmercial-Iree TV for Kids.

DESIGN FIRM | SJI Associates Inc. ART DIRECTOR | SUSAN SEERS DESIGNER | Karen Lemke COPYWRITER | JESSY Vendley CLIENT | HBO, Cindy Matero TOOLS | QuarkXPress, Adobe Photoshop and Illustrator PRINTING PROCESS | Offset

HBO wanted a brochure design that would promote their line-up of children's programming and give each program the space to show its own personality. The use of patterned backgrounds gave each spread its own identity, while tying the brochure together.

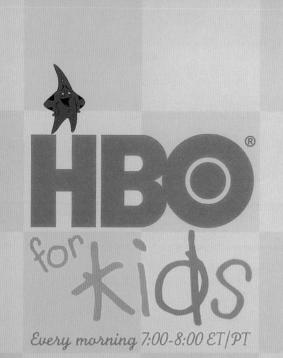

ore than ever, parents are concerned about what their kids are exposed to on television. Which is why we created HBO for Kids-a fun,

can feel good about. Intelligent shows that are as educational as they are entertaining, and scheduled at sensible times so that kids of all ages can enjoy them.

enriching alternative to commercially driven children's programming. We don't answer to advertisers; we answer to parents. Which means HBO for Kids airs only programs that parents

... so much fun, kids don't even notice it's good for them!

DESIGN FIRM | AWG Graphics Communicação, Ltda. ART DIRECTOR | Renata Claudia de Cristofaro DESIGNERS | Dennys Lima, Marcello Gava CLIENT | Reifenhäuser Ind. Maq. Ltda. TOOLS | Adobe Photoshop, CorelDraw, PC PAPER | Couchê 180 gsm PRINTING PROCESS | Offset

This brochure was designed to sell plastic extrusion machinery by artistically showing the final product its applications. To achieve this objective, the desig mixed products obtained by the machinery with the machinery itself.

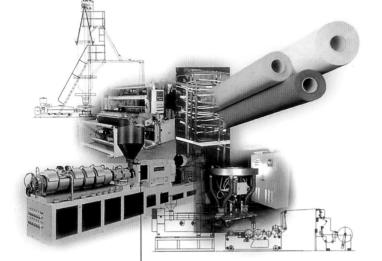

nlight Media s the power potential of me media at r service.

Our experienced, imaginative staff is ready to serve as your technology partner, helping you achieve your business goals with speed and efficiency. And Moonlight Media's commitment to you is ongoing. Once we design your Internet or Intranet site, we consult with you on developing

your strategy and targeting your audience. And our technology experts keep you aware of emerging tools and opportunities that will prove valuable to you and the success of your business. You see, Moonlight Media takes a handcrafted approach to handling your Internet, Intranet, and Web-based needs. And if you think "handcrafted" is an inappropriate term to describe an outfit whose stock in trade is leadingedge online technology, please keep this in mind:

Our company is not about technology. Our company is about using technology to help your company do business more successfully.

For this forectry consulting firm, Moonlight Medic developed a web site that provides critical imbee market information for investors, along with a private archive of timbe publications that may be reviewed by authenticated a SIAP members. We also constructed a SIAP members. Tool thet allows site visitors to demo the company's PREAR/V-ECOW software that predicts timber yields and their associated financial returns.

SELENT C. 1129 COMPANY Montight Media constructed a tentroy planning and reporting tool for Leby that allows outside salesmen to plan and track their weekly sales activity. Salesmen are causton Active X controls. developed by Montight Media, to eater their plans into the parent Call Planner database. Once entered, these plans are tracked and their married to mainforme data to generate performance reports. Managers also have the capability to lag on and review the call planning activity.

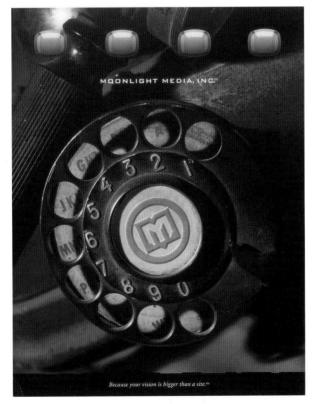

DESIGN FIRM | Communication Arts Company ART DIRECTOR/DESIGNER | Hilda Stauss Owen PHOTOGRAPHER | Photodisc: Design Photo Image COPYWRITER | David Adcock CLIENT | Moonlight Media, Inc. TOOLS | Macromedia FreeHand PAPER | Stock Karma PRINTING PROCESS | FOUR-COLOR Offset lithography

In contrast to the youthful client's high-tech enterprise of Web design and services, the designers chose a striking collection of nostalgic images that suggest tried-and-true reliability and strength.

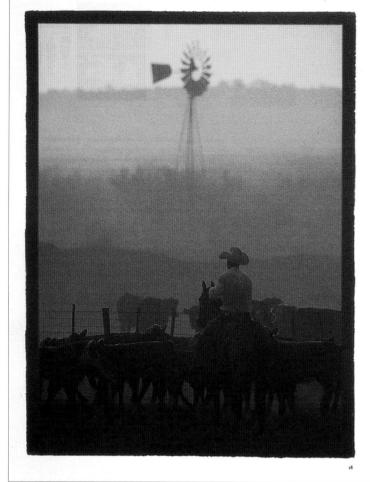

internation of the

discoveries last Pickluk Ranch ed in dally of gos barrels of Storeal acreage is for y0 seismic 1998.

the history bekind PITCHFORK RANCH W The circus partnership of Barnum 6 Buliey was not the only important aliance formed in 186. Bapter Willmans and Dan Gadner, boyhood friends in Mississippi before the Civil War, Joined forces their year to start a cattle business on the south Wohth Biver near Labbeck, Bean. The Lar quarter of the 19th century was a rough-andtumble time for the growing cattle industry. Burviring drought, howeve wintere, unable perices and occasional rusifiers, the Pitchfork Ranch held title to 70,000 arere and had increased its held to more than 12.000 carls how 1900.

The present-day operation, an outstanding example of preseverance, loyalty and respect for the cowboy way of life, has incorporated the modern world of helicopters and cellular phones with traditions of the past, including the historie chuckwapen, seasonal roundups and a brand then has been around more B48. The IdS CoO acceranch in central West Tesas has endured over 100 years of assorted political and economical difficulties that defeated many large cattle syndicates from ranching9 Colden Fex.

The descendants of Eugene Williams have been directly twolved in the Pitchfork land and Cattle Company since it was incorporated in 1883. With a contravy of concellulation and acquisitions, the ranch is actually larger today than at any other time in its history. Louis Dreylas Natural Gas and Pitchfork, tharing a brild in traditional standards of trust and honory, work together for results that are munially beneficial to both companies.

19

reasonated from practical of pressions and pression of the pre

South Wichita River. L a 8 8 o c 8

The Permian Basin of southeast New and West Texas is another region in which Louis Dreyfus Hatural Gas has comm important exploration projects. The Company's leasehold inventory of over 1.4 acres will yield approximately is exploration wells in 1998 with a focus on pri the Midland, Val Verde and the Delaware Basins of New Mexico. Typical exploration are the Strawn, Morrow and Atoka, with depths ranging from 7,000 to 15,000 fe percent of the total dilling budget for the Western region will go to exploration price Middland, and the Analysian of the Western region will go to exploration price to the total dilling budget for the Western region will go to exploration price to the total dilling budget for the Western region will go to exploration price price to the total dilling budget for the Western region will go to exploration price price to the total dilling budget for the Western region will go to exploration price price to the total dilling budget for the Western region will go to exploration price price to the total dilling budget for the Western region will go to exploration price price to the total dilling budget for the Western region will go to exploration price price to the total dilling budget for the Western region will go to exploration price price to the total dilling budget for the Western region will go to exploration price price to the total dilling budget for the Western region will go to exploration price price to the total dilling budget for the Western region will go to exploration price price to the total dilling budget for the Western region will go to the sploration price to the sploration

Company has exclusive exploration rights and a 25 percent working interest in a gross acres. Louis Dreyfus Natural Gas negotiated with the landswners of this ranch in West Texas to be one of the first companies to shoot a large 3D seismic Following a 30-square-mile survey and four successful Tannehill discoveries la there are plans for at least four more exploratory wells in 1998. Knowledge gains this shoot and from current drilling is being used to identify similar anomalier ranch area. The Company has plans for a new 50-aquare-mile 3D survey, after tion of this data, additional drilling is expected to begin by the fourth quarter.

Exploration. MED-CONTINENT Louis Dreyfus Natural Gas proper Oklahoma, Kanass and the Tesas Panhandle represent some of its most establish duction. And despite the extensive amount of development in this area, exploration have successfully identified numerous targets, each of which has the potential (f production levels exceeding one million cubic feet. Almost one-fourth of the \$40 total drilling budget will focus on exploratory targets, including the Watonga-Gh. Trend which produces from the Morrow/Springer formation.

DESIGN FIRM | Wood Design ART DIRECTOR | Tom Wood DESIGNERS | Tom Wood, Alyssa Weinstein Photographer | Chris Shinn COPYWRITER | Maryanne Costello CLIENT | Louis Dreyfus Natural Gas TOOLS | QuarkXPress, Adobe Illustrator PAPER | Mohawk Navaho PRINTING PROCESS | Six-color, die-cut

The annual report parallels the exploration and productic activities of the company and the lives of the cowboys and ranchers working on the properties. The design contrasts editorial and technical attitudes through typography, journalistic photography, feature stories, color, and sequence.

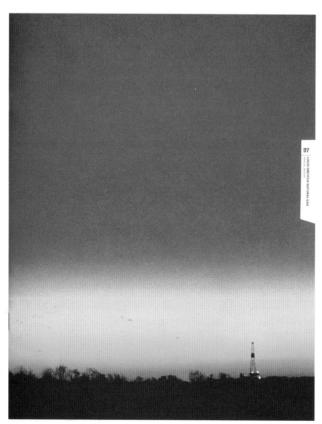

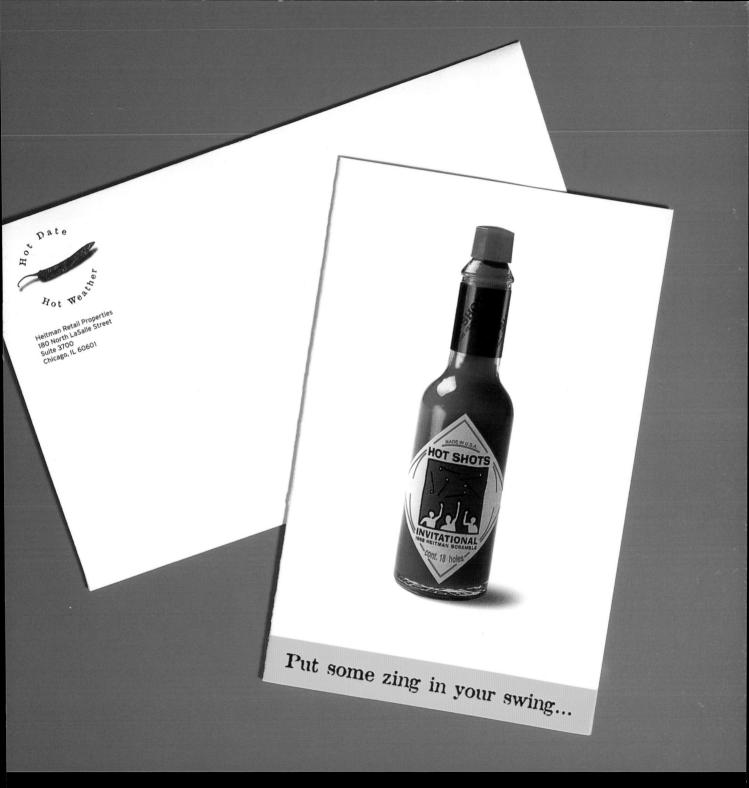

| WATCH! Graphic Design R | Bruno Watel Tim Goldman ER | Hot Shots, Chicago | Jay Dandy Sitman Retail Properties Sybe Photoshop and Illustrator, Macintosh rren Lustro Dull Recycled

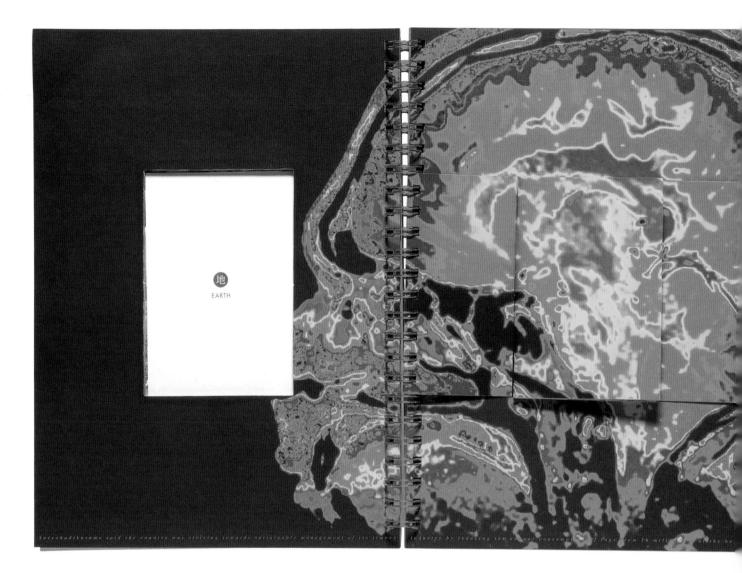

 DESIGN FIRM | Alan Chan Design Company ART DIRECTOR | Alan Chan DESIGNERS | Alan Chan, Peter Lo, Pamela Low COPYWRITERS | Margaret Tsui, Todd Waldson, Ann Williams CLIENT | Swank Shop

The Chinese philosophy of heaven, earth, and man was adopted as the metaphor in this environmentally themeo brochure. Heaven and earth easily translated to the secfor the Swank Shop and A Swank Inspiration, respective The concept behind the Man section for the Swank Stuc however, depicts the evolution of humankind and the influence of technology.

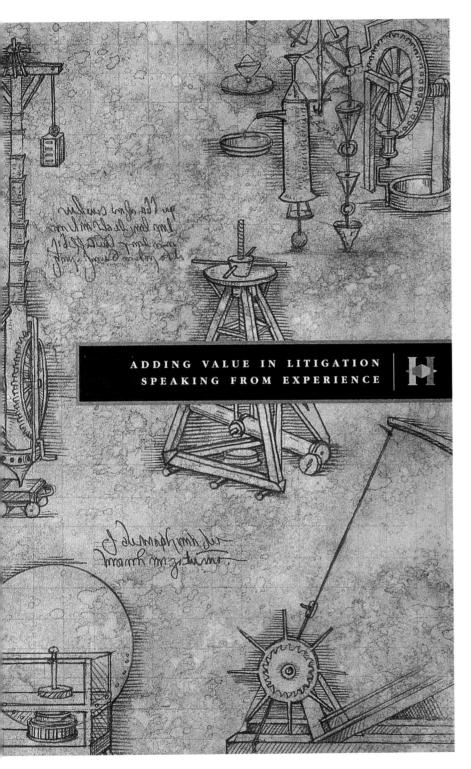

DESIGN FIRM | Julia Tam Design ART DIRECTOR/DESIGNER | Julia Chong Tam ILLUSTRATOR | Kirk Caldwell COPYWRITER | Dennis Moore CLIENT | Houlihan Howard Lokey and Zukin TOOLS | QuarkXPress, Adobe Photoshop PAPER | 80 Ib. Superfine cover, Mohawk eggshell soft white smooth

The client wanted an Leonardo da Vinci-type drawing to show class and simplicity, so the designers scanned in paper with an aged patina to simulate old-time paper. The client also needed pockets to hold cards, but wanted to be sure that the cards did not fall out. The designers decided on a glued-in flap and stepped slits for a strong display.

DESIGN FIRM | Jeff Fisher Logo Motives CREATIVE DIRECTOR | Sara Perrin, Seattle Seahawks DESIGNER/ILLUSTRATOR | Jeff Fisher PHOTOGRAPHERS | Various COPYWRITER | Sara Perrin CLIENT | Seattle Seahawks TOOLS | Macromedia FreeHand, Macintosh PRINTING PROCESS | Six-color process

.....

1111

WE'LL KNOCK YOU OFF YOUR FEET!

Sold of

\$410

11220 NE 53rd Street Kirkland, WA 98033

1-888-NFL-HA

minutur

h Ticket

Seattly Seaha

Or Ar Ar

Scallle Callands

NAME AND A PARTY OF A CHARACTER OF A PARTY O

1 North

IOCK *DPP* RAN

Seal Sea

Seahawks

RETAIL

2

OPPORTUNITIES

EOSPITALITY

SUITES/CORPORATE

COMMUNITY OUTRAL

CONTRACTOR SORTS

STRETS AND SHAD

BROADCAST SULLAND STREET

ALLANDA ANALANA ALLANDA ANALANA ALLANDA ANALANA ALLANDA ANALANA ALLANDA ANALANA

PORISCATIONS PRINT

THOMAS STATES

SEAKAWAS TRAINING CAMP

This multi-element package of materials for the Seattle Seahawks promotes their 1998–1999 season. Various pieces can be used to target potential corporate sponsors, season-ticket holders, and the general public.

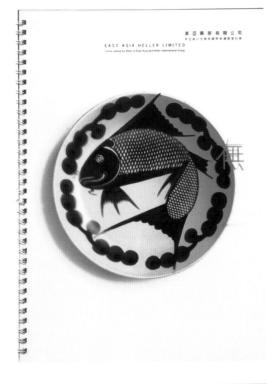

DESIGN FIRM | Alan Chan Design Company ART DIRECTOR | Alan Chan DESIGNERS | Alan Chan, Jiao Ping CLIENT | East Asia Heller Ltd.

The fish visual was adopted to symbolize the proficient and Chinese-focused services the client provides. Four Chinese idioms, each containing a word-play on fish, were used to highlight four successful business stories. The cover is a familiar Chinese-style dish with an acetate overlay of a fish; this layout allows the fish to transfer over the empty plate—a metaphor for prosperity and abundance.

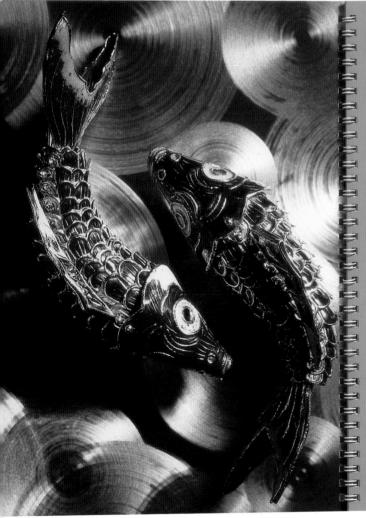

為生於無的故事 由痛難媒團製品有限公司關鍵

東亞興萊勇於打破傳統的融資方式,為高雅線圈提供發票貼現與機器租賃 服務:信貸額緊隨銷售額遞增,緊密配合高雅線圈急速擴展的業務,令公司 業務架構日益完備。從無至有,有賴融資及時而充足,如魚得水。

partnership devoted to maximizing access to higher education for students

LANGERING SUCCESS ...

na. We responded by d repay responsibly endina institutions

Education Services Foundation

Beyond Due Diligence Counseling Program a comprehensive counseling service aimed at reducing default rates on student loans

ESF Services

H.E.L.P. Software a personal student

loan planning program provided without charge

to colleges, high schools

lenders, and students

OneLink

a coordinated electronic funds transfer network

through which schools

receive disbursements

in one transaction

from multiple ESF lenders

Entrance/Exit Loan Counseling service provided by ESF prior to the borrower's receiving the loan proceeds or prior to the borrower's graduating from school

Financial Ald Hotline

and connections for school-specific matters

800-362-1304 or 981-1075 in Jackson, MS

a free information service for students and parents with

up-to-the-minute student financial aid information

a loan program that offers students an opportunity to consolidate multiple student loan debt which can result in a single-often lower-monthly payment

Loan Consolidation

an online Internet resource for general higher education and career planning, financial aid advice, and financial planning assistance,

with connections for scholarship searches, electronic completion of aid application forms, and H.E.L.P. software www.esfweb.com

College Access Planning Program a comprehensive education planning program providing a range of information and counseling to students and their families in the areas of personal assessment. career possibilities, school election, and wise financing

DESIGN FIRM | Communication Arts Company ART DIRECTOR | Hilda Stauss Owen DESIGNER | Anne-Marie Otvos Cain ILLUSTRATOR | Russell Thurston, Artville COPYWRITER | David Adcock **CLIENT** | Education Services Foundation TOOLS | Macromedia FreeHand PAPER | Sterling Gloss

PRINTING PROCESS | Four-color, offset lithography

As an extension of an existing corporate publication, pamphlet highlights the specific services with playfu abstract collage illustrations.

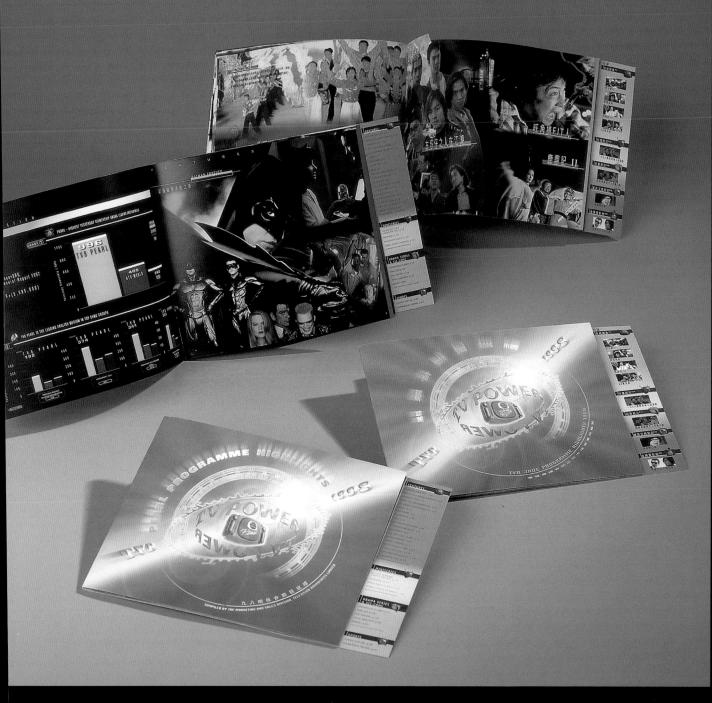

DESIGN FIRM | Television Broadcasts Limited ART DIRECTOR | Alice Yuen-wan Wong PRINCIPAL DESIGNER | Sai-ping Lam DESIGNERS | Isabella Wai-ping Chan, Fanny Lai-fan Chan, Yiu-chuen Jew, Tat-fun Liu CLIENT | TVB Programme Highlights 1998 TOOLS | Adobe Illustrator and Photoshop, Macromedia FreeHand PAPER | Matte Art Paper, Rives BrightWhite PRINTING PROCESS | Four-color process offset and die-cut effect

DESIGN FIRM | Tom Fowler, Inc. ART DIRECTOR | Thomas G. Fowler DESIGNER | Karl S. Maruyama PHOTOGRAPHER | Tod Bryant/Shooter, Inc. COPYWRITER | Brad Elliot CLIENT | UIS, Inc. TOOLS | QuarkXPress, Adobe Illustrator and Photoshop PAPER | Neenah Classic Columns, Zanders Ikono Gloss PRINTING PROCESS | Offset and foil stamping

UIS needed a brochure to send to brokers and prospective sellers describing who they are, what kind of business they buy, and the kinds of products their subsidiaries produce.

FLAVORS

D om Antonellis joined New England Confectionery as an engineer. His first assignment: Modernize the company's outdated production lines. That success led to others, and in 1978 he became prevident, a position the holds today. "We've built an organization in which companies can thrive" he says. "There is no corporate bureaurcaye to deal with, and by bringing so many great brands together we open the way to more effective marketing and stronger year-round sales." More than eight billion Sweetheart Conversation Hearts are sold annually, and together with type COS Sweet Talk line they make the company the leading manufacturer of these products. Contemportary slogans keep this action of the state of the state of the state of the state company the leading manufacturer of these products. Contemportary slogans keep this product popularity high

extension of the famous Candy Cupboard line of boxed chocolates. Marketed

U I

chocolates. Marketed exclusively hrough more than 2,000 K-Mart stores across the country, the brand was created to further strengthen the entire company's position in the mass merchandiser marketplace. Response to the second and the second s

150th ANNIVERSARY

The original candy worker

Confectionery

U I S

The New England Confectionery Company is the oldest multi-line candy company in the United States. UIS acquired it in 1963. Today, with its two divisions, Stark Candy Company and Haviland Candy, Company, the \$100-million company is steadily expanding through a highly aggressive brand development strategy, year-round product marketing programs and strategic acquisitions.

Haviland Thin Mints became the topselling brand in its category after UIS acquired the company. Today it is on of the backbones of the company's comprehensive product line.

PAGE 7

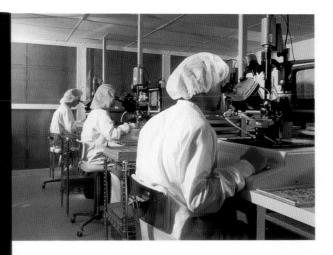

wery day in America 8 threlighte will suffer a respiratory injury. of those, 1 out of 24 will die.

over **56,000** deaths and injuries were related to Carbon Monoxid over a period of **10** years. no other poisonous agent has ever been implicated in

about 250 people die,

and thousands more are injured each year from accidental Carbon Mor

On a Tuesday, in one of our plants that is environmentally controlled, with stringent, comprehensive Electrostatic Discharge (ESD) systems in place, where Die Attachment, Calibration, Wire Bending and highly sentitive, proprietary operations are performed in a class 1000 clean room - hazardous gas detection equipment is manufactured by hand specifically for, among others, the chailonging tasks of codary Sirefighter.

> At the same time dashing from a hazardous response truck, a Firefighter responds to the urgent need to assess the threat of a grimm railcanderailment, spilling Ochknien gas, or perhaps to a letal domestic Cabon Monoxide leak from a household furnace some half a hemisphere away. In an instant, two worlds meet over a gas-safety device which in either cass will serve to protect and user human life - an AM Setty gas detector.

AlM Safety gas detection products have always brought people and safety together. The relationships we've formed over gas safety are significant and deep. Friendships with our nations free departments, with industrial corporations, utilities and select marketing partners... with our customers and within communities - these are the relationships that help define us as a company, set us apart, and are responsible for our growth and success.

19

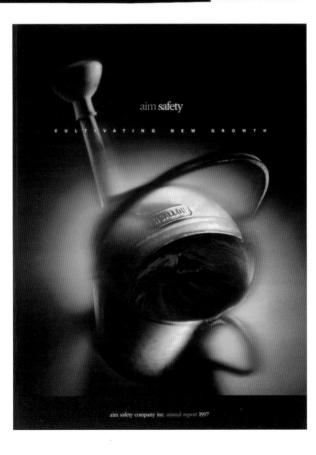

DESIGN FIRM | Big Eye Creative, Inc. ART DIRECTOR/DESIGNER | Perry Chua ILLUSTRATOR | Stephen Dittberner PHOTOGRAPHERS | Grant Waddell, Dann Ilicic COPYWRITER | Craig Holm CLIENT | Aim Safety Company, Inc. TOOLS | Adobe Illustrator and Photoshop, QuarkXPress PAPER | Cover and text: Utopia; financial section: Potlatch Karma Natural PRINTING PROCESS | Six Colors: four process, spot metallic, spot varnish

The watering can is a universal symbol of careful nurturing, growth, and rejuvenation of life, and here it represents the seeds of the future carefully planted by management. The concept also relates nicely with Aim's main business—saving lives with their gas-detection equipment.

ams

Invoice Connect

In the competitive telecommunications marketplace, service is a critical factor in unioneer evention. This is expectably true with your important commercial accounts. Emproving the rolue of your billing services can be a key to retaining their business.

meetchanners: part of MMS Tapens' size of counter-care and billing statistics offers a sample way to enhance year costamer service. With Theoref annext, cound-daried usage information from one or malippe billing streams and bill analyso tools is delivered to costamers; on CD ROM or was the Torener. This self installing Windows based application prendes a single platform from which bounces costamers; can allocate cors, expert data cost trends and investigate abuse or fraud.

InvoceConnect gives your customers a powerful interactive system that can streamline to they manage their communications expenses. And it gives you a way to provide the le billing service that your corporate accounts demand.

TAPESTRY

DESIGN FIRM | Lee Reedy Creative, Inc. ART DIRECTOR | Lee Reedy DESIGNER | Heather Haworth PHOTOGRAPHER | Dan Sidor COPYWRITER | Nancy Meyerson CLIENT | AMS TOOLS | QUARKXPress PAPER | COVET: Columns

PRINTING PROCESS | Six-color process

ams

customer Care Anywhere

ams

Systems That W

DESIGN FIRM | Marketing & Communication Strategies Inc. DESIGNER | Lloyd Keels PHOTOGRAPHER | Marketing & Communication Strategies Inc CLIENT | Linn Area Credit Union TOOLS | QuarkXPress, Adobe Illustrator and Photoshop PAPER | Neenah Classic Laid cover; Olympian 80 lb. coated text PRINTING PROCESS | Two color offset

The client wished to have an annual report that was modern and classy without a lot of printing extras. A two-color design with ornate icons and interesting page headers and footers created a piece that conveye the personality of the growing credit union.

212:61

AUDIACOMMITTER REPORT

The Audit Committee is responsible for monitoring and evaluating credit union activities. The committee reviews credit rocedures to ensure that the highest degree of integrity is sed in operations and that the Credit Union adheres to all and state laws and regulations.

This year, the Audit Committee retained the auditing firm of Peterson & Associates of Omaha, Nebraska, to assist in out its responsibilities. This firm conducted a comprehensive d performed a full examination of the Credit Union's financial trs for the calendar year 1996. The audit and examination no areas of concern and confirmed the soundness of the Credit A letter from the firm's latest audit is included in this report.

Each year, Petersen & Associates performs a verification of member account balances and requests that members notify any discrepancies. No significant discrepancies have been 9. The Audit Committee also works with the firm to evaluate the controls that are used in the operation of the Credit Union to be call areas of risk are adequately controlled.

In addition to this independent assessment, our Internal Auditor randomly monitors operations through a continuous of random loan reviews, member account verifications, and dit procedures to ensure the safety and soundness of your credit

Linn Area Gredit Union is also examined, on an annual basis, by the Gredit Union Division of the State of Iowa. This tion assessed the Credit Union's lending practices and financial ns for compliance with applicable laws and regulations. Linn edit Union was given a favorable report.

As a result of the independent audits, examinations and the observations of the committee, it is our belief that the enclosed statements fairly and accurately reflect the financial condition Area Credit Union as of December 31, 1996.

LLOYD BAIRD

VERYL SIEVERS

CREDIT COMMITTEER RÉPORT

Ray VanderWiel Credit Committee Chairman

KENT BAKER

R. MICHAEL GILLEN

The Credit Committee establishes guidelines for the Credit Union's lending programs. The committee has empowered a staff of professional loan officers to meet the borrowing needs of our members and provide knowledgeable solutions and advice. Members are offered a wide range of personal and real estate loans at competitive rates and terms.

Loan demand continued to be active in 1996. Loans granted to members increased 17.3% over the prior year. The Credit Committee is especially pleased to report that the quality of the loan portfolio is outstanding. Throughout the year we maintained very minimal delinquency. At year end only 17 credit cards totaling \$57,499.68 were delinquent, and just 7 consumer loans for \$47,019.54 and one \$195,653.88 moretgage were past due more than 60 days. Out of \$,690 loans this is an incredibly low number and reflects the high moral standards of our members and the fine work of our lending staff.

The mortgage department was busy with first mortgage, construction loan, and refinancing activity throughout the year due to rats maintaining historically low leves. Credit Union members were granted 220 first mortgage loans totaling 516.8 million. This included 23 construction loans, a 69% increase over the prior year. With projections that the current interest rate environment will remain steady, it looks like 1997 will be a very active year as well.

Our MASTERCARD, VISA Classic and VISA Gold programs continue to increase in numbers and attract new members. With all three cards at very competitive interest rates and terms, we were able to increase credit card outstandings to \$4,917,817, up from \$3,968,248 in December of 1995. The total number of cards has increased from 2,723 to 3,150 reflecting the favorable rates that the Credit Union has to offer.

We congratulate and thank our loan staff for their exceptional efforts over the past year. We also thank you for utilizing the Credit Union for all of your borrowing needs and we look forward to serving you in the future. DESIGN FIRM | Belyea Design Alliance ART DIRECTOR | Patricia Belyea DESIGNER | Ron Lars Hansen PHOTOGRAPHER | Jim Linna COPYWRITER | Toby Todd CLIENT | Pacific Market International PAPER | Strobe, Classic Columns PRINTING PROCESS | Hexachrome

This brochure gives an overview of PMI's philosophy, capabilities, and services. The bold product shots are designed to show the company's focus on detail and the active-lifestyle market they target.

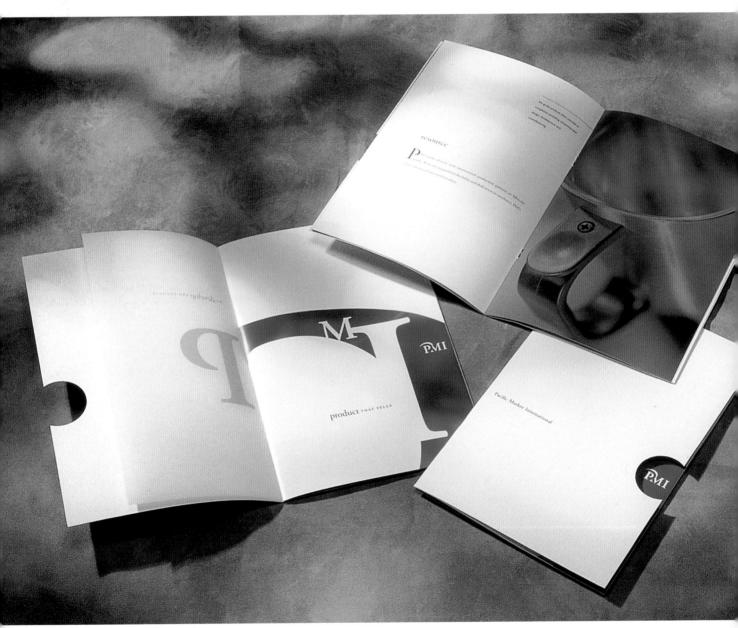

DESTAN FIRM T DI AUCHUELCUX ART DIRECTOR/DESIGNER | Kevin Rayman PHOTOGRAPHER | Stock, Pat Leeson COPYWRITERS | Kevin Rayman, Sarah Starr CLIENT | United Concordia TOOLS | QuarkXPress, Adobe Illustrator and Photoshop PAPER | Fox River Sundance, Strathmore Elements PRINTING PROCESS | Black plus PMS Warm Gray, duotone photos

The client wanted to relate their success in the past year along with a down-to-earth feeling. Because of the small amount of information used in this piece, the designers felt it was important to let the delivery of the information communicate its importance, thus the fold-out pocket folder with inserts.

> and the

P

BS202

1811

ner

(P)/IIII

P

C

itive

CSC

DESIGN FIRM | Ramona Hutko Design ALL DESIGN | Ramona Hutko CLIENT | Computer Sciences Corporation TOOLS | Adobe Illustrator, QuarkXPress, Macintosh PAPER | Mohawk Superfine PRINTING PROCESS | Offset

we made a commitment to grow.

Since the building interior was incomplete, type was used as illustration deniction the main messanes

nies" ((())

DESIGN FIRM | Vaughn Wedeen Creative Art director | Steve Wedeen Copywriter | Foster Hurley CLIENT | US West

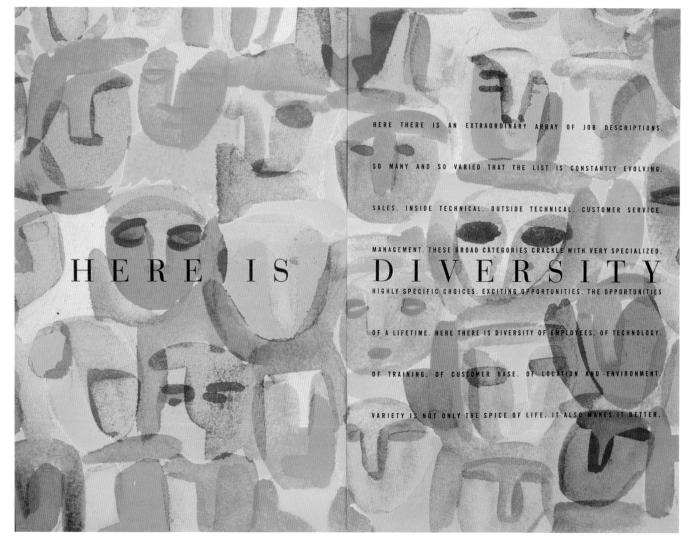

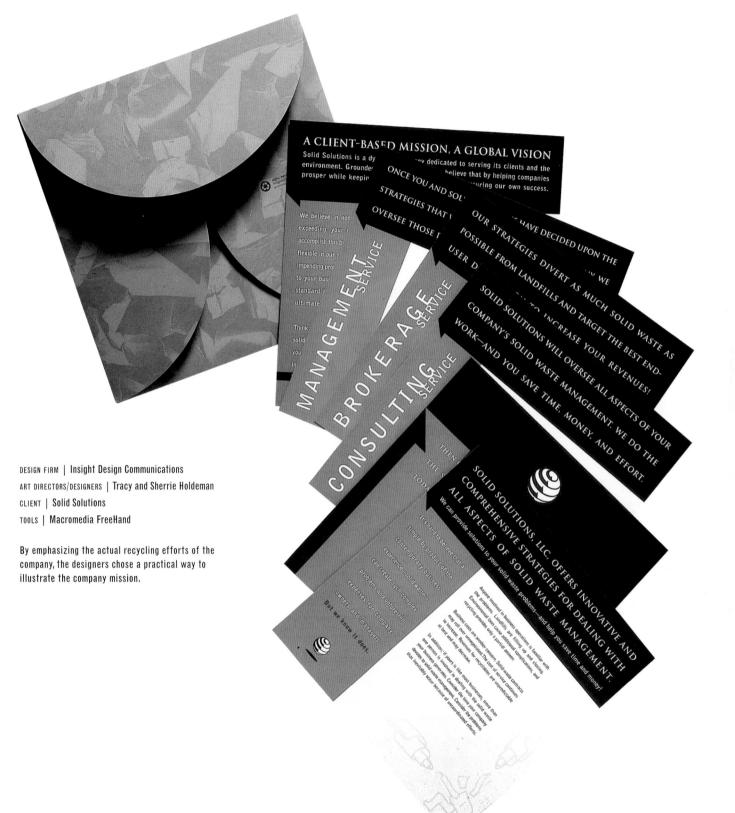

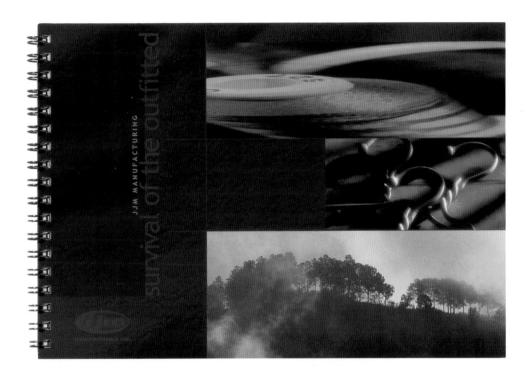

DESIGN FIRM | The Riordon Design Group, Inc. ART DIRECTOR | Ric Riordon DESIGNERS | Dan Wheaton, Shirley Riordon, Greer Hutch Sharon Pece PHOTOGRAPHER | Robert Lear COPYWRITERS | Shirley Riordon, Dan Wheaton, Greer Hut CLIENT | JJM Manufacturing TOOLS | QuarkXPress, Adobe Photoshop and Illustrator PAPER | Supreme Gloss Cover, Glama Vellum PRINTING PROCESS | Four-color stochastic (Somerset Gra

Inspired by the client's commission to create a public-relations piece specifically aimed at the high-end corporate market, the designers used soft textural images and natural colors to visually imply the qualities of the sportswear.

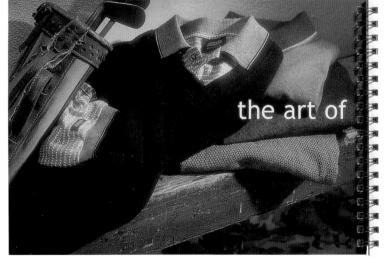

GOLF • The JJM Tour Line goes the distanc

OULP - I me juin icon Line goes une usualle with soft, 100% cotton lightweight fabrics, subtle patterns and rich hues. The Tour Line embodies a refined style and easy comfort that won't leave you in the rough.

looking good.

t's all about style and quality – it's about being noticed. We're in the business of dressing up your corporate image. More specifically, we design, manufacture and customize garments for companies worldwide.

> Dur garments are created with careful attention to the smallest detail. Choose from a discerning two-button placket or make a statement with a stylish zigoered closure. Our golf shirts will bring you in under par, with labels strategically placed on the right sizene, to help prevent hools or silos.

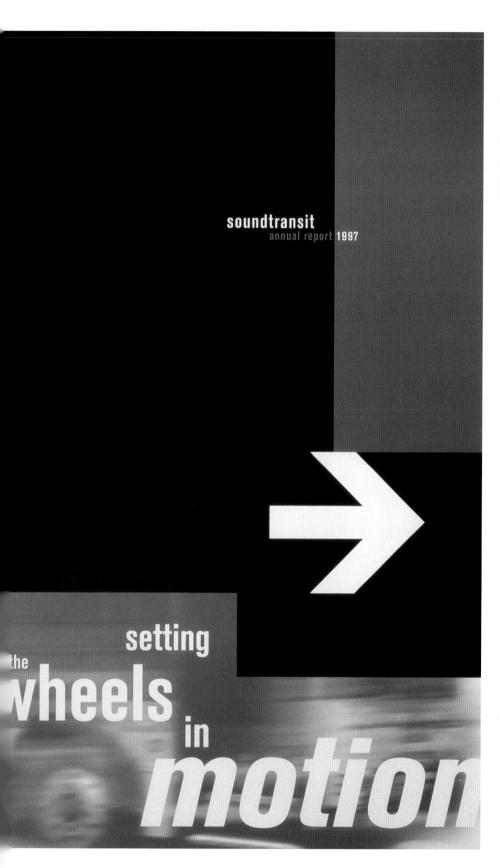

DESIGN FIRM | Sound Transit ART DIRECTOR/DESIGNER | Anthony Secolo COPYWRITER | Evelyn Eldridge, Tim Healy CLIENT | Sound Transit TOOLS | Adobe PageMaker, Macromedia FreeHand PAPER | Matrix Coronado PRINTING PROCESS | Two-color plus varnish

Successful elements include metallic ink for the image in metallic monotone and the radius diecut. The client response to this report was ecstatic.

DESIGN FIRM | Alan Chan Design Company ART DIRECTOR | Alan Chan DESIGNERS | Alan Chan, Miu Choy, Pamela Low COPYWRITER | Lam Ping Ting CLIENT | Swank Shop

The spring/summer fashion catalogue portrays the evolutionary process of Hong Kong and its fashion scene during rule by the British. The legend of Nu Wo repairing the hole in the sky is also included in the design.

DESIGN FIRM | Mervil Paylor Design ART DIRECTOR/DESIGNER | Mervil M. Paylor PHOTOGRAPHER | Stock, Kelly Culpepper COPYWRITER | Melissa Stone CLIENT | The Close Family TOOLS | Adobe Photoshop and PageMaker PAPER | Strathmore Grande

The client is the majority stockholder in Springs Industries, manufacturer of select Ultrasuede,[®] The branch attached to the cover comes from one of the 6,000 Fort Mill, South Carolina, peach trees grown by client's family since the mid-1800s.

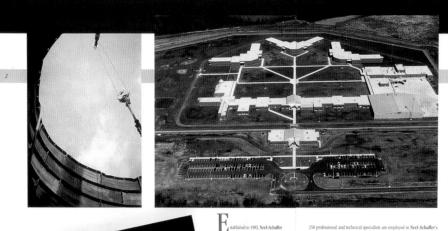

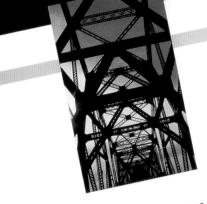

rotessional and technical specialists are employed in Neel-Schaff

ge. LA:

life in the

d raise their families. More than

projects, mobilizing qualified personne

the latest technology to produce quality

DESIGN FIRM | Communication Arts Company ART DIRECTOR | Hap Owen DESIGNER | Anne-Marie Otvos Cain COPYWRITER | David Adcock CLIENT | Neel-Schaffer, Inc. TOOLS | Macromedia FreeHand, Adobe Photoshop PAPER | Potlatch Karma, Neenah classic laid, Kromek PRINTING PROCESS | Five-color, offset lithography

The purpose of this booklet was to highlight the vast capabilities. Their large-scale projects calle for large-scale photographs. The challenge was to rhythm and symmetry throughout using a variety photographs and subjects.

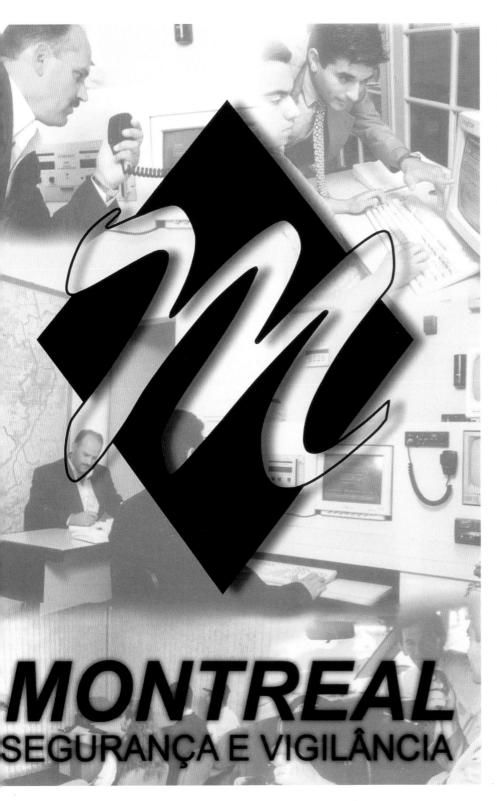

DESIGN FIRM | AWG Graphics Communicação, Ltda. ART DIRECTOR | Renata Claudia de Cristofaro DESIGNER | Luciana Vieira PHOTOGRAPHER | Fabio Rubinato CLIENT | Montreal Segurança TOOLS | Adobe Photoshop, CorelDraw, PC PAPER | Couchê 150 gsm PRINTING PROCESS | Offset

The creative concept shows the company and its employees right on the cover, so prospective clients will see immediately what Montreal services deliver. The fusion of images reinforces the creative concept.

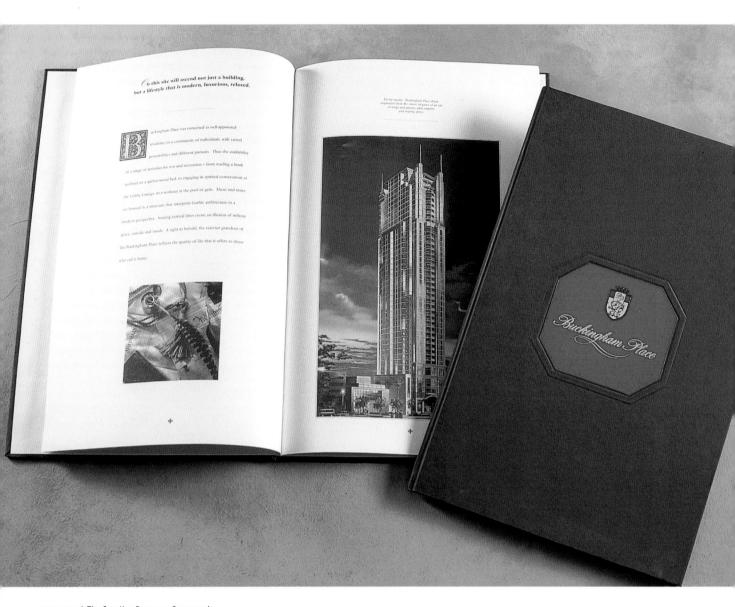

DESIGN FIRM | The Creative Response Company, Inc. ART DIRECTOR/DESIGNERS | Creative Team COPYWRITERS | Creative Copy Team CLIENT | Sun City Marketing TOOLS | Adobe Photoshop and PageMaker, Macromedia FreeHand PRINTING PROCESS | Offset

The objective of this brochure was to position Buckingham Palace as a first-class residential condominium, fit for a king with the most discriminating taste. To achieve this objective, the creative team used an oversized trim, cut with elegant fonts and handsome photos printed on special paper to emphasize grandeur. A hard-bound cover was used with foil stamping to complete the nobility image the client desired.

DESIGN FIRM | Melissa Passehl Design ART DIRECTOR | Melissa Passehl DESIGNERS | Melissa Passehl, Charlotte Lambrechts PROJECT MANAGER/WRITER | Caroline Ocampo PHOTOGRAPHER | Geoffrey Nelson COPYWRITER | Susan Sharpe CLIENT | Girls Scouts Annual Report 1995–1996: Girl Power TOOLS | QuarkXPress, Adobe Illustrator and Photoshop PAPER | Gilclear and Lustro Gloss PRINTING PROCESS | TWO-COLOR Lithography

This annual report defines girl power as it relates to a day-in-the-life of a Girl Scout. The designers used a tall, thin format with bold type, graphic color, and a photojournalistic approach to show how Girl Scouts promote programs that enable the development of character, courage, respect, honor, strength, and wisdom.

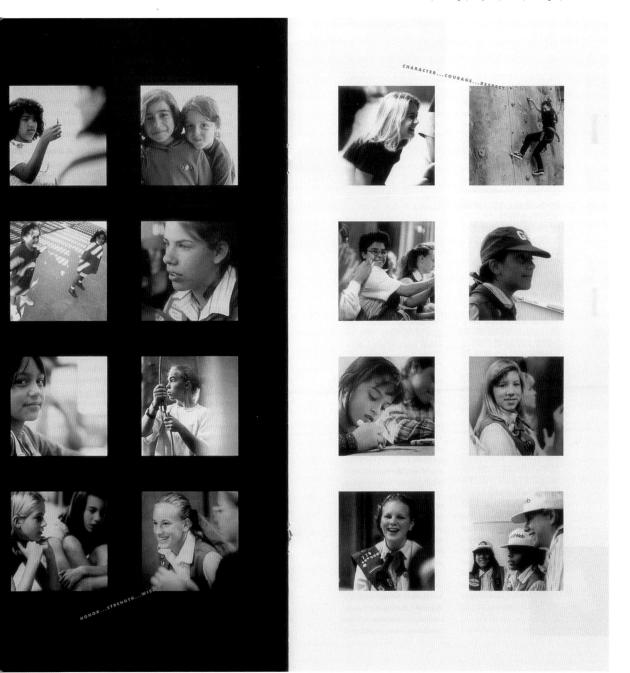

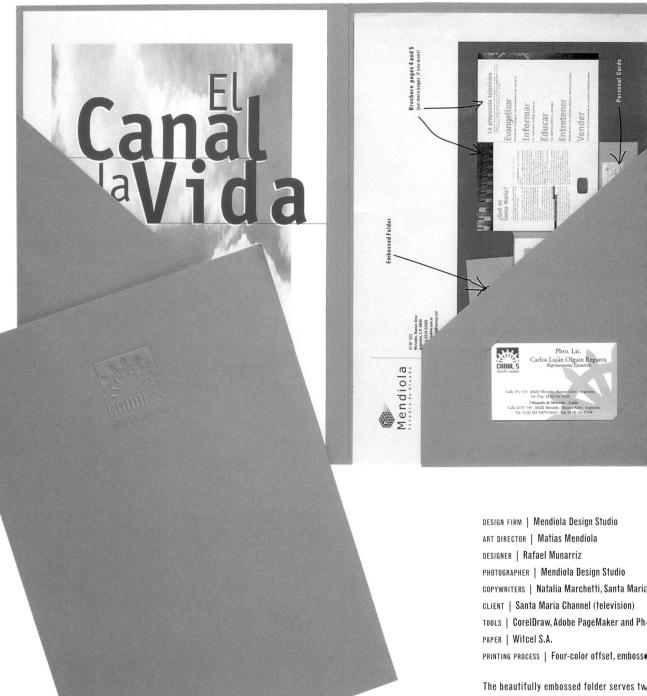

The beautifully embossed folder serves tw It maintains the brochure safely and store important documents with the brochure. SIXTIETH Anniversary EDITION

Stories

DESIGN FIRM | Nesnadny & Schwartz ART DIRECTORS | Mark Schwartz, Joyce Nesnadny DESIGNERS | Joyce Nesnadny, Michelle Moehler PHOTOGRAPHERS | Ron Baxter Smith. cover: Design Photography, artwork COPYWRITER | Peter B. Lewis, The Progressive Corporation

CLIENT | The Progressive Corporation

TOOLS | Trade Gothic, QuarkXPress

PAPER | French Construction Whitewash 100 lb. cover; French Parchtone White 60 lb. text. uncoated fly: SD Warren Strobe Gloss 100 lb. coated text; French Frostone Flurry 70 lb. uncoated text

PRINTING PROCESS | Outside cover: four-color process plus dull aqueous coating; inside cover: three match colors plus dull aqueous coating; five special match colors, uncoated fly; four-color process plus gloss varnish. coated text: six special match colors. uncoated text

The Progressive Corporation Annual Report 1997

In a free-association test recently administered to 1,153 college students, the word "insurance" prompted the response "roadmit it — we're only kidding. Still, for our claim representatives (at our more han 350 claim offices), romance isn't n unknown continent. On a recent aturday evening, Chandra Haines, a rogressive claim representative in avannah, Georgia came to the rescue of young couple involved in a fender ben-

der. She helped them contact their families, and, despite the late hour, arranged to have their car repaired immediately. mance" in 82.8% of cases...Alright, we The couple, who had just been married, were heading to Florida for their honeymoon and had thought for certain their trip was ruined. But they weren't counting on the efficiency of Progressive's Immediate Response[®] claims service. In a romantic cause, our claim representatives stand ready to slay any dragon.

no.

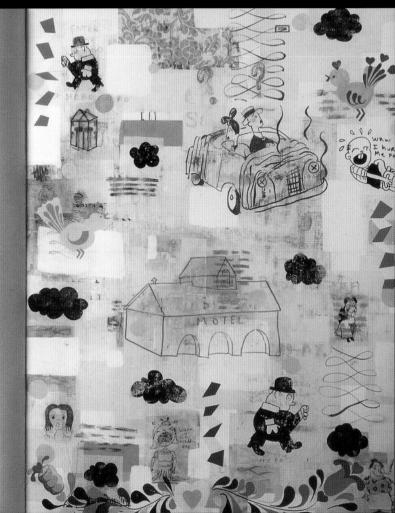

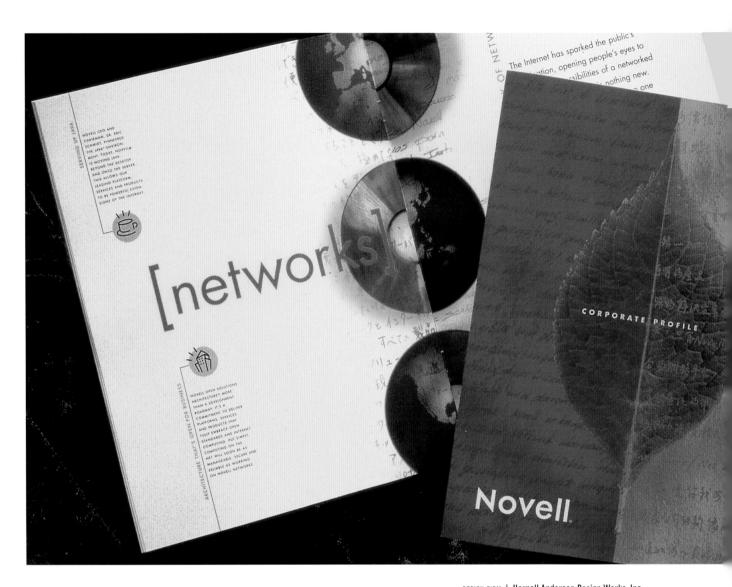

DESIGN FIRM | Hornall Anderson Design Works, Inc. ART DIRECTOR | Jack Anderson DESIGNERS | Jack Anderson, Lisa Cerveny, Heidi Favour, Jana Wilson Esser ILLUSTRATOR | Hornall Anderson Design Works, Inc. PHOTOGRAPHER | TOM COllicott COPYWRITER | Scott Ford CLIENT | Novell, Inc. TOOLS | QuarkXPress PAPER | Signature dull, UV Ultra

This corporate profile displays the company's vast networking experience. It was important to create a brochure that emphasized business-to-business communication, and had a straightforward, easyto-read approach to its technical information.

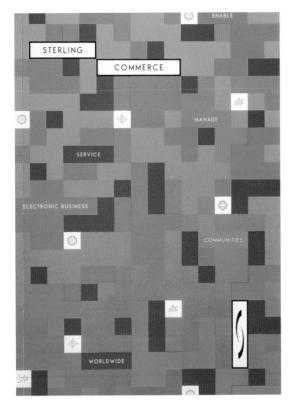

DESIGN FIRM | Pinkhaus Design ART DIRECTOR | Kristin Johnson DESIGNER/ILLUSTRATOR | Raelene Mercer PHOTOGRAPHER | John Running COPYWRITER | Frank Cunningham CLIENT | Sterling Commerce TOOLS | QuarkXPress, Adobe Illustrator and Photoshop PAPER | Potlatch McCoy Velour PRINTING PROCESS | Offset 8/8, four-color process plus two Pantone plus two varnishes (dull and gloss)

Sterling requested their story be told through the voice of their customers. The creative inspiration was driven by the graphic image the designers established for Sterling Commerce during this past year.

> Nobody can tell our story better than our clients. We asked twelve of them, each representative of a different industry, to share their experience. The fact is, we have 40,000 other clients, each with a similar story to tell. But that's a bigger brochure than we wanted to tackle.

AND THEY'LL TELL YOU

11

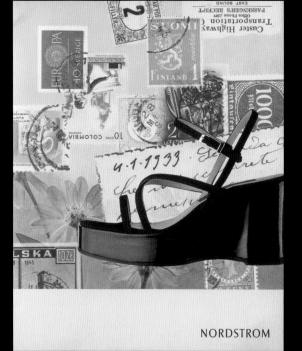

DESIGN FIRM | The Leonhardt Group DESIGNERS | Greg Morgan, Janee Kreinheder ILLUSTRATOR | Greg Morgan PHOTOGRAPHER | Europe: John Rees; shoes:Don Mason COPYWRITER | Renee Sullivan, Jodi Eschom CLIENT | Nordstrom PAPER | Cougar Opaque

Nordstrom wanted their shoe catalog to go beyond the traditional, to be artistic and tactile, yet maintain the feel and look of Nordstrom. The message is conveyed by the your-feet-take-you-places theme, while the designed-in-Europe message is subtly expressed by the destination imagery and exotic foreign postage stamps.

opposite and this page. D: Nordstrom 'Dayton' sandal. When it comes to comfort, this is a classic. Camel, red or black: 59,95. E: Nordstrom 'Darcy' loafer. As easy as a lazy gondola Beige or black: 59,95. Both styles feature an unlined hubuck upper and latex rubber sule, in 7-11n: 4-12.13m. 6-10w. In Women's Shoes

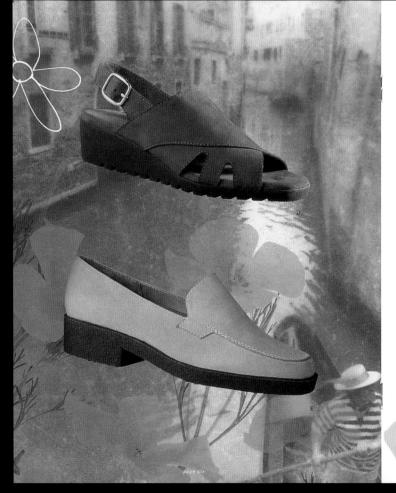

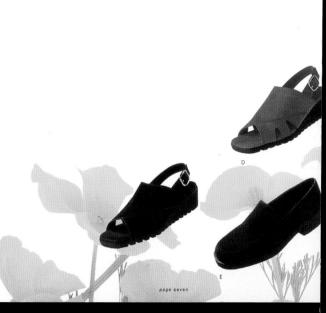

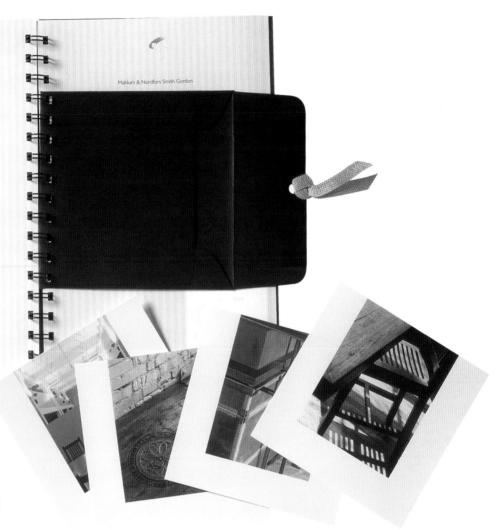

FIRM | Michael Courtney Design RECTOR | Michael Courtney NERS | Michael Courtney, Michelle Rieb, Bill Strong GRAPHER | Pete Eckert, Eckert & Eckert VRITER | Leslie Brown, In Other Words F | Mahlum Architects | Adobe PageMaker and Photoshop

um wanted to create a one-of-a-kind invitation would draw past, current, and prospective ts to their new office space, and that could be also for their long-term marketing objectives.

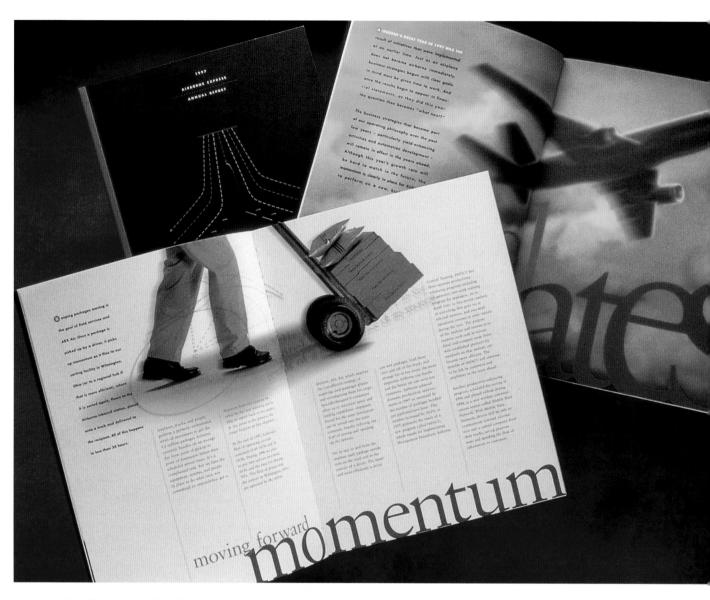

DESIGN FIRM | Hornall Anderson Design Works, Inc.

- ART DIRECTORS | John Hornall, Lisa Cerveny
- DESIGNERS | John Hornall, Lisa Cerveny, Heidi Favour,
 - Bruce Branson-Meyer
- PHOTOGRAPHER | Robin Bartholick
- COPYWRITER | Elaine Floyd
- CLIENT | Airborne Express
- TOOLS | QuarkXPress, Macromedia FreeHand, Adobe Photoshop
- PAPER | Mohawk Superfine

Large, bold type and photographic images stress the company's inherent goals: acceleration, frequency, momentum, consistency, and potential. Each photo reflects movement, which emphasizes the client's business of swift international air-courier services.

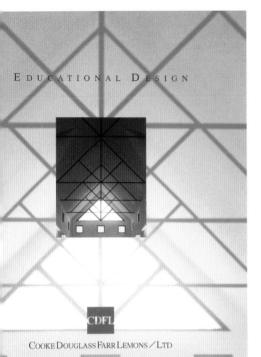

DESIGN FIRM | Communication Arts Company ART DIRECTOR | Hilda Stauss Owen DESIGNER | Anne-Marie Otvos Cain COPYWRITER | David Adcock CLIENT | Cooke Douglass Farr Lemons, Ltd. TOOLS | Macromedia FreeHand, Adobe Photoshop PAPER | Patina matte PRINTING PROCESS | 5/5, offset lithography

The second in a series of booklets, this piece focuses on the firm's educational design work. Although the booklets had to be produced at three different points during the year, they were designed simultaneously to keep the look consistent throughout the series.

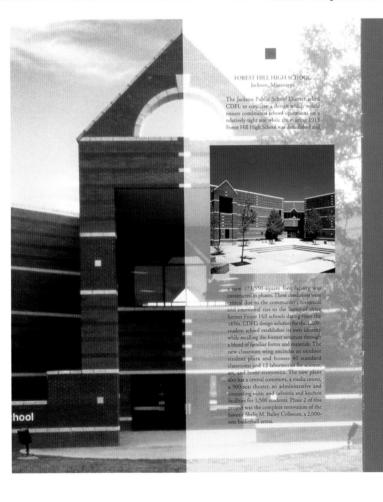

CDFL Selected Clients: HIGHER EDUCATION Alcon State University Auburn University Belhaven College Hinds Community College Indians Seate University Jackon State University Mississippi University for Women University of Atkansas

PUBLIC & PRIVATE SCHOOL SYSTEMS Clahome County School District Clanton Public School District First Peulpterian Day School Hinde County Public School Britic Jackon Public School District Jackon Preparatory School Montgomery County School District Rankin Gounty School District Rankin Gounty School District Sharky-basenera Line Consolidated School District

GOVERNMENTAL Mississippi Bureau of Buildings Mississippi Department of Educatio United States Department of Labor

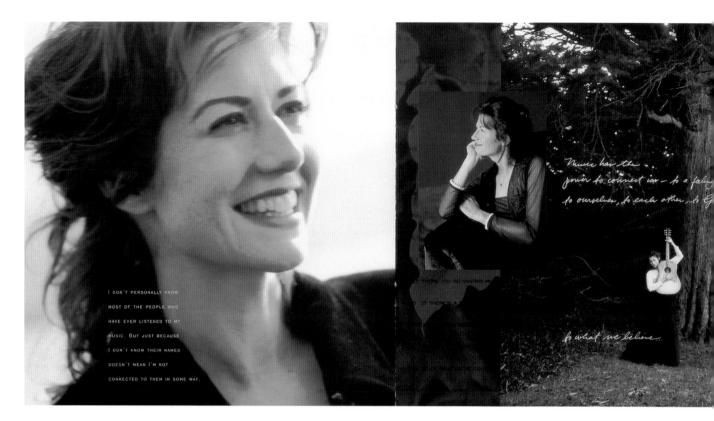

DESIGN FIRM | Anderson Thomas Design, Inc. ART DIRECTOR/DESIGNER | SUSAN Browne ILLUSTRATOR | Kristi Carter (hand lettering) PHOTOGRAPHERS | Kurt Markus, Just Loomis COPYWRITER | Amy Grant CLIENT | Amy Grant Productions/Blanton Harrell Entertainment TOOLS | QuarkXPress, Adobe Photoshop PAPER | Gilbert Voice, Sandpiper, Warren Lustro Dull PRINTING PROCESS | Four-color process plus dry-trap gloss plus dull varnishes

The client requested a clean, understated, sophisticated design, specifically not Photoshop layered. The album title lent itself to the image of Amy Grant looking directly at the camera; the design unfolded aournd this. There was a tight deadline for this project; after photography, the concept and design/engraving/printing were completed in about four weeks.

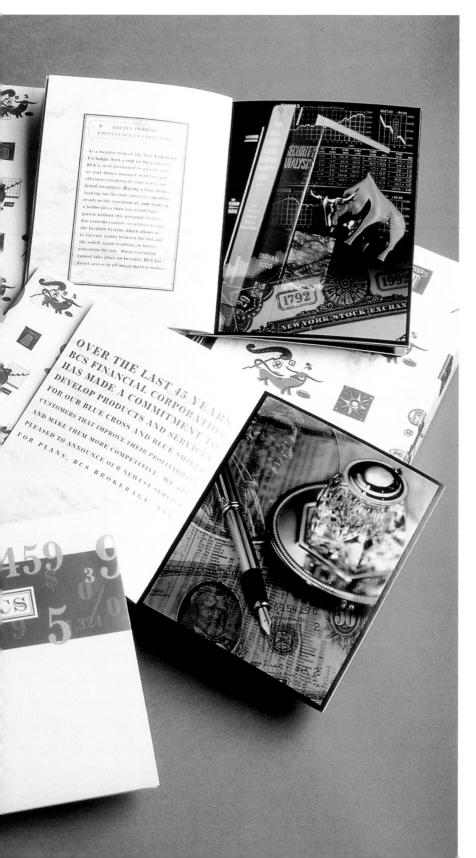

DESIGN FIRM | Sayles Graphic Design All design | John Sayles Photographer | Bill Nellans copywriter | Jill Schroeder client | BCS Insurance Company PAPER | Terracoat cream Printing Process | Offset

Targeted to BCS affiliates with investment interests, the announcement arrives in an elegant presentation box. The hinged lid is printed with a pattern of illustrations: bulls, bears, and currency symbols printed in copper, silver, and gold metallic inks on a marbled paper stock. Inside, a fitted tray holds a brochure filled with dramatic four-color photo collages, bold illustrations, and copy printed on alternating cast-coated and marbleized pages, along with a special gift: a glass paperweight etched with a bull.

DESIGN FIRM | Vardimon Design ART DIRECTOR | Yarom Vardimon DESIGNERS | Yarom Vardimon, D. Goldberg, G. Ron PHOTOGRAPHER | Avi Ganor COPYWRITER | Copirite Y. Fachler CLIENT | Elite Industries Ltd. PRINTING PROCESS | Offset

The photographer tried to show the cut-outs imaginatively, in three dimensions, to emphasize the company's A-brands.

SNAAL CT KYS

N JUST 5 YEARS, ELITE HAS ACHIEVED A DOMINANT SHARE OF THE SALTY SNACK MARKET, VASTLY INCREASING TOTAL SALES VOLUME IN THIS EXPANDING MARKET. ELITE NOW ACCOUNTS FOR MORE THAN 50% OF THE POTATO CHIP MARKET AND 25% OF THE PUFFED CORN SNACKS MARKET.

UNDER A LICENSING AGREEMENT WITH "FRITO-LAY". PART OF "PEPSICO FOODS INTERNATIONAL". ELITE PRODUCES "RUFFLES" THE WORLD'S NUMBER ONE POTATO CHIP SNACK; "CHEETOS", THE POPULAR CHEESE-FLAVORED SNACK; AND "DORITOS". THE CORN CHIPS FAVORITE. OTHER LOCALLY DEVELOPED AND MANUFACTURED PRODUCTS SUCH AS "SHOOSH" ARE WELL ESTABLISHED IN THE DOMESTIC MARKET, AND ENJOYED BY A WIDE CROSS-SECTION OF THE CONSUMER PUBLIC.

ELITE'S ENTRY INTO THE SALTY SNACK MARKET HAS PROVED A RESOUNDING SUCCESS. THE WIDE VARIETY OF DIFFERENT PRODUCTS NOW AVAILABLE HAS INCREASED DEMAND AND RAISED THE QUALITY OF SNACKS ON THE MARKET BY OFFERING HEALTHY AND VITAMIN-ENRICHED PRODUCTS WITH WIDE CONSUMER APPEAL.

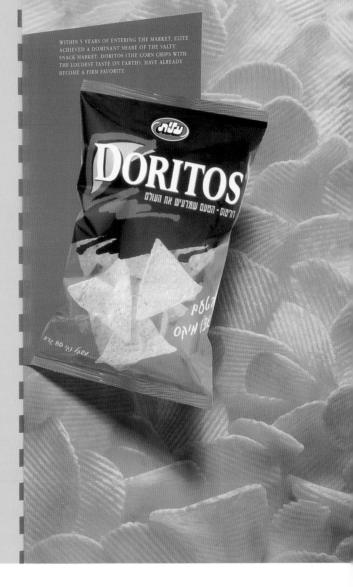

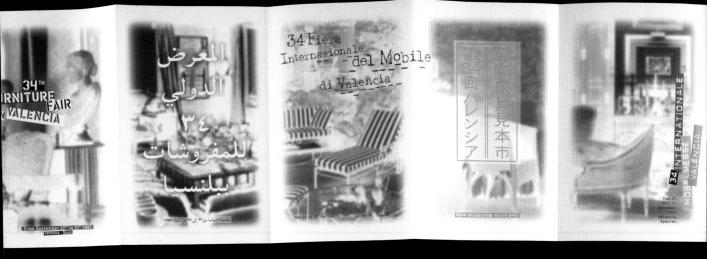

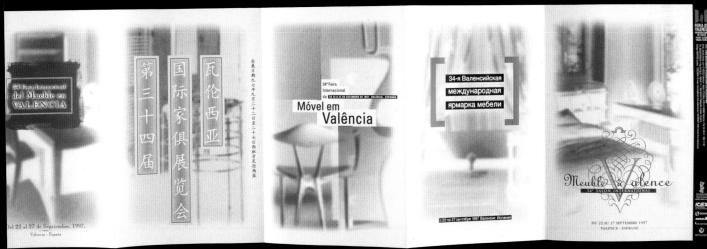

DESIGN FIRM | Pepe Gimeno, S.L. DESIGNER | Pepe Gimeno CLIENT | Feria Internacional del Mueble de Valencia TOOLS | Macromedia FreeHand, Adobe Photoshop PRINTING PROCESS | Offset

These were 1997 mailings to promote the client.

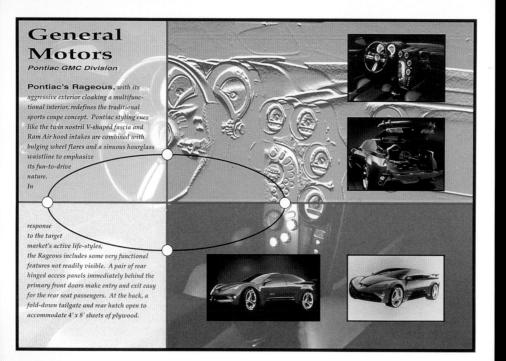

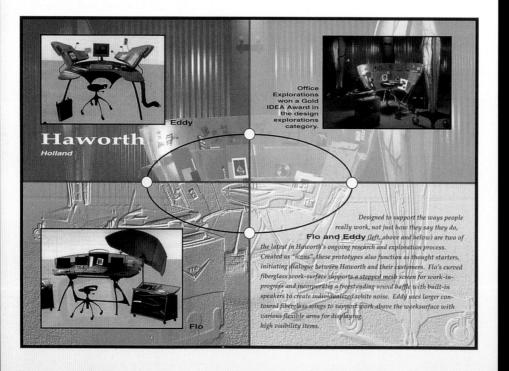

ALL DESIGN | Barry Hutzel COPYWRITER | Roger Quinlan CLIENT | IDSA Michigan Chapter TOOLS | Adobe PageMaker and Photoshop PAPER | Neenah Classic Columns 80 lb. cover; Romaine #1 house stock gloss 80 lb. text PRINTING PROCESS | Two color

This yearly publication is a showcase for Mich Industrial Designers' products. The budget was by producing a two-color piece that took full a of the colored cover stock.

AN EMPERS NULL ON A GROCEST STOLL

DESIGN FIRM | Goodhue & Associés Design Communication CREATIVE DIRECTOR | Lise Charbonneau ART DIRECTOR | Paulo Correia DESIGNERS | Josée Barsalo, Dany DeGrâce ILLUSTRATOR | Caroline Merola PHOTOGRAPHER | Jean Vachon COPYWRITER | Ivanhoe, Communications and Public Affairs CLIENT | Ivanhoe Inc. TOOLS | QuarkXPress, Macromedia FreeHand, Adobe Photoshop PRINTING PROCESS | Offset

The client, a real-estate giant specializing in shopping centers, sought to show prospective investors its sound expertise and flair for innovation. Outsized images and classical serif type draw the reader in.

STRENGTH

IVANHOE IS WITHOUT DOUBT A FORCE IN THE CANADIAN REAL ESTATE INDUSTRY

Franker is one of Canada's more respected property management, development and investment companies, specificing in galley beging centrin turbin accas e Ar son an the Campor provide of the score ordy in the 1955, it is begin carriage out a place for mild in the rail in Queber and Channish bat also. Wherein Canada through in Queber and Channish bat also. Wherein Canada through in Queber and Channish bat also. Wherein Canada through in Queber and Channish bat also. Wherein Canada through in Queber and Channish bat also. Wherein Canada through in Queber and Channish bat also. Wherein Canada through in Queber and Channish bat also. Wherein Canada through requirements in Canada growth, first also the anise of the United States. Instanced partnerships with a multier of USA to tester growth. When handbee was created, is capitalized on the "queber and the consonic conditions of the Brane Areas and the consonic conditions of the Brane transfersion of the 1990 and sons dile sing on inversing in a cardia dipatient muomer schellenge, havabac beaves that no dapter to share and algoeiner, and a scampethanian induced to the reaches and deconsonic conditions of the bargene career and on the quality carand algoeiner, and a scampethanian induced in patients in the care transformer and deconsonic conditions of the bargene career and on the quality carand algoeiner muoties of the same transformation transmitter and dynamic and and and cale and patient and the care patient and and the cale and and acceleration of the bargene care and on the quality care transformer of the transformer and and the cale differed for terms and questioners to labors. All these remeans are differed for terms and questioners on classes are balance and patientian terms and the case are patient and and the compariment for terms the off terms of the terms of the labors of terms and dynamic terms and the compariment of terms and dynamic terms and the compariment for terms and the compariment of terms and the compariment of terms and the compariment of the

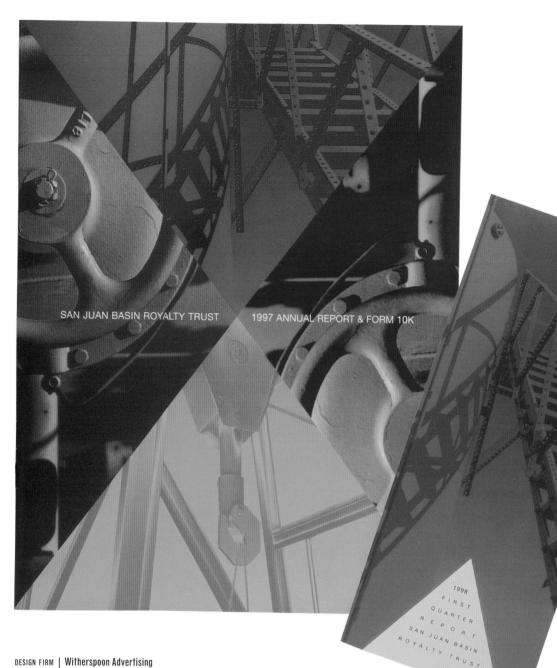

DESIGN FIRM | Witherspoon Advertising ART DIRECTOR/DESIGNER | Rishi Seth CLIENT | San Juan Basin Royalty Trust TOOLS | QuarkXPress, Macintosh PAPER | Signature Gloss PRINTING PROCESS | Offset

Although an oil and gas trust, San Juan Basin Royalty does not produce or distribute oil and gas. Witherspoon decided to spice up the dry financial information with a series of pictures of tools and large equipment used in oil and gas fields.

68 THE BEST OF BROCHURE DESIGN

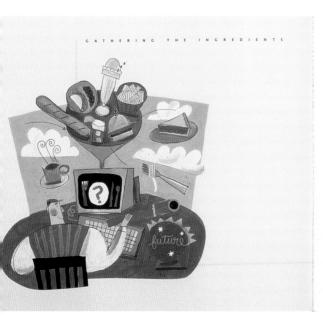

The successful outcome of a respect is dependent on two things: the skill of the cook and the quality of the materials. Half measures and substitutes are not acceptable, for a wise cook works with only the lost ingredients,

Brinker's own recipe for success also calls for the best. We hire the best popple, and we ask the best of them, In order to ensure optimum results from their efforts, Brinker utilizes curtingedge information systems. Years ups, when we learned there was no software available that addressed our needs, we decided that rempromise on an issue this important was simply,not an option. As a result, we created a proprietary system that not only fits our unique requirements but also offers the capacity to grow and change along with our loainess.

The technologies we use allow Brinker to efficiently acquire and analyze data. Equally important, they enable us to format information so it can be enably understood and implemented. Our sales tracking system is an excellent case in point. Since Brinker concepts are always in the process of refining their memo, this system raddes us to accurately assess contonner response to all menu items on a darb, weekly, and monthly hasis. Using the sales tracking system. Brinker can determine which items are succeeding with the public and see the impact hey're having on a concept's profit picture. Conversely, we discover which items should be recired or reconfigured to pique customer interest. We also use sales tracking to spot customer trends well before they become evident in the marketplace.

> DESIGN FIRM | JOSEPH Rattan Design Art Director/designer | Joe Rattan Illustrator | Linda Hilton Photographer | Stuart Cohen Copywriter | Mary Langridge Client | Brinker International Tools | Macintosh Printing Process | Offset

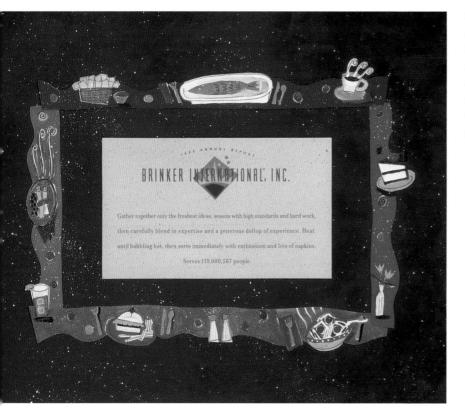

Loos cooling annulats the best inpreferent. That's why Brinker international has created a costonical information system that allows on to captore, analyze, and actify implement storegenerated data. Our leadingding system also streamlines operations, cuts costs, tracks custome brends, and allows is to why up such tasty creations as Chil's highly successful Frequent Diner Program. "AND WHEN I LOOK INTO THE EYES OF MY CHILD, SO INNOCENT. THERE'S EVIDENCE OF YOUR LOVE, EVIDENCE OF YOU"

TALK TO ME

SOMETIMES WE SEE GOD AS OMINOUS AND UNAPPROACHABLE BUT I BELIEVE THAT GOD LOVES WHEN WE CAN HAVE A SIMPLE CONVERSATION WITH HIM, JUST AS WE WOULD A CLOSE FRIEND: HE'S BEEN WHERE WOULD A CLOSE FRIEND: HE'S BEEN WHERE WE ARE THERE IS NO FEELING OR EMOTION WE HAVE THAT HE DOESN'T UNDERSTAND.

I recall a time in my file when I was scared to share my heart with anyone Arraid of who I really was I'd hide behind a wall where no one could see Then the stones that formed the wall began to

complex And your whisper knocked me off my feet and took me to my knees

conversation I hear more than just words, I can hear down

So talk to me, Til do more than listen 1 stood where you're stariding and Liknow just how you feel

Almiess IId go searching for a twisted play on words, that made me heel that I was alright Striving for perfection when the only perfect thing I had was weakness Then strongth began to build in me All it took was four words to get me to my knees. And you saids.

(J

(I

- HER

ALC: NOT

11

5

I know every breath you take, every feeling in your heart. Talk to me, tell me what you're feeling. Know I'm always here for you, whenever you

DORS

PAMPLIN

TIVE PRODUCERS: PLIN, JR. AND GARY RANDALE

DESIGN FIRM | Anderson Thomas Design, Inc.

ART DIRECTOR/DESIGNER | Jay Smith

PHOTOGRAPHER | Russ Harrington

COPYWRITER | Shari McDonald

CLIENT | Pamplin Music

- TOOLS | QuarkXPress, Adobe Photoshop
- PAPER | Potlatch, Vintage Gloss, Gilclear,

French Construction, Factory Green PRINTING PROCESS | Four-color, spot Pantone color,

and black

The client's request was that this piece tell the story of John Elefante; the man, the musician, the ministry, and the music, so his audience would know more about the man behind the voice.

DESIGN FIRM | Phillips Design Group Art director | Steve Phillips Designer | Alison Goudreault Illustrator | David Tillinghast Photographer | Stock copywriter | Boston Financial client | Boston Financial tools | QuarkXPress

Phillips Design took an unusual approach to promoting financial services by using a contemporary illustration style that focuses on the way the real estate industry looks at risk-management and insurance.

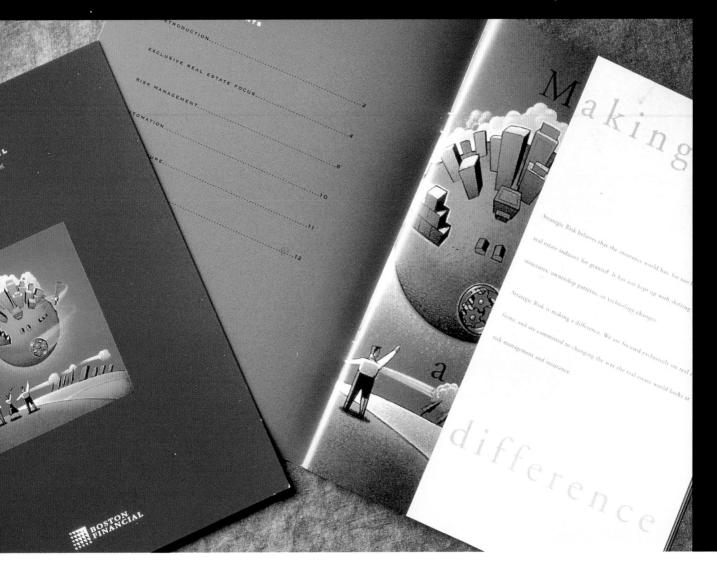

BROCHURES

DESIGN FIRM | Mires Design ART DIRECTOR | JOSE A. Serrano DESIGNER | Mary Pritchard ILLUSTRATOR | J. Otto CLIENT | Invitrogen Corporation TOOLS | Adobe Illustrator PAPER | White gloss cover weight PRINTING PROCESS | Four-color process

The design team created a cover for this catalog that had a fresh look without appearing too high tech.

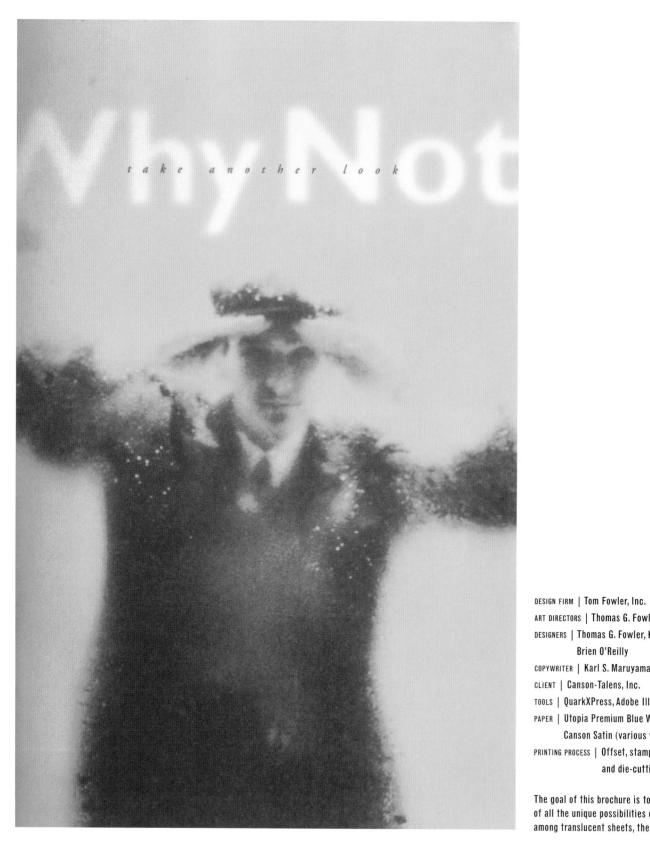

ART DIRECTORS | Thomas G. Fowler, Karl S. Maruy DESIGNERS | Thomas G. Fowler, Karl S. Maruyama Brien O'Reilly COPYWRITER | Karl S. Maruyama CLIENT | Canson-Talens, Inc. TOOLS | QuarkXPress, Adobe Illustrator PAPER | Utopia Premium Blue White 110 lb. cov Canson Satin (various weights) PRINTING PROCESS | Offset, stamping, embossing, and die-cutting

The goal of this brochure is to make the user a of all the unique possibilities of translucent pa among translucent sheets, the superiority of C

DESIGN FIRM | Kan & Lau Design Consultants ART DIRECTOR | Kan Tai-Keung DESIGNERS | Kan Tai-Keung, Yu Chi Kong, Leung Dai Yin CHINESE INK ILLUSTRATOR | Kan Tai-Keung PHOTOGRAPHER | C. K. Wong CHINESE ILLUSTRATORS | KWUN Tin Yau, Leung Wai Yin, Tam Mo Fa CLIENT | Tokushu Paper Manufacturing Co. Ltd. TOOLS | Macromedia FreeHand, Adobe Photoshop, Live Picture PAPER | Bornfree recycled paper

The idea of using Bornfree recycled paper derived from a philosophy of Buddhism: economize to protect the Chinese market. Inspired from this philosophy, elements of calligraphy were applied to demonstrate the printing aspects of the paper series.

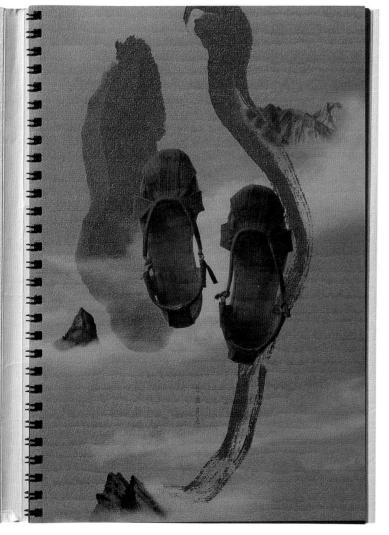

"BORNFREE" CONNOTES A FREE AND EASY LIFE-

STYLE THAT IS HARMONIOUS WITH NATURE,

BACKED BY A PHILOSOPHICAL LINKAGE WITH 佛家思想中的一 《自在》乃中 198 新生 15 CHINESE BUDDHISM THINKING. CATERING TO -興 大 自 然 THE CHINA MARKET, THE DESIGN OF "BORNFREE 《自在》從 徽 新 ×. 列 品 特别 為 da. TRN. PAPER SERIES IS DERIVED FROM THE IDEA OF 2 自 中 國 傳 統 BAMBOO GRAINED SURFACE AND TEAR-OFF EDGES 竹纹 HAL m 以自然的變化構 10 自 OF TRADITIONAL CHINESE HAND-MADE PAPER 人悠然自得的生活 THE TEXTURE ENHANCES A NATURAL, BRISK AND RHYTHMICAL APPEAL WHICH REPRESENTS

AND RHITHMICAL APPEAL WHICH REPRESENTS

A PART OF THE CHINESE CAREFREE LIFESTYLE.

DESIGN FIRM | Lee Reedy Creative, Inc. ALL DESIGN | Lee Reedy PHOTOGRAPHER | Martin Crabbe CLIENT | National Ski Patrol TOOLS | QuarkXPress PRINTING PROCESS | Web

The strong illustration on the cover invites ski patrollers to review the new merchandise offered and breaks the predictable photographic visual solutions often seen in the ski industry.

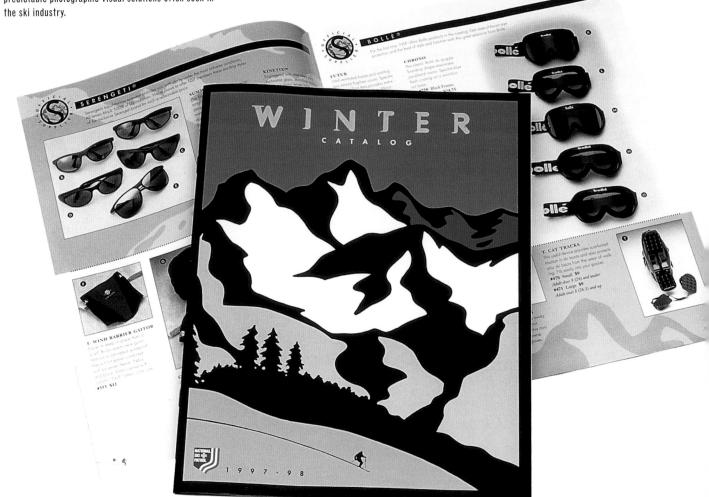

accessories

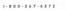

r | Our Batty caffakin agenda is steeker and less bulky than most agendax, yet it holds eight credit cards and your yea-ta-bglance. Two inside pockets and a secure snap closure (pen sold separately). 8 x 5 is x 1 is inches D9701 7500 8195 6 | The partice cit/L our sterling uiver medalition fob is formed from sold silver bar stock. Git-boxed. A 950 999 501 518.50

 H | Our stunning handbag is an exclusive design, with custom hardware and all the perfection of detail you'd expect from Balty Made in Italy. Black califskin 8 x 7 ½ x 3 ¼ inches A950 999 6603 **5450**

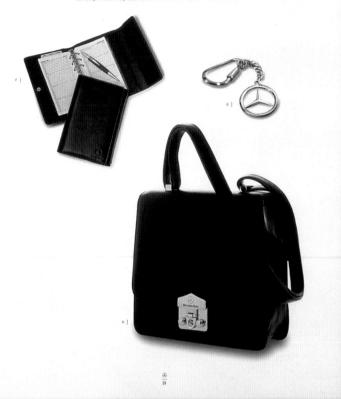

A 1 Not every day is sumy, which is why the SLK has a retractable hardtop and why you should have our power dome print neumberla. It's made of Tellon treated mylion and folds to 0 inches, perfect for your toto or glove box. A 500 990 0404 **529.50** A 1 Our Keyring opens and closes with the prevailion of a Swits watch. Sumptous catalian leather with nickel/finished hardware. Exclusively ours, by Baily. A 950 999 350 **3 64.50** 1 Our Suppred walled of Duttersoft "Tartufo" califakin has a coin compartment and holds three credit cards. No need to worry abut spliting our change, as the zipperder closure security holds everyfing in pice. 4k x 39 in holes. A 950 999 106 **3 188**

 b | The SLK was designed with one eye on the past and one on the future. Our SLX aquare scarf in 100% silk mimics over dome shapes in a suble pattern, surrounded by a black border. Imported from Taly, 43 inches square. B6 790 7501 578

 £ | Power dome SLK efficiently and the straining share with gold plating. Matte-sanded surface offsets the gleaning silver power domes. IK 66 400 7802 596

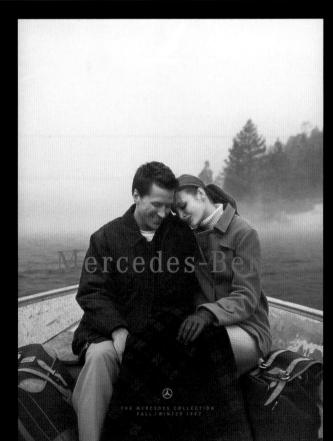

DESIGN FIRM | Pinkhaus Design ART DIRECTOR/DESIGNER | Kristin Johnson DESIGNER | Caroline Keavy COPYWRITER | Frank Cunningham CLIENT | Mercedes-Benz: Personal Accessories Fall/Winter '97 TOOLS | QuarkXPress, Adobe Photoshop PAPER | Cover: Potlatch Northwest Dull: 80 lb.; 70 lb. text

PRINTING PROCESS | 6/6 four-color process plus one PMS plus spot varnish

The client wanted an approachable, friendly catalog full of Mercedes-Benz products for people on strict budgets. The designers succeeded by using great photography that appeals to luxury car owners as well as to the younger crowd who aspire to be luxury-car owners.

- DESIGN FIRM | Hornall Anderson Design Works, Inc.
- ART DIRECTORS | Jack Anderson, Larry Anderson
- DESIGNERS | Larry Anderson, Mary Hermes, Mike Calkins,

David Bates, Michael Brugman

ILLUSTRATOR | John Fretz, Jack Unruh, Bill Halinann

- PHOTOGRAPHER | David Emmite
- COPYWRITER | John Frazier

CLIENT | U.S. Cigar

- TOOLS | QuarkXPress, Adobe Photoshop, Macromedia FreeHand
- PAPER | Beer Paper, Havana, Cougar Natural, Gilbert Voice

The client needed a brochure and guidelines to disperse to distributors involved in the cigar trade. The brochure composite replaces the client's original glossy, slick program with a more natural and textured look and feel, reminiscent of tobacco leaves. To complete the natural feel of the package, an eco-friendly stock was used.

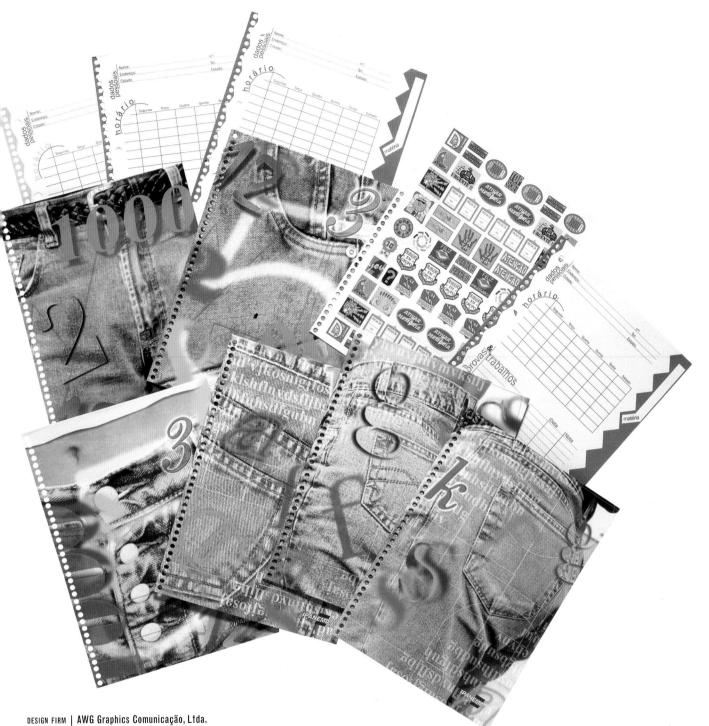

ART DIRECTOR | Renata Claudia de Cristofaro DESIGNERS | Luciana Vieira, Marcelo Gaya PHOTOGRAPHER | Renata Claudia de Cristofaro CLIENT | Tresele Ltda. TOOLS | Adobe Photoshop, PC PAPER | Triplex 400 gsm PRINTING PROCESS | Offset

These cover books have been created on one theme: jeans. The client wanted to illustrate jeans in a futuristic way by connecting them with letters and numbers.

DESIGN FIRM | Design Guys ART DIRECTOR | Steven Sikora DESIGNERS | Jay Theige, Amy Kirkpatrick PHOTOGRAPHERS | Darrell Eager, Michael Crouser COPYWRITERS | Jay Kaskel, Steven Sikora CLIENT | Target Stores PRINTING PROCESS | Offset lithography

Due to the client's limited advertising budget, a great deal of pressure was placed on this product brochure to completely define the brand character of Herbasis to consumers. The creative team kept the design simple and clean, but also used appropriate people and botanicals to add dimension and mystique.

DESIGN FIRM | Visual Marketing Associates, Inc. ART DIRECTOR | Lynn Sampson DESIGNERS | Lynn Sampson, Jason Selke PHOTOGRAPHERS | Jim France, Michael Verdure CLIENT | JWA/Scubapro TOOLS | Macromedia FreeHand, Adobe Photoshop PAPER | Champion Influence Web Gloss PRINTING PROCESS | Four-color web press

Scubapro wanted to speak to a new generation of divers. By collaging and juxtaposing out-of-water photos with underwater imagery, the designers captured the excitement of scuba diving. Curve elements help to create a flow of information while color-coded sidebars help readers find their place in the catalog.

CLASSIC EXPEDITION

The Expedition is the ultimate expression of SCUBAPRO's stabilizing jacket design. This latest version of the industry standard preserves the Classic's fit and durability while providing new features demanded by today's active divers.

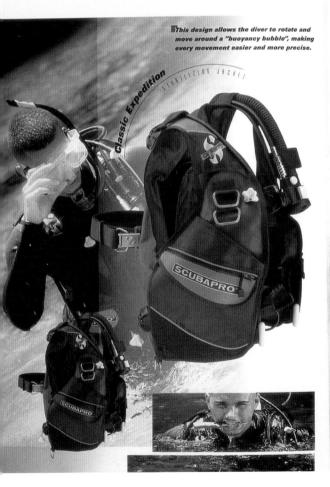

Wraparound Air Balance allows unrestricted air movement and provides u stability and control

Integrated Weight System allows you to carry up to 22 lbs. of fully releasable weights and eliminates the need to use a weight belt in many environments

Hand Glued Finseal Seam Construction many years of field testing have proven the Finiseal seam holds up twice as long as any other seam even when exposed to punshing conditions.

Double Neoprene Coated 420 Denier Fabric for extended life and reduced maintenance

Soft Back Design with integrated cummerbund for added comfort and stability Integrated Inflation/Deflation System

for simple one-hand buoyancy control
Standard Rear Pull Dump

Standard Kear Pull Dump for easy air release in a head-down position

All SCUBAPRO BC's accommodate either the A.I.R. 2 or Balanced Inflator for ultimate flexibility.

SCUBAPRO A.I.R. 2 Simplify your hose configuration by using the same hose to supply both the power inflator and the backup regulator.

QUICK RELEASE BALANCED INFLATOR Featuring ergodynamic styling, the SCUBAPRO Balanced Power Inflator provides push button budyancy control in a compact, high tech package designed with simplicity of function.

DESIGN FIRM | Shields Design ART DIRECTORS | Stephanie Wong, Charles Shields DESIGNER | Charles Shields PHOTOGRAPHER | Keith Seaman-Camerad CLIENT | Innerspace Industries TOOLS | Adobe Illustrator and Photoshop PRINTING PROCESS | Four-color

The client wanted a series of brochures highligh different furniture lines. The designers came up color-coding system to identify each line. Coloralso saved money by allowing two-over-four prin

DESIGN FIRM | Visual Marketing Associates, Inc. ART DIRECTORS | Tracy Meiners, Ken Botts DESIGNER | Tracy Meiners ILLUSTRATOR | Cliff Parsons PHOTOGRAPHER | Jim France, France Photography; stock COPYWRITER | Pamela Cordery CLIENT | Suncast Corporation TOOLS | Macromedia FreeHand, Adobe Photoshop PAPER | Mead Sig-Nature 80 lb. cover PRINTING PROCESS | Six-color plus off-line varnish, dry-trapped, offset lithography

The embossed cover reflects the unique mold pattern of the Just Stuff product line. Large lifestyle imagery adds a playful human element, and is Quadtoned, allowing focus on the product. Kraft paper hints at the product packaging, while providing a neutral backdrop for specific information.

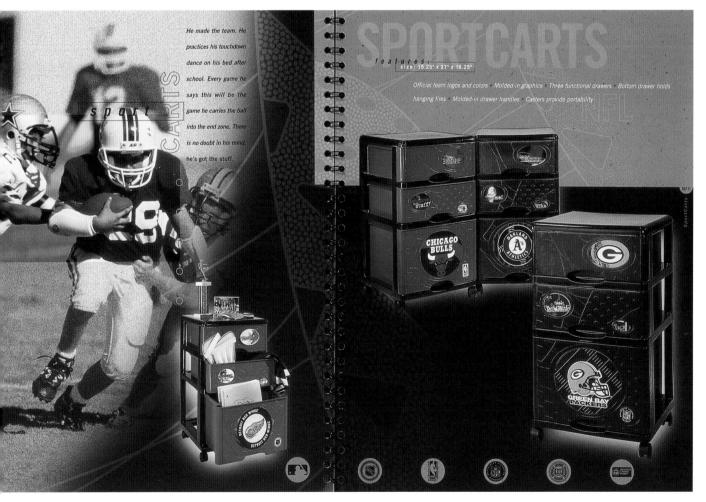

CHAD JACOBS DESIGNS

£66

CATERPILLAR

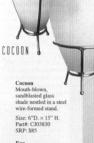

Egg Mouth-blown, sandblasted glass shade nestled in a steel wire-formed stand. Size: 6°D. × 10° H. Part#: CJ03840 SRP: \$85

Caterpillar Interlocking system of stacked acrylic discs, styrene diffuser and steel wire-formed frame.

Two sizes avail: Large: 6.5"D.×16" H. Part#: CJ03810 SRP: \$125 Small: 5.5"D.×7" H. Part#: CJ03820 SRP: \$55

4 ORDER TOLL FREE 1-888-461-LBRI (5864)

KEITH WILBER DES

Los Angeles artist and actor, Keith Wilber became interested in lamp design when h lamp but couldn't find anything really unique. So he decided to make his own! He creating a lamp that would change the room into something magical when switched most of his lamp design ideas come either from nature, or the subconscious, he idea motion intrigued him. Thus, the motion lamp was born. His philosophies for lamp e) it must invoke a response either positive or negative, 2) one must not tire of it too and 3) the viewer's perspective should change slightly each time you look at it.

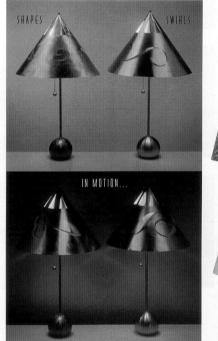

MOTION LAMP Aluminum Motion Lamps Shapes Part#: KW Swirts Part#: KW Size: 14"D. × 24"H. SRP: \$125

Vinyl Moiré Motion Lamps Fire Part#: KW Ice Part#: KW Liquid Part#: KW Size: 8"D. × 19.5"H. SRP: \$85

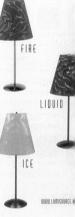

DESIGN FIRM | LumiSource DESIGNER/ILLUSTRATOR | Jeff Pears CLIENT | Jeff Pears, Steve Lee: Lu TOOLS | Adobe Illustrator and Phot PRINTING PROCESS | Four-color proc

DESIGN FIRM | Modelhart Grafik-Design DA ART DIRECTOR | Herbert O. Modelhart DESIGNER | Kristina Düllmann PHOTOGRAPHER | Walter Oczlon COPYWRITER | Herbert Lechner CLIENT | Schlosserei J. Meissl GmbH TOOLS | Adobe Illustrator and Photoshop, QuarkXPress PAPER | Munken Pure Elegance Bordeaux Cover PRINTING PROCESS | Four-color plus one-color silkscreen print on cover

Since the products are technically complex, they must be communicated in a highly informative style. Meissl's sales process is now more targeted and their salespeople more knowledgeable, thanks to the extensive verbal and visual information transported through this brochure.

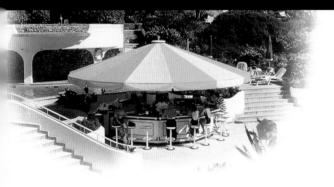

pitzentechnik für Spitzenrendite

Meissl bietet die besten Voraussetzungen fürs perfekte Event-Marketing, Kein Wunder, daß erfolgreiche Gastronomen, Hoteliers und Brauereien auf Meissl setzen.

Alle Meissl Schirmbars sind auf höchste Belastung ausgelegt. Nicht nur was Wind und Wetter betrifft, auch die Bar ist auf Höchstleistung vorbereitet: Stabile, erprobte Konstruktionen, widerstandsfähige Materialien, klare Linien und hochwertige technische Gastro-Ausstattung. Denn schließlich soll hr Geschäft brummen und nicht die Gästel

> Das passende Zubehör wird mitgeliefert: Hocker und Stehtische setzen die markante Linie fort – und sind ebenso stabil wie die Konstruktion der Schirmbar selbst!

The matching accessories are delivered with the bar: stools and bar tables extend the product line – and are as stable as the construction of the Umbrelia Bar itself.

Technology for Top Returns

Meissl offers the best conditions for perfect event-marketing. No wonder that successful innkeepers, hoteliers and breweries rely on Meissl.

All Meissl Umbrella Bars meet the highest standards. Not only wind and weather proof, the bar also offers top performance: stable, tested construction, resistant materials, clear lines and high tech gastronomic equipment. As in the end – it is your business that should move and not your guests.

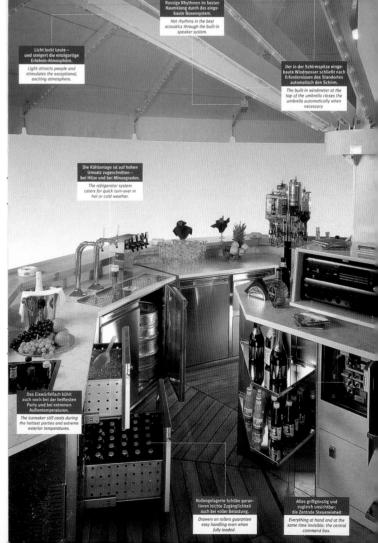

DESIGN FIRM | Big Eye Creative, Inc. ART DIRECTOR/DESIGNER | Asiza Ilicic PHOTOGRAPHER | Dann Ilicic COPYWRITER | Craig Holm CLIENT | Steel Magnolia TOOLS | QuarkXPress, Adobe Photoshop PAPER | Centura Gloss PRINTING PROCESS | Four-color with spot tint varnish

This catalogue was designed to convey the delicate elegance of Steel Magnolia's custom metal furniture, while balancing the icy strength of the steel they use in all of their creations. Since interior designers are their biggest customers, the catalogue had to be refined, exclusive, and of the finest quality.

The Monarch

PAUL BOLLENBACK, RECORDING ARTIST, CHALLENGE RECORDS

"My Buscarino Monarch inspires me to play new things. Even fellow musicians tell me that my sound is so much better."

RON AFFIE, RECORDING ARTIST, FANTASY RECORDS

EGAL WITHOUT PRETENSIONS, the MONARCH as designed in collaboration with master archtop luthier Robert Benedetto. It follows in the tradition of the master handing down years of perfected

methods and designs to his apprentice. of the ARTISAN, the MONARCH boasts several attractive additions. Crowning this guitar is a large Benedetto-style headstock with mitred purflings and pinstripe-enhanced binding. The f-holes are fully bound and also trimmed with mitred pinstriped purflings. Only the finest quartersawn seasoned instrument woods are used in its construction, and as with every archtop guitar in the Buscarino lineage the MONARCH is meticulously assembled and tuned.

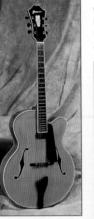

long list of options and color choices (including the sunburst finish shown opposite), allow the MONARCH to be custom designed as a guitar fit for a king.

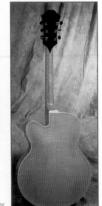

NARCH back, sho triple-A wood Honey Blonde

DESIGN FIRM | Ken Weightman Design ART DIRECTOR/DESIGNER | Ken Weightman CLIENT | Buscarino Guitars TOOLS | QuarkXPress, Adobe Photoshop PRINTING PROCESS | Offset, die-cut, liquid laminate cover

Liquid laminate on the cover's full-size image suggests the finish of the actual guitars. The F-hole is die-cut. Inside, each of the handcrafted guitar models is presented as fine art.

DESIGN FIRM | Pensare Design Group, Ltd. ART DIRECTOR | Mary Ellen Vehlow DESIGNERS | Camille Song, Amy Billingham COPYWRITERS/CLIENT | Devin O'Brien, Adam Attenderfer TOOLS | Adobe Illustrator and Photoshop, QuarkXPress PAPER | Monadnock Dulcet, Bier Papier Ale PRINTING PROCESS | Four-color; silver, white, black on cover

The purpose of this catalog is to showcase the works of the untrained artists of Kenya. The concept was to make readers feel as if they had journeyed into the lives of these children and this is a scrapbook of their adventures.

David Kinywa

David is 19 years old and has been a part of Streetwise since its beginning. In January 1994. He was one of the first to get a job painting for a carpentry business. He began working there parttime in April 1995, but they recently refused to make him a permanent employee. He has now returned to Streetwise where he is one of the top designers. The nomadic Maskai are people of the land. Their survival depends upon the heraling, of cattle and the harvesting, of its milk: and blood.

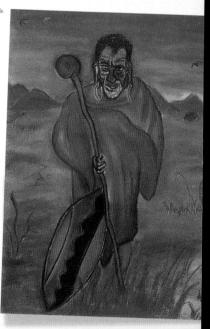

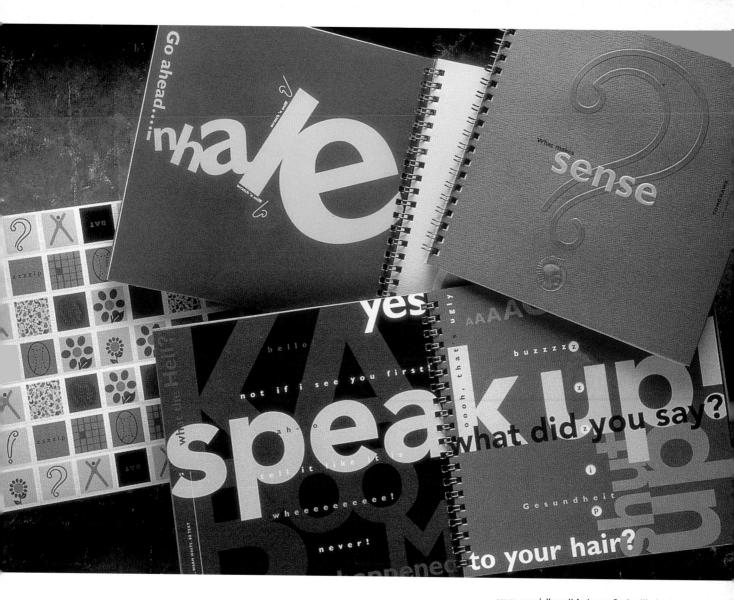

DESIGN FIRM | Hornall Anderson Design Works, Inc. Art directors | Jack Anderson, Lisa Cerveny DESIGNERS | Jack Anderson, Lisa Cerveny, Mary Hermes,

- Jana Nishi, Virginia Le, Jana Wilson Esser
- ILLUSTRATOR | Dave Julian Photographer | Tom Collicott
- COPYWRITER | Suky Hutton
- CLIENT | Mohawk Paper Mills
- TOOLS | Macromedia FreeHand, Adobe Illustrator, QuarkXPress
- PAPER | Mohawk Tomahawk

The booklet features the best characteristics of the Tomahawk line by appealing to the reader's senses of smell, sight, touch, hearing, and taste. Humor was used to showcase the client's versatile Tomahawk textured line, including optical illusions, insightful trivia, and scratch-and-sniff pages.

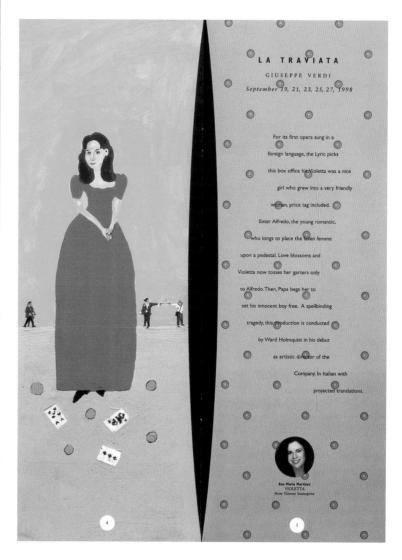

DESIGN FIRM | Muller and Co. All design | Jeff Miller Copywriters | Lyric Opera Client | Lyric Opera Tools | QuarkXPress, Macintosh Printing Process | Four-color offset

The imagery came from taking traditional elements, such as a rose, floral wallpaper, and patterns, then cutting, scratching, reversing, and replacing their original colors with bright, saturated hues.

DESIGN FIRM | DIA ART DIRECTOR/DESIGNER | Andrew Cook Photographer | Vic Paris Copywriter | Robert Davis Client | AD&D Paper | Mohawk Printing process | Lithography

The catalogue clearly demonstrates the range of products through photographic and graphic styles.

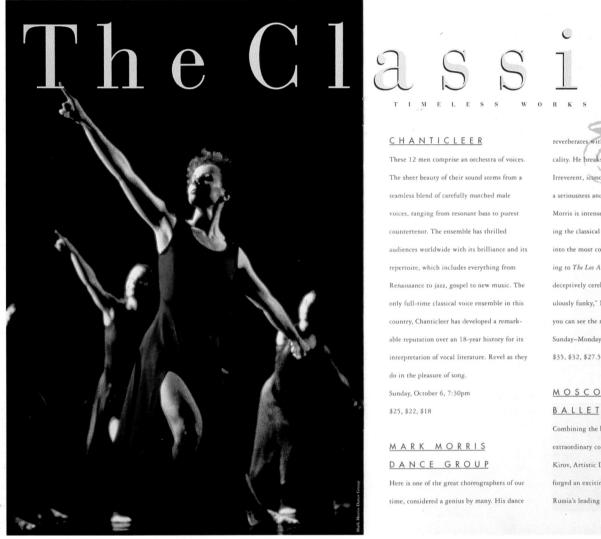

T I M E

CHANTICLEER

These 12 men comprise an orchestra of voices. The sheer beauty of their sound stems from a seamless blend of carefully matched male voices, ranging from resonant bass to purest countertenor. The ensemble has thrilled audiences worldwide with its brilliance and its repertoire, which includes everything from Renaissance to jazz, gospel to new music. The only full-time classical voice ensemble in this country, Chanticleer has developed a remarkable reputation over an 18-year history for its interpretation of vocal literature. Revel as they do in the pleasure of song.

Sunday, October 6, 7:30pm \$25, \$22, \$18

MARK MORRIS DANCE GROUP

Here is one of the great choreographers of our time, considered a genius by many. His dance

DESIGN FIRM | Vaughn Wedeen Creative ART DIRECTOR/DESIGNER | Rick Vaughn PHOTOGRAPHER | UNM Public Events Management COPYWRITER | UNM Public Events Management CLIENT | UNM Public Events Management PAPER | Cougar Opaque White 80 lb. text PRINTING PROCESS | Four-color process

reverberates with wit, humor and lucid musicality. He breaks all the rules, even his own. Irreverent, iconoclastic and yet his work reveals a seriousness and deep understanding of dance Morris is intensely musical, miraculously turn ing the classical works of Haydn and Vivaldi into the most contemporary of dances. According to The Los Angeles Times, Mark Morris "is deceptively cerebral, insinuatingly sensual, fabulously funky," Now, in the prime of his car you can see the miracle of Mark Morris. Sunday-Monday, October 13-14, 7:30pm \$35, \$32, \$27.50

MOSCOW FESTIVAL BALLET

Combining the best classical elements of two extraordinary companies, the Bolshoi and the Kirov, Artistic Director Sergei Radchenko has forged an exciting new company with some of Russia's leading dancers, including Prima

PROMISE

DESIGN FIRM | Louisa Sugar Design ART DIRECTOR | Louisa Sugar DESIGNERS | Louisa Sugar, Melissa Nery ILLUSTRATORS | Joey Mantre, Greg Spalenka COPYWRITER | Lee Nordlund CLIENT | Monterra Promise Proprietor-Grown Wines TOOLS | QuarkXPress PAPER | Teton, Starwhite Vicksburg PRINTING PROCESS | Letterpress, hot stamping, offset lithography

Research into the place where Monterra Promise wine grapes are grown uncovered a fascinating history, beginning with discovery of the land by the King of Spain' explorers in the 1600s. To communicate these historical roots, this launch brochure was designed to look like a rare book from that era.

Monterra Promise

G R A P E S F R O M THE BEST VINTAGES ONLY ARE SELECTED FOR

MONTERRA PROPRIETOR GROWN WINES.

TOM SMITH WINEMAKER BILL PETROVIC VINEYARD MANAGER

COLORER Vice you can sugnature statement with these revisalizing enlargest. Enapside iterational with a day weak pipola of and essential of these refersion the states while adding a lar of fragmate to complement your lifestile TS ML (25.4) (10) (25.2) (10.4) (10.4) (25.2) (10.4) (10.4) (25.2) (10.4) (10.4) (25.2) (10.4) (10.4) (25.2) (10.4) (10.4) (25.2) (10.4) (10.4) (25.4) (10.4) (10.4) (25.4) (10.4) (10.4) (25.4) (10.4) (10.4) (25.4) (10.4) (10.4) (25.4) (10.4) (10.4) (25.4) (10.4) (10.4) (25.4) (10.4) (10.4) (25.4) (10.4) (10.4) (25.4) (10.4) (10.4) (10.4) (25.4) (10.4) (10.4) (10.4) (25.4) (10.4) (1

FOAMING BATH Surround yourself with pure berbal fra mounds of hubbles delight your series jojohn oil, aloe vera and Viumin E, the creates a private sanctuary that leaves y

and remeved. 235 ML / 8 FL OZ 02071 EUCALMPTUS 02072 LAVINDER

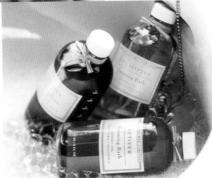

Pare vogetable glvervine and fragmate sessent her beginning of three beautiding servicel jes Enricheet with joghta oil, housy and Vitamine due gratte lather relearnes thoroughly and the away clean, Perfect for all skin spike. 2 NAVPS – 85 G / 5 OZ LACH 02001 EVCANFULS 02001 EVCANFULS 02002 EVENDER 02005 VETVER

GLYCERINE SOAP

DESIGN FIRM | Design Guys ART DIRECTORS | Steven Sikora, Lynette Sikora, Gary Patch DESIGNERS | Jay Theige, Amy Kirkpatrick PHOTOGRAPHER | Patrick Fox COPYWRITER | Jana Branch CLIENT | The Thymes Limited PRINTING PROCESS | Offset lithography

The inspiration for this catalog was the product packaging. Design Guys styled the brochure similar to the style of each collection, like a travel journal of different places. This entire book was shot in-studio, in natural daylight.

DESIGN FIRM | Factor Design ART DIRECTOR/ILLUSTRATOR | Paul Neulinger DESIGNER | Kristina Düllmann PHOTOGRAPHER | Photodisc COPYWRITER | Hannah S. Fricke CLIENT | Römerturn Feinstpapier TOOLS | Macromedia FreeHand, QuarkXPress, Macintosh PAPER | Römerturm Kombination PRINTING PROCESS | Four-color offset

This brochure introduces the new paper line of Römerturm Feinstpapier called Kombination. The big benefit of this new assortment is that it combines different surfaces and shades of white in one line of stock.

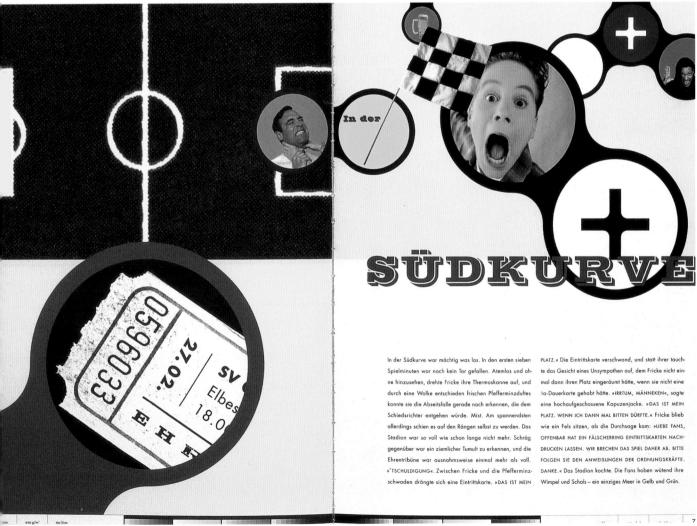

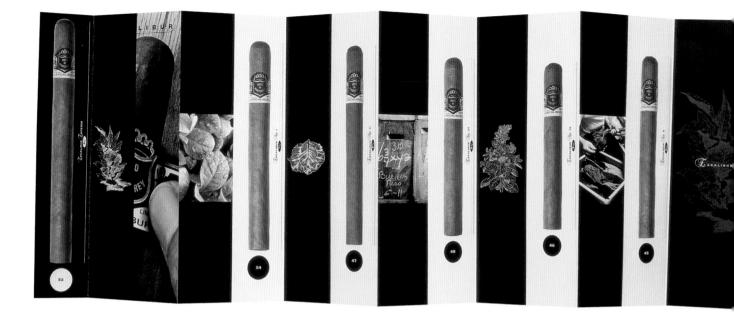

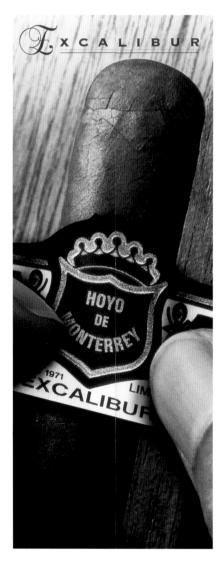

DESIGN FIRM | SJI ASSOCIATES DESIGNER | Anthony Cinturatti PHOTOGRAPHER | Client-supplied photos COPYWRITERS | Kevin Rayman, Sarah Starr CLIENT | General Cigar/Villazon TOOLS | QuarkXPress, Adobe Illustrator and Photoshop PAPER | Productolith PRINTING PROCESS | Four-color offset, die-cut and die-scored

The client wanted a brochure that showed all the cigars in the Excalibur line in an exciting, non-traditional format. The use of alternating cream and black panels, duotones, and a short-fold cover create a warm, sophisticated look that appeals to the younger, fashionable cigar smoker.

DESIGN FIRM | Greteman Group ART DIRECTORS | Sonia Greteman, James Strange DESIGNER | Craig Tomson, James Strange PHOTOGRAPHER | Paul Bowen COPYWRITER | Deanna Harms CLIENT | Learjet TOOLS | Macromedia FreeHand, Adobe Photoshop PAPER | Reflections PRINTING PROCESS | Four-color process, spot metallic, gloss varnish

This highly successful, four-color product brochure communicates the Learjet 31A's key selling points through stunning photography, graphs, fold outs, subtle screens, and generous white space.

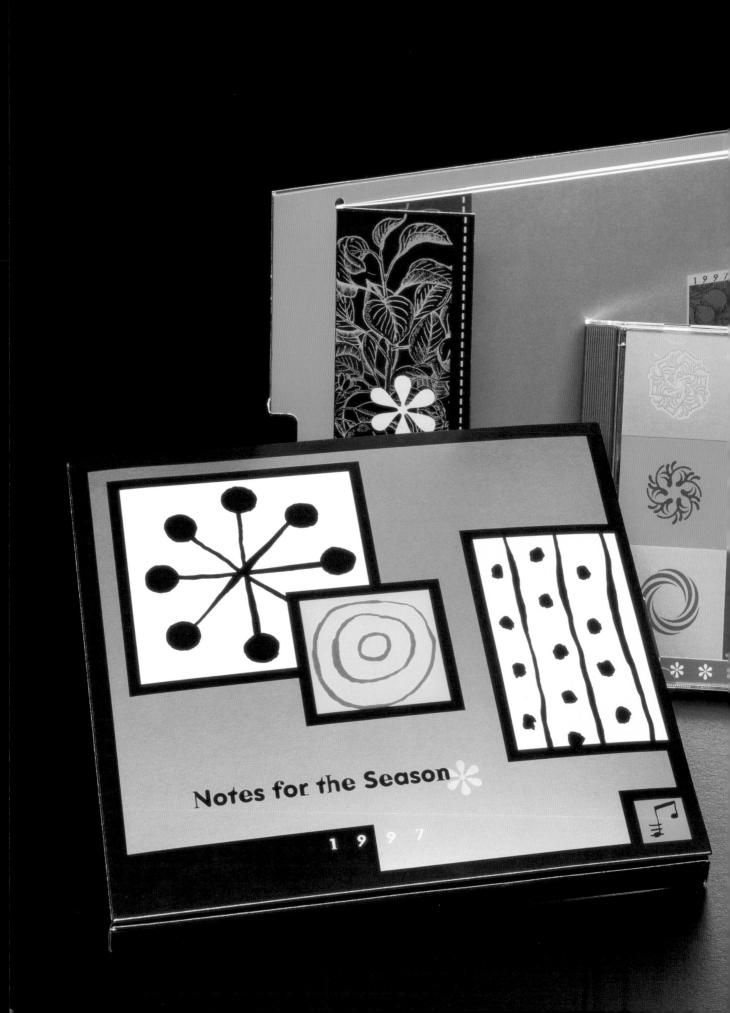

BROCHURES

DESIGN FIRM Lee Reedy Creative, Inc. ART DIRECTOR Lee Reedy DESIGNER/ILLUSTRATOR Heather Haworth COPYWRITER Jamie Reedy CLIENT Frederic Printing TOOLS QUARKXPress PRINTING PROCESS Six-color with metallic silver

A holiday music CD was given to clients with this brochure for diary notations about Christmas dinners, gifts, and other holiday pleasures. Handpainted graphics added to the friendly mood of the holidays.

DESIGN FIRM | revolUZion ALL DESIGN | Bernd Luz COPYWRITER | Eveline Feier CLIENT | Follow Me, Sprachautenthalle, Bern TOOLS | QuarkXPress, Macromedia FreeHand PRINTING PROCESS | Four-color offset

A low-budget brochure for language travels was designed to appeal to young clients 13-17 years of age.

Grossbritannien erst 1964 erlangt wurde. Sonne gibt es auf Malta im Überfluss und die geschützen Buchten mit kleinen Sandstränden an der sonst vorwiegend felsigen Küste werden Dich begeistern. Für Wasser-ratten ist Malta mit seinem kristallklarem Wasser ein Paradies und die Bedingunger für Tauchen, Segeln und Windsurfen sind optimal! Dank der ständigen leichten Brise wird es auch im Hochsommer nie uner träglich heiss. Das tolle Mittelmeerklima und verschiedenste Sportmöglichkeiten runden einen unvergesslichen Sprachaufenthalt auf Malta ab.

te Animationsteam sorgt für spannende Aktivitäten. Auf dem Programm stehen Pool-Barbecues, Discobesuche, Talentabende sowie Ausflüge zu lokalen Sehenswürdigkeiten, Kino- und Theaterbesuche usw.

Ausrüstung gratis benützen. Das aufgestell-

Anfangsdaten: 04.07.98 (für 2, 3 od. 4 Wochen) 11.07.98 (für 2 od. 3 Wochen) 18.07.98 (für 2 Wochen)

Im Preis inbegriffen:

Kurs

- Einschreibegebühr Sprachkurs mit 20 Lektionen
- à 45 Min./Woche
- a max. 15 Studenten/Klasse, Ø 12 👒 Kursmaterial

Unterkunft Subterkunft auf dem Campus im Doppel- oder Viererzimmer mit Küche und Badezimmer (Reinigung 1x wöchentlich) Verpflegung: Halbpension

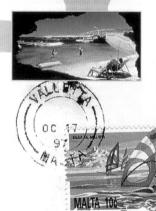

Freizeit

1 Tagesausflug pr

- Animationsprog
- pro Woche S Gratiseintritt in den Beachclub und Gratis-Benützung der nicht- motorisier-Ausrüstung inkl. Transfer Residenz-
- pro Woche

Reise

- Linienflug Zürich-Malta retou mit Swissair
- Transfer Flughafen Malta-Campus retour

und

4 Wochen

- S FOLLOW ME Rucksack deutschsprachige Betreuung vor Ort
- Annullierungskostenversicherung
- Preise 2 Wochen Fr. 1700.-3 Wochen Fr. 2190.-

Meet you at the

eachparty ton

Fr. 2680.-

Prairie Crossing-a 660-acre residential development in Grayslake, Elinois-is a "conservation community" devoted to maintaining and enhancing the prairie landscape. PLSLA, Inc. has designed all on-site planting, as well as the planting and detailing of the Market Square and Village Green, The design of individual home site landscapes is also being done by PLSLA, Inc. Collaborating with architectural, environmental and marketing consultants, the team is building a community that includes equestrian and pedestrian trails, passive/active recreation areas, flower gardens, and restored prairies and wetlands. The master plan was completed by William Johnson, FASLA.

DALEY CENTER PLAZA REN Chicago, illinois

Daly Ganzer Plans in hennel in the hower of the Chilopy Loop and its nonof the strip's grant orban spaces. As part of a complete plane remension in 1929, PEAL, here, pervided design and full contraction documentation for landsscape improvements to the plans. New obligatel planters, which was built over there up to 15-first tall at instillations. Prevential grants and linewers, highlight of by exergence sheahs and groundcover, are the fixes of the planters at ground let end and all excluses to the plan's minimal modern composition.

DESIGNER | Renate Gokl COPYWRITER | Peter Lindsay Schaudt CLIENT | Peter Lindsay Schaudt Landscape Architecture, Inc. TOOLS | QuarkXPress PAPER | Champion Pagentry PRINTING PROCESS | Offset

robert-(lark design studio

CLIENT | Robert Clark Design Studio TOOLS | Macromedia FreeHand, Macintosh PAPER | Wausau Royal Fiber, white PRINTING PROCESS | Offset

The client wanted an upscale look to match their salon and a unique shape to set the piece apart from standard brochures. Printing pages individually allows cost-effective reproduction in the event of price changes.

COUVER

JULY 1997

Fido's Good Heavens, It's Fido! Fido is a featless breed A rover at heart, he can be seen failing over the country behind the wheel of his airship. Now floating over office towers, totem poles and pine trees in Vancouver, Fido was recently seen gliding over the control and nest the CN Tower into Lake Ontario and past the CN Tower into Toronto. Fido has also been spotted gracefully poised above the Château Frontenac and the Plains of Abraham in Quebec City. In Ottawa, his logo was reflected in the waters of the Rideau Canal. Drawn by memories of his maiden voyage, he will even reappear in Montreal. From coast to coast, Fido will fill the sky.

> A Star IS BORN FIDO IS THE RISING STAR IN PERSONAL COMMUNICATIONS SERVICES (PCS THE NAME FIDO INSPIRES CONFIDENCE, AN ESSENTIAL VALUE IN OUR CHANGING TIMES. WHEN HE CAM INTO BEING, WE MADE A POINT OF SHOUTING IT FROM THE ROOFTOPS.

A Faithful Friend Fido always recognizes his owner. The smart card you insert in your handset contains the information the GSM network needs to identify you. The chip in your

OTTAWA

TORONTO

smart card also lets you access your services. But each time you turn on the handset, you must enter your PIN (personal identification number). Because when you're this smart, you can't be too carefull

A Clever Ally The moment he knows it's you, Fido's at your municate effectively, you nee service. You can make and receive calls and take advantage of many different functionsincluding Call Waiting, Call Forwarding and Conference Call-all from one handset. You can even have Call Display and receive faxes (stored in memory), voice

DESIGN FIRM | Goodhue & Associés Design Communication CREATIVE DIRECTOR | Lise Charbonneau ART DIRECTORS | Nathalie Houde, Anne Isabelle Roussy DESIGNERS | Josee Barsalo, Florent DuFort ILLUSTRATOR | Mark Tellok PHOTOGRAPHER | Jean Vachon **COPYWRITER | Microcell Solutions Language Services CLIENT | Microcell Solutions** TOOLS | QuarkXPress, Macromedia FreeHand, Adobe Photoshop

PRINTING PROCESS | Offset

messages (through Personal

Voice Messaging) and short to

or numeric messages (display

on your handset). Fido know

your needs are constantly

urgent and more complex.

Fido can handle them all.

Fido Is Always There To com

quality sound. Fido's fully digi

technology ensures optimu

voice quality. Digital techno-

logy also codes signals so

they're indecipherable to

prying ears. How reassuring

to know that nobody else ca

listen in on your conversation

All your communications are

now totally confidential.

expanding, becoming more

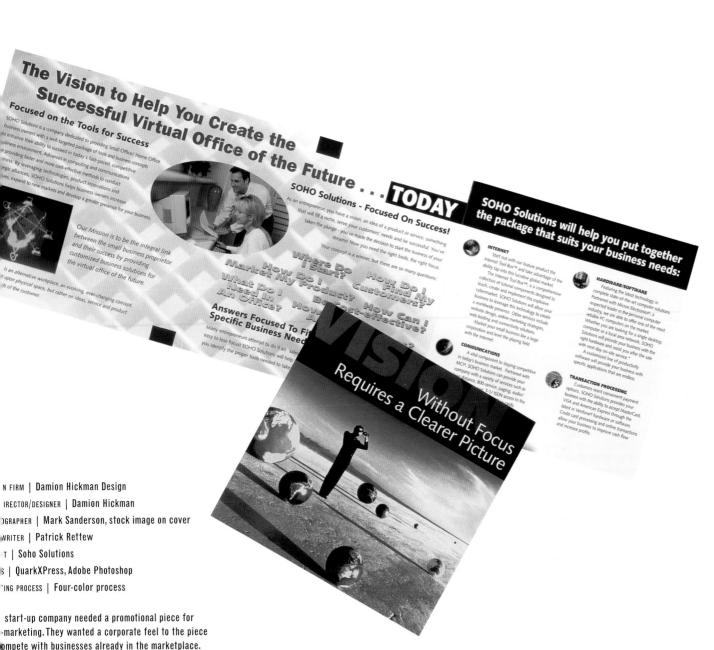

ompete with businesses already in the marketplace. brochure was sent as part of a direct-mail strategy.

DESIGN FIRM | X Design Company ART DIRECTORS/DESIGNER | Alex Valderrama CLIENT | McDermott Planning and Design

The goal was to create a brochure that could double as a leave-behind and as a direct mailer. Thus this brochure was designed to stand alone, but it could also be rolled, held together with a belly band, and placed in the box when used for direct mailing.

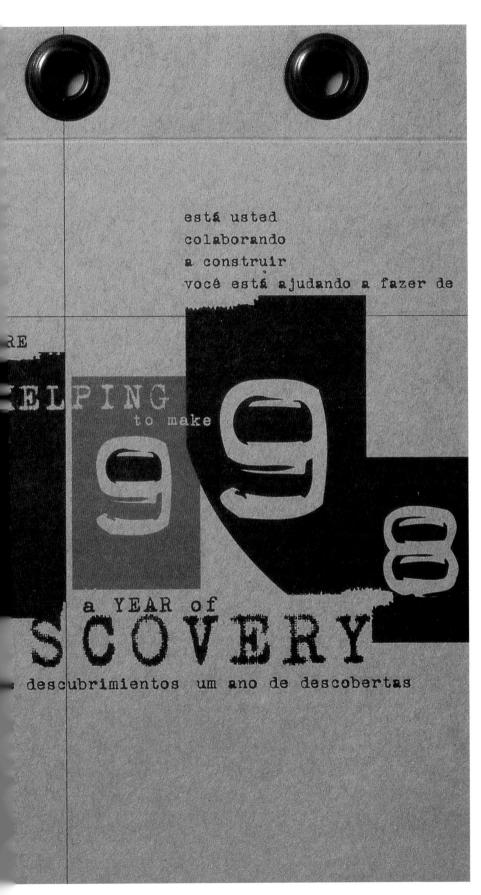

- DESIGN FIRM | Pinkhaus Design ART DIRECTOR | Joel Fuller DESIGNERS | Cindy Vasquez COPYWRITER | Doug Paley CLIENT | Discovery Network TOOLS | Adobe Illustrator and Photoshop
- PAPER | Simpson Evergreen Kraft, 80 lb. cover, Champion Pagentry Handmade
- PRINTING PROCESS | Four-color process plus two PMS

The client was planning to make a donation in the name of all those who received this Christmas card. The card needed to reflect the significance of this donation and the Spirit of Discovery.

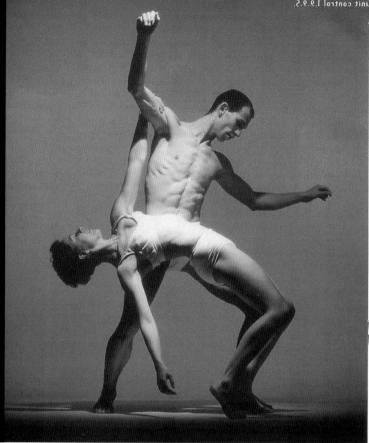

5.6.6.1 lorinositinuontrol 1.9.9.5. Junit control 1.9.9.5. 17995

Tonjuos jiun

Création en mai 1995 à Luxembourg aux Foires Internationales au Kirchberg

Durée: 1H20 Min

Chorégraphie: Bernard Baumgarten

Bernard Baumgarten, chorégraphe luxembourgeois, a débuté sa carrière au S.O.A.P. Dance Theatre à Francfort.

Après des études au Conservatoire de Luxembourg et chez Rick Odums à Paris, il fut engagé comme danseur dans la compagnie de Rui Horta. En 1993, le «Mousonturm» offrait aux membres de la compagnie l'opportunité de produire une soirée chorégraphique. «Im Falle des Fallens eines gefallenen Wortes», chorégraphie de Baumgarten, avait suscité l'intérêt par son langage très personnel et ses images, d'une beauté parfois glaciale et distante. Dans ses productions suivantes, «Jedes X Wenn Du», 1994 au Gallus Theater à Francfort, et «Honni soit qui mal y pense», 1994 à l'Atelier Cosmopolite Fondation Royaumont à Paris, il est resté fidèle à son approche chorégraphique, orientée vers l'expression théâtrale de la danse.

Avec unit.control 1. 9. 9. 5. B. Baumgarten franchit une étape importante: les premières pièces ont été chorégraphiées pour 2 à 3 interprètes - la production unit control, créée dans le cadre Luxembourg, Ville Européenne de la Culture, met en scène sept danseurs, un travail vidéographique et la composition d'une musique originale.

The client was very open to a free style of design. Being able to break typographical re helpful in depicting movement, dynamism, a dancers expresses themselves.

DESIGN FIRM | Melissa Passehl Design ALL DESIGN | Melissa Passehl CLIENT | Interchange Family Services TOOLS | QuarkXPress, Adobe Illustrator and Photoshop PAPER | Lustro Dull PRINTING PROCESS | Four-color lithography

This brochure is a quick reference for families with special-needs children aged one to three. Color and hand-rendered type help to create a child-friendly feeling.

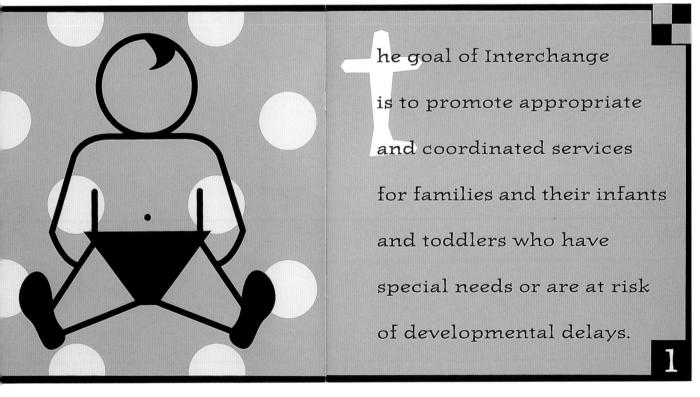

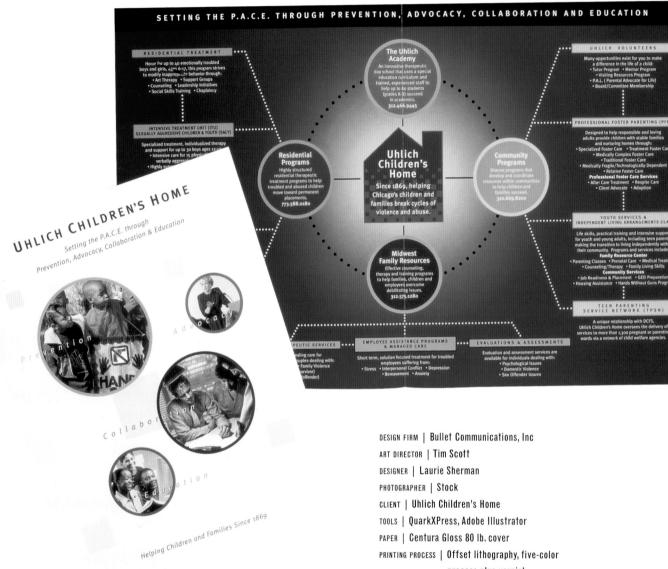

process plus varnish

This brochure illustrates how Uhlich Children's Home is Setting the P.A.C.E. in the social-services industry through its full array of programs and services.

DESIGN FIRM | Elton Ward Design ART DIRECTOR | Jason Moore DESIGNER | Justin Young CLIENT | Australian Design Awards TOOLS | Adobe Illustrator and Photoshop PAPER | 350 gsm A2 Gloss Art PRINTING PROCESS | Four-color offset plus special plus varnish

A technical approach was required for this call-forentries leaflet to encourage industrial designers to submit their product designs for judging in the 1998 awards competition. This brochure set the theme for the upcoming award-winners annual. DESIGN FIRM | Integrated Marketing Services/IMS Design ART DIRECTOR/DESIGNER | Michael Grant PHOTOGRAPHER | Neil Molinaro COPYWRITERS | Stan Mallis, Karen Goldman, Tony Casale CLIENT | Ungerer & Co. TOOLS | QuarkXPress, Adobe Illustrator and Photoshop PAPER | Consort Royal Silk white, cover and text PRINTING PROCESS | Offset

Using dramatic color and photography, the brochure repositions an older, mid-sized flavor-and-fragrance formulator as Master of the Elements. The idea was to create a visual experience of history, color, and capability. The transformation photo illustrates this idea.

We test the fragrance in its base for compatibility efficiency, stability and cost effectiveness. Then, we conduct market tests to ensure consumer

acceptance. This 364 painstaking process creates new ideas and fragrances that help distinguish our clients' brands and product lines. Clients can also opt to choose from the extensive Ungerer database of fragrances for applications ranging from household and industrial products to toiletries and fine fragrances. This database is

product line extensions. This close working relationship with customers has become an integral part of the Ungere culture and helps to create the synergy needed for a successful end product Whether a client choose

r.

a custom-created fraprance or one from our library. we guarantee it to be of the highest quality

Havor Ungerer's flavor professionals design and develop intricate and complex flavors using

We understand the value of essential oils, aromatic investing today in technology needed to produce the flavors chemicals, specialty products, essences, distillates and raw materials acquired throughout the world. We believe that partnership with our customers is the key to serving their needs.

advise on new product ideas and creativity, technical in service and quality available

pushing back the barriers of authenticity and natura Keeping abreast of what is happening in the marketplace

formulations.

We pride ourselves on

responding with the most

innovative blends, forever

オキーで

of tomorrow. Our flavorists and food technologists work closely together, pooling their creativity and knowledge

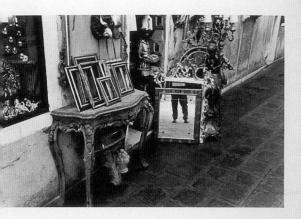

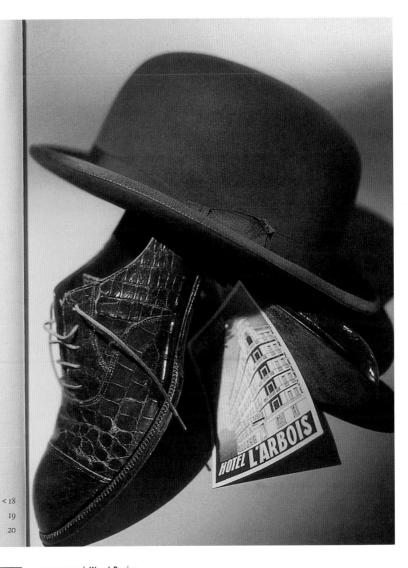

DESIGN FIRM | Wood Design ART DIRECTOR | TOM Wood DESIGNERS | TOM Wood, Alyssa Weinstein PHOTOGRAPHER | Craig Cutler CLIENT | Craig Cutler Photography TOOLS | QuarkXPress PAPER | Monadnock Astrolite PRINTING PROCESS | Six-color offset

The photographer, recognized as a leading studio photographer, requested a promotion that would show his other photographic talents in portrait and location work. The designers played on the concept of travel and places. They paralleled and contrasted the photography in a leatherette-style passport book. DESIGN FIRM | Price Learman Associates ART DIRECTOR | Patricia Price Learman DESIGNER | Sandy Goranson COPYWRITER | Douglas Learman CLIENT | Trammell Crow Residential Services: Chandler's Reach PAPER | Starwhite Vicksburg Archiva cover and text; UV Ultra 36 lb. flysheet

PRINTING PROCESS | Four-color process

The client wanted to enhance the Chandler's Reach image, gain upscale residents, and portray an overall feeling of uniqueness. The brochure has the hint of a posh boathouse atmosphere with views of the property's lake activity and the rope that ties it all together.

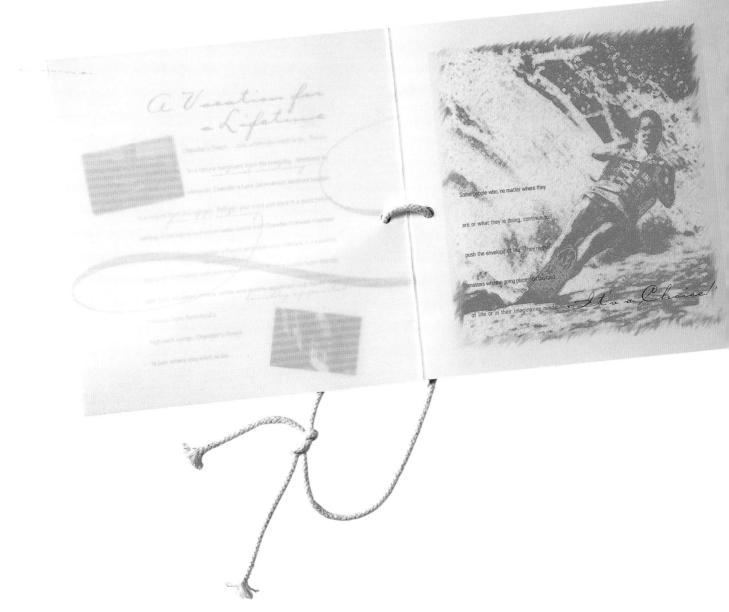

Change

TRAINING

ТНЕ

TON DEADLINE: Your registration must be postmarked on or 24, 1998, to guarantee your spot at TRAIN FOR CHANGE.

eed any assistance, please call JULIE HILE OF CAROL HOENIGES at HE TRAINING CONNECTION at 309.454.2218.

> CHANGE - AUGUST 25. 26. AND 27. 1998 THE TRAINING CONNECTION

DESIGN FIRM | Griffin Design DESIGNER/ILLUSTRATOR | Tracy Sleeter COPYWRITER | Carol Hoeniges CLIENT | The Training Connection PAPER | Neenah Peppered Bronze Duplex Classic Laid (folder) PRINTING PROCESS | Two-color offset by Commercial Printing Associates (folder and inserts); four-color Indigo by Starnet (stickers)

The goal was to produce a multi-functional marketing tool. The self-mailing folder, printed with two colors on the inside only, can be used to hold conference promotions or marketing information. An indigo press was used to create multiple sets of stickers that provide artwork on the outside of the folder.

DESIGN FIRM | Adele Bass & Co. Design ALL DESIGN | Adele Bass COPYWRITER | Tina Gordon-McBee CLIENT | Social Model Recovery Systems TOOLS | Adobe Illustrator and Photoshop, PAPER | Evergreen 80 lb., Kraft Cover PRINTING PROCESS | One-color lithography

Budget was a major consideration for thi The theme of violence inspired the typog cover and the inside copy. The Kraft pape raw nature of the subject matter.

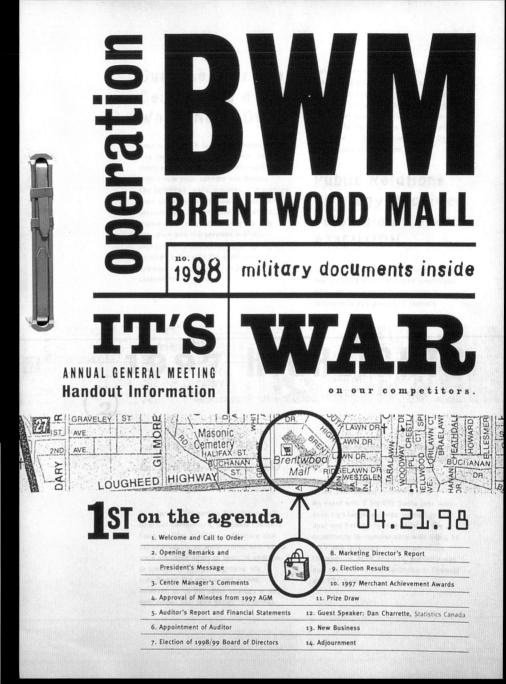

DESIGN FIRM | Big Eye Creative, Inc. ALL DESIGN | Nancy Yeasting COPYWRITERS | Nancy Yeasting, Folanda Smits CLIENT | Brentwood Mall TOOLS | Adobe Illustrator and Photoshop PAPER | Currency Cover Silver and blueprint paper PRINTING PROCESS | Lithography and blueprints

This annual meeting for a local mall required economical print material to promote their war against the retail competition. The designer creatively used blueprint paper (an inspiration being the blueprint shop around the corner) rolled into a camouflaged tube, and an oversized dog tag invitation card (complete with chain) printed with black on a metallic stock.

vine Dividends Heavenly STIR

wood Mall launched our Divine ends Customer Rewards Program py with the intent to encourage wood customers to shop more ently, increase individual expenditures ist and encourage these goals

sit and encourage these goals from the year. The incentive was a tible series of custom-designed Angels d exclusively for Brentwood Mail. tised within the shopping centre only, ogram boasted over 500 members gresented over 598,000.00 in revenue.

Heights

97

Winner of MERIT Maple Leaf Award: Overall Marketing Campaign

This award recognizes a single campaign that combines elements from at least two areas of shourging center marketing. The category looks for sparsey of wellingrated marketing programs. That use multiple and varies efforts to bundle their hoge? Continues campaign integrated scales promotion, conserver advertising, contenser relations and community program initiatives to give customers unique reasons to shour all formetand Mall.

HLIGHTS

AND SOUTH

TOU CAN PLAN AHEAO

MS TO REMEMBER

Octobe

EVENTS for 1998

HIG

Brentwood LAWN DR.

h Week: May	Antique Show: Septer
ue Show: May	Halloween Festivities:
ty Week: June	Christmas Promotions
walk Sale: July	November/December
To School Promotion:	Sidewalk Sale:
st/September	January 1999

Great Valley Center

LEGACI Grants

DESIGN FIRM | Shields Design ART DIRECTOR/DESIGNER | Charles Shields PHOTOGRAPHER | Stock COPYWRITER | Carol Whiteside CLIENT | Great Valley Center TOOLS | Adobe Illustrator and Photoshop PAPER | Classic Crest 70 lb. text PRINTING PROCESS | Offset

This was an inexpensive, two-color brochure for a local client. It combines information about available grants and an application form. Within a limited budget, the client wanted a sophisticated brochure to showcase the new program. DESIGN FIRM | X Design Company ART DIRECTOR/DESIGNER | Alex Valderrama CLIENT | Northwest Bank TOOLS | QuarkXPress, Adobe Photoshop PAPER | Cougar Opaque, Beckett RSVP PRINTING PROCESS | Cougar Opaque, Beckett RSVP

The challenge was to design an invitation that did not look like a direct-mail piece. The solution drew inspiration from researching visuals of China. He treated the invitation like packaging and established a creative visual language. Client expected 1,200 responses and received double that.

DESIGNER | Eric Dean Freese PHOTOGRAPHER | Barb Gordon CLIENT | Guaranty Bank & Trust Company TOOLS | Adobe Illustrator and Photoshop, QuarkXP PAPER | Beckett RSVP Greenbriar, Beckett Expression Iceberg PRINTING PROCESS | Three-color offset plus varnish foil stamped, die-cut band

DESIGN FIRM | Marketing and Communication Strat

The Trust Department of this bank wanted an ide piece at a reasonable cost that would be upscale friendly. The bank president provided his collecti antique bank illustrations to lend a nostalgic feel and the foil-stamped, die-cut band added sophist that pleased the client.

THE TAO OF NEVER ENOUGH

To think is to be alive, or so said Descartes.

Is the universe dead?

Are earthquakes alive?

Are we the only thinking creatures? When animals protect their young are they thinking, or merely responding instinctively? Do computers think or merely respond to instructions? For that matter, do we ourselves merely respond to genetic instructions?

I presume that Hitler, the unabomber, the Menendez brothers, were once trusting infants and loveable babies. What virulent instructions were mixed with their daily formula? And how do we accept that they, like us, are human beings, offspring of male and female coupling, born of mothers' wombs?

Somehow love was not enough, or perhaps there was not enough love.

Perhaps there is never enough love.

There is never enough art

For art is an act of love.

Corinne Whitaker

lower: Battered, 1998 30 x 30"

DESIGN FIRM | Digital Giraffe ALL DESIGN | Corinne Whitaker

The challenge was to design an eye-catching brochur on a small budget, to promote the digital painting of Corinne Whitaker.

CORINNE WHITAKER

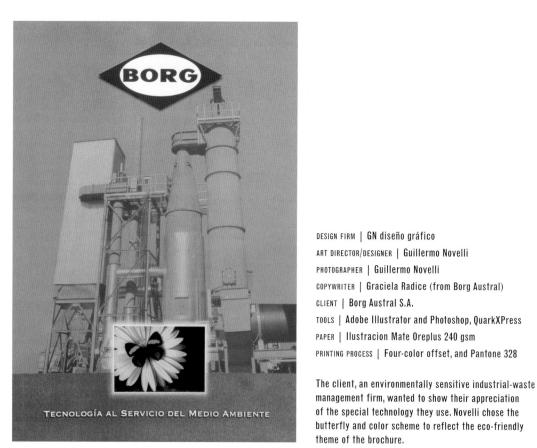

· PLANTA INTEGRAL DE TRATAMIENTO Y DISPOSICIÓN FINAL La planta presta servicios integrales de análisis, clasificación, reciclado, recuperación y tratamiento de residuos industriales

 Quenta con las siguientes áreas de procesamiento:
 Unidades de recuperación de materiales com-bustilites, impurificados con sólidos y agua, instalaciones de recepción y pesaje de cargas.
 Instalaciones de recepción y pesaje de cargas.

Laboratorio de análisis físico-químico donde se realiza la identificación y la verificación de las maliteriates, van alisis y dasificación, el control de liós procesos de tratamiento y el monitoro amilientat.

Nave de almacenamiento de tambores, de 1.500 m2 de superficie cubierta, con capacidad para almacenar 10.000 tambores, complementada por instalaciones de vaciado y transferencia de material bombeable a tanques.

Playa de tanques de almacenamiento a granel de diversos productos bombeables, diseñada y construida según normas API.

I inidiad de incineración, compuesta de un homo de tipo rotativo, de SOU lapo por hora de capacidad de processamiento, dobie cámara de quemado, sistema de enfriamiento y depunación de gases de combusitón e instalacions de alimientación continua y automática de liquidos, sólidos y semisiólidos, tantos a granel como en tambores. Cuenta con un diseño alitamiente finicible que le permite manejara divensos tipos de materiales, en diferentes condiciones filicas y de alimecen-miento. Cuenta con un compete sistema de purificación de gases y monitoreo continuo de emisiones.

Unidad de tratamiento físico-químico de estabilización-solidificación, para el procesa-miento de cenizas y escorias generadas durante la incineración, y de semisólidos inorgánicos.

Oficinas, comedor y vestuarios para el personal de la planta, báscula para control de cargas y servicios de mantenimiento liviano preventivo.

TRATAMIENTO DE ESTABILIZACIÓN-SOLIDIFICACIÓN

ediante la transor e los contaminantes presentes, mitando su solubilidad y moviidad, mitando su toxicidad. Los

100

alta estabilidad, una estru friable, similar a muchos

ALL I

de rea

UNIDAD DE INCINERACIÓN

un de ce

(DRE) y la efficiencia (CE) es superior al 99. ts y trata

rador de

eficiencia de de ites del 99,9999 9

DESIGN FIRM | GN diseño gráfico

1.05

en det

los residuos previo al tratamiento. tal de sólidos Análisis de verificación djaria. 11. III. Control de las operaciones

LABORATORIO

Caracterización de

procesos de la planta IV. Monitoreo ambi-

> Servicios de análisis y caracterización de residuos y efluentes industriales a tercer

> > 195

122 THE BEST OF BROCHURE DESIGN

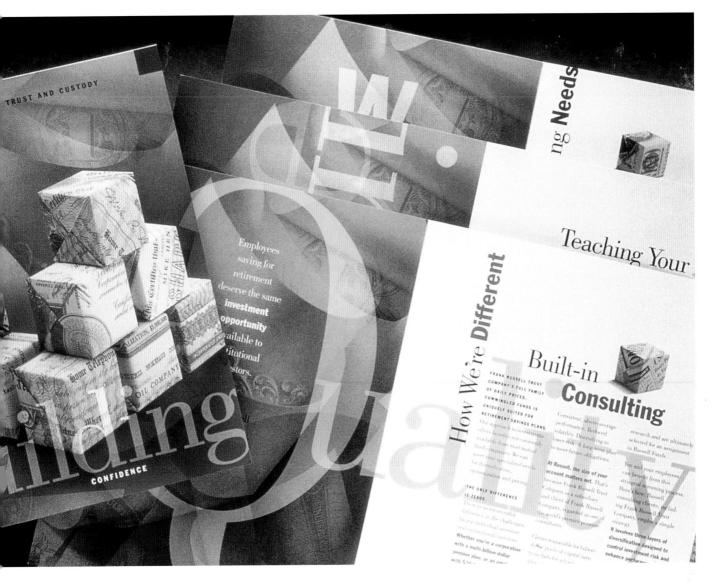

- FIRM | Hornall Anderson Design Works, Inc.
- RECTOR | Jack Anderson
- ERS | Jack Anderson, Lisa Cerveny, Jana Wilson Esser,
- Alan Florsheim, Michael Brugman
- RAPHERS | Robin Bartholick,

Will Agranoff (composites only)

- RITER | Client
- | Frank Russell Company
- | QuarkXPress, Macromedia FreeHand,
- Adobe Photoshop
- | Mohawk Superfine

and enlarged type treatments alleviate the idating print that is frequently found in financial "ial.The warm color palette lends an upscale look eel to the piece. Photo composite illustrations, a red lineal-grooved paper stock, emboss, and special o closures all contribute to making this kit e, yet elegant. We're taking off the gloves on this one! Yes, we've given away cars before, but never like this. Steer your customers in the right direction and your sales will shift into high gear. So will your chances to win! You're in the driver's seat and the race to the finish is in your hands.

DESIGN FIRM | Vaughn Wedeen Creative ART DIRECTOR | Steve Weeden DESIGNERS | Steve Weeden, Pam Farrington COPYWRITER | Foster Hurley CLIENT | US West

you

Black Cat Design | Anthony Secolo, Kelly Coller TRATOR | Anthony Secolo Kelly Coller tle Opera's Bravo! Club omedia FreeHand, Adobe Photoshop River White ss | One-color plus varnish

ed beautifully in this brochure, color.

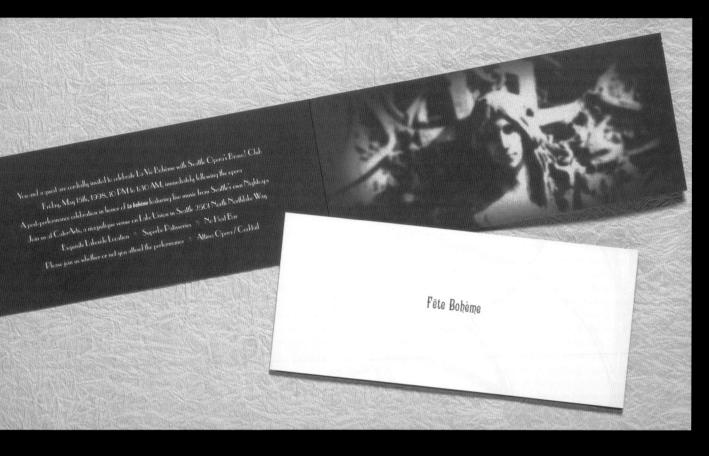

DESIGN FIRM | Wood Design & Art Studio ART DIRECTOR/DESIGNER | Linda Wood COPYWRITER | Doreen Lecheler, Project C.U.R.E. CLIENT | Project C.U.R.E TOOLS | QuarkXPress, Adobe Photoshop PAPER | Grafika Vellum—Autumn Mist PRINTING PROCESS | One-color offset

The Pasaporté's key visual feature is the passport-style leather pocket created to simulate a quarterly invitation for armchair travel to featured countries. Project C.U.R.E. collects and donates surplus medical supplies to Third World countries.

Pasaporté to North KOREA

Editor Doreen M. Lecheler

.

Contributing Editor Erin E. Jackson

Graphic Design Wood Design & Art Studio Linda Wood

President Dr. W. Douglas Jackson

PASAPORTÉ to North Korea Spring 1998 Volume 1, Number 1 7 7

PASAPORTÉ is a quartery publication of Project C.U.R.E. If you know someone who would like to receive a free subscription to PASAPORTÉ, please call (303) 727-9114. Please send address below. Copyright @ 1998. Permission to reprint in whole or in part is hereby granted, provided a copy of the reprinted article is sent to Project C.U.R.E. and a version of the following credit line is included: "Reprinted by permission from PASAPORTÉ, the quarterly journal of Project C.U.R.E."

Project C.U.R.E. 2040 South Navajo Denver, Colorado 80223-3848 North Korea: A View From Inside

Phone 303.727.9414

Fax 303.727.8397

projectcure@juno.com

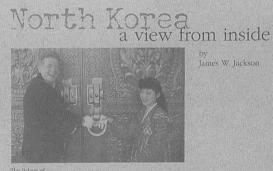

Gifts, housing treasures given to Kim II Sung by other world leaders (1995)

James W, Jackson is a successful businessman, autior, international economic consultant and humanitarian, Jackson has served as seconomic consultant to various governments and husinesses. He received the Gold Medallion Book Award in recognition of his works. He is the founder, chairman of the board and past president of the board and past president of the board and past president of the Boardone Montherboard Foundation, Inc. For the past 10 Poundation, Inc. For the past 10 Poundation and the former Soviet countries

Jackson was the first person to receive State Department clear ance and licensing for shipping to DPIRs and Cuba. If is work with foreign officials has awarded him many national and international honors, including "Who's Who is Business" and "international Man of the Year" in 1991.

A HISTORY OF RISK

Since 1950 the Democratic People's Republic of Korea (North Korea) was one of the most adamant Communist players in the Cold War stalemate. The country, with its socialist leader Great Leader Kim II Sung, was seen as the most natural and least expensive safeguard for protecting the back door of Russia and China. Following the Korean War, Joseph Stalin and Mao Tse-tung determined to subsidize the government and army of Kim II Sung for the purpose of defense against the United States and Republic of Korea troops stationed south of the 38th Parallel. It was more efficient to pay for Kim's efforts than to deploy Soviet or Chinese armies to guard the borders.

The strategy toward D.P.R.K. has been quite simple and very consistent: one of deterrence through a strong military defense. Throughout the years, there has been a legitimate threat of rekindled aggression. Many times both sides have been totally convinced that out-and-out war would again commence as a result of some overt provocation from one camp or the other, e.g. the South's Francis Gary Powers situation, the Pueblo occurrence, the North's bombing of the South Korea Airline KAL flight #858 in 1987 or the recent submarine grounding on the South Korean coast.

This risk management strategy has worked well to bring relative stability to the Korean peninsula, Neither the North nor the South has engaged in any type of preemptive strike. However, the strategy of deterrence has come at a very high price. For South Korea, the price has been approximately \$15 billion per year for military defense. The U.S. spends more than \$3 billion per year to support some 37,000 troops in

DESIGN FIRM | Greteman Group ART DIRECTOR | Sonia Greteman DESIGNERS | Craig Tomson, Sonia Greteman PHOTOGRAPHER | Steve Rasmussen COPYWRITER | Deanna Harms CLIENT | Rock-n-Steel TOOLS | Macromedia FreeHand, Adobe Photoshop PAPER | Reflections PRINTING PROCESS | Four-color process

In spite of a low budget, this four-color, accordion-fold brochure does its job. Its postcard-sized photographs showcase samples of the firm's work in sculpture, metal, stone, and wood.

Ihr persönlicher Reisekalender 1998

Timmendorf & Göteborg

9 Tage kombinierbarer Urlaubsgenuß

rundleistungen Buschitt, Zuhringerdienst 8 Übernachtungen im essel-lenten ****Hotel Princess im Transmedneis Strand (sol um ***Hotel im Hamover (La) im ***Hotel im Hamover (La) Sachtsburfet, Ze Halppension komfort, Zimmer (BD/OU/WE) Keiseru derfislootenisersderung

Reiserücktrittskostenversicheru reis für Grundarrangement pro Person im DZ 920,- DM (EZ-Zuschlag 200,- DM)

usetzleistungen Secreise Hiel-Göteborg-Kiel mit der "Stena-Line" 2 Obera. Physt butfet an Bord, Innenkabinen (bUWC) ganztägige Stadtrundfahrt Göteborg mit Ansling Westkäste

uppreis zum Grundarrangement pro Person in der DK 70,- DM (EK-Zuschlag 20- DM) (Zuschlag DK außen 80,- DM)

Ihr ****Hotel "Princess" in Timmendorf In + +++ +thdel _Phocess' in Timmendorf Das Hotel liegt am Stadtrand im Grünen. Bis zum Strand sind es nur 100m. Das Hotel verfögt über ein eigenes Restaurant und einen Svimmingpool mit Fitness-Bereich. Alle Zimmer sind mit Bad oder Dusche und WC, Fernseher, Radio, Telefon und Balkon ausgestattet. Sonne, Strand, Wellen und Ostsee; Freizeit, Entspannung und gesunde Luft - das ist Timmendorfer Strand. In Kombination zum Badeurlaub haben Sie die Celegenheit, eine Schffrezise nach Göteborg zu unternehmen. Neben der Szereise mit einem komfor-tablen Schiff der "Stena Line" können Sie die zweitgrößte und gemütlichste Stadt Schwedens sowie die Meerengen und romantischen Buchten der Westküste kennenlernen.

Programm Samstag: Anreise über Ulm, Würzburg und Fulda zur Zwischenübernachtung nach Hannover. Hotelbezug.

Sonntag: Weiterfahrt nach Timmend fer Strand. Ankunft am frühen Nach-mittag. Begrüßung im Hotel, Zimmer bezug, Erster Orientierungsbummel.

Montag-Mittwoch: Genießen Sie Ihren Urlaub am Timmendorfer Strand!

Donnerstag: Am späten Vormittag Fahrt nach (Kel. Einschiffung auf einem modernen Schliff der "Stena-Line". Kabinenbezug. Um 1900 Uhr legt das Schliff nach Göteborg ab. Feliahahme am abwechslungsreichen Bordleben mit "Arrade-Bar", Kino. Duty-Fes-Shop, Night-Club u.v.m. Übernachtung an Bord.

Freitag: Ankunft im Hafen von Göteborg um 300 Uhr. Anschließend Stadtrund-fahrt und Ausflug an die Westküste mit umserem eigenen Bus. Aufenhalt/Preizeit. Am frühen Abend Einschliftung, Genießens Sie nochmals die veißfätigen Unterhal-tungsmöglichkeiten an Bord.

Samstag: Ankunft in Kiel in den Mor-genstunden. Weiterfahrt zur Zwischen-übernachtung im Raum Würzburg. Hotelbezug.

Sonntag: Heimreise über Ulm. Rückkunft am frühen Abend.

41

Für alle Freunde der Volksmusik sind die Konzerte von Stefanle Hertt & Stefan Mross ein besonderes Ereignis. Sie sollten es sich nicht entgehen has-sen, ein paar abwechstungsreiche Tage in der atemberaubenden Landschaft des Pustertals und der Dolomiten mit einem Konzertbesuch zu verbinden.

Programm Mittwoch: Anreise über Bregenz und

über die Brennerstraße in das zaub hafte Puster-/Eisacktal. Hotelbezug,

Donnerstag: Start zur faszinierenden Dolomitenrundfahrt: Cortina d'Ampezzo, Monte Cristallo, Tre Croci Paß, Misurinasee, 3 Zinnen, Höhelsattel und zurück über Toblach zum Hotel.

Freitag: Ausflugsfahrt in das Tauferer Ahmtal mit herdichem Panorama auf die Zillertaler Alpen zunächst nach Sand in Taufers. Anschließend Weiterfahrt nach Kasern. Kleine Wanderung in wun-derschoner Alpenflora nach Heilig-Geist. Besichtigung der bekannten Wallfahrts-

ingementpreis pro Person im DZ 510, DM (EZ-Zuschlag St

26.-30. August

DESIGN FIRM | revolUZion ALL DESIGN | Bernd Luz COPYWRITER | Armin Stork CLIENT | Stork Bustouristik TOOLS | QuarkXPress, Adobe Photoshop PRINTING PROCESS | Four-color

A catalog for a bus tour was designed as a calendar, allowing clients to use it the whole year. Watercolor in different shades for each month gives it a special flair.

8.-16. August

5 tägige Reise mit Open-Air-Konzert von Stefanie Hertl & Stef

kirche: Rückfahrt zum Hotel Abend Pahrt an den Kaltere 19:30 Uhr Beginn des Open Konzertes mit Stefanie Hert Moss. Nach Ende der Verar Rückfahrt zum Hotel

amstag Vormittags Freize achmittag unternehmen s albfaøisen Ausflug an der slegenen Pragser Wildsee eeumwanderung

sonntag: Heimreise über D wienthalt, weiter über den mit Ariberg, Rückkunft am

Giorgio Canali

SA ELETTRIFICATA

SA ELETTRIFICATA j fa, d'salate, mentre a Paris alla terrazza di un bar mi sto suicidando con il sesto Ricard, scopro in un tra-di un quolidano italiano di essere invece in quel momento in Mongolia. Mi guardo intorno sospettoso: ancora qui, quella di sempre. Place des Abèsses a sa place comme toujours, il cameriere del SI. Jean con la he fa voglia di chiedergli (s'1) vous plati) di mettersi di profilo per poterla più comodamente spiacciare la da caldarroste. Mi tranquillizzo, il nome collettivo "C.S.I." non mi contiene per forza, tiro un sospiro di ancava solo la Mongolia... ure lui tira il suo sospiro di sollieve: mica è stagione di caldarroste e di padelle a portata di mano non ce ne della castagna arriva. Per comporre ci si ritrova in monlagna, monlagne tra virgolette ma pur sempre ontagna da farmi venire i bufoli, montagne deprimente quanto la piogerellina merdosa che vedo dalla o sondo montagne. Nessuna idea musicale già decisa in testa, come al solito, siamo qui per scrivere un lo.

no. golia mica ci sono slato. sono anni che faccio finta di saper suonare la chitarra, è tutta una vita che simulo felicità, mi sono persino siarmi per violinista, posso benissimo inventarmi una mia Mongolia virtuale, orribile almeno quanto la paro-

ni arrivano una dietro l'altra, veloci e, incredibilmente, non si litiga fra di noi. Bam! L'album è registrato, nivato e, manco in questa fase, ci sono screzi tra di noi. "Tabula Rasa Elettrificata" esce in agosto, d'estale, so, l'album mi piace tutto, moltissimo, non sto simulando. cameriere con la faccia a cuto non c'è più. Peccato, soprattutto per l'energia che ho sprecato per far entra-padella da caldarroste nella mia borsa da viaggio.

14 Giorgio Canali

Tabula Rasa Elettrificata

All'inizio dell'anno, mentre lavoravo alla copertina degli estAsia, sono andato diverse volte a trovare i C.S.L che stavano registrando il nue album, e in una di quelle occasioni Massimo mi ha dato la cassetta del documentario "Viaggio In Mongolia". Nelle settimane successive ho "macinato" il film guardandolo e riguardandolo, cercando in ogni fotogramma gli elementi che, assieme ai racconti di Giovanni e Massimo su quell'esperienza, potevano darmi gli spunti necessari per realizzare una proposta per la copertina per l'album che stava nel frattempo prendendo forma. In un primo momento avevo pensato di fotografare le scene del film così come erano, con i pixel dello schermo TV in bella evidenza e le prime bozze che ho realizzato avevano questa caratteristica. Poi finalmente ho avuto la desideratissima cassetta demo del nuovo disco "Tabula Rasa Elettrificata", fresco di registrazione. Fin dal primo ascol to mi è sembrato non solo il più bel disco dei C.S.I. ma anche l'album più emozionante e sensuale che avessi ascoltato negli ultimi anni. Ho capito che la copertina doveva essere diversa da come l'avevo immaginata in un primo tempo, e così ho cercato non più solo nel film ma anche e soprattutto nelle canzoni le immagini che potevano "vestire" il disco. L'estrema naturalezza dei brani, la loro luminosità (Giovanni ottimista?!?) mi hanno alla fine portato a realizzare questi "dipinti" basati su montaggi di diverse scene del film. Dipinti elettronici però, realizzati con un Macintosh, il programma "Painter" e una tavoletta grafica, partendo da collages che mescolavano vari personaggi, animali, e elementi di paesaggio naturale e urbano. Ho cercato di non caratterizzare in maniera troppo esotica le immagini: la fabbrica con l'aquila, il cavallo e la linea elettrica, la pianura con la centrale lontana, quelle tende di nomadi, potevano infatti far parte anche di un paesaggio "nostro"; solo il cavaliere in primo piano può alla fine far pensare a un mondo (e forse a un tempo) diverso.

Diego Cuoghi

Forma E Si

Tabula Rasa Elettrificata CD - MC - LP

DESIGN FIRM | Punto e Virgola S.A.S ART DIRECTOR/DESIGNER | Anna Palandra COPYWRITER | Andrea Tinti CLIENT | Consorzio Produttori Indipendenti TOOLS | QuarkXPress, Adobe Photoshop PAPER | Serenissima PRINTING PROCESS | Lithography

The purpose of this brochure was to present the biography of the Italian rock band C.S.I. and their new album, *Skimming*, through a sepia-colored 1950s-style photo album design.

DESIGN FIRM | Vaughn Wedeen Creative ART DIRECTOR/DESIGNER | Steve Weeden PHOTOGRAPHER | Julie Dean COPYWRITER | Client CLIENT | Balboa Travel TOOLS | QuarkXPress, Adobe Photoshop, Macromedia FreeHand

D TC EY CAN

È 11 1 87 ì 1 T. Ì)] 1

T 7 7 FURIFICIA 1

Ì]

1

DESIGN FIRM | Barbara Ferguson Design ALL DESIGN | Barbara Ferguson COPYWRITER | Stephanie Weaver CLIENT | Zoological Society of San Diego TOOLS | Adobe Illustrator PRINTING PROCESS | TWO-COlor process

This booklet in a series of three was developed by the Education Department to aid students and teachers in their exploration of the zoo and the animals.

Das Volkshochschulheim Inzigkolen ist eine ge, überkonfessionelle und überparteiliche Einrichtung der freien Erwachsenenbildung und wird getragen vom Verein "Volkshochschulheim Inzigkofen e.V." Finanziell und ideell unterstützt wird es vom Land Baden-Württemberg und einem Freundeskreis, der sich aus begeisterten berg und einem Freumansson son son hat. Kursteilnehmern und Dozenten gebildet hat.

HORIZONTE ERWEITERN

Die ruhige Umgebung und die besondere Atmosp des Hauses bieten beste Voraussetzungen für konzen triertes Arbeiten, für Gespräche und Entspannung Unser Ziel ist es einerseits, Erwachsenen eine umfascende Allg meinbildung sowie die Fähigkeit zu selbständigem, kritischen und zukunftsorientierten Denken und Handeln in unserer Gesellschaft zu vermitteln, andererseits die individuellen Begabungen des Einzelnen zu fördern und so die positive Entfaltung seiner Persönlichkeit zu unterstützen.

WISSBEGIERDE BEFRIEDIGEN

IN SICH GEHEN - AUS SICH HERAUS GEHEN

Sie wohnen bei uns in den ehemaligen Nonner die jetzt als 32 Einzelzimmer, sieben Doppel- und zwei Familienzimmer eingerichtet sind.

UNTERKUNFT & VERPFLEGUNG

Alle Zimmer sind konsequent einfach eingerichtet, ver-lügen über fließend Warmwasser und wirken ganz **AKTIVER URLAUB** besonders durch ihre Butzenscheiben und individuell gestalteten Stuck- oder Holzkassettendecken, Außerdem stehen zehn komfortable Einzelduschen zur Verfügung Unsere Küche versorgt Sie mit vier Mahlzeiten pro Tag, immer frisch und mit Liebe zubereitet. Sie haben die Wahl zwischen bürgerlicher Normal- und vegetarischer

Kost. Alle Kurse können aber auch ohne Übernachtung und Verpflegung gebucht werden.

HISTORISCHES AMBIENTE

von Blü

pflanzen, Bär Moosen, Flechten, Pilzen, Vögeln, Insekten, Plankton

Versteinerungen und Gesteinen, sowie erkunden von

Musik hören, erleben und verstehen. Musizieren in klei-

nen Ensembels und großen Orchestern. Gesangs- und tentalunterricht von Klassik bis Jazz.

Landschaften und ökologischen Zusammenhängen.

NATER

MUSIK

	Umweltschutz, Rhetorik, Erziehung, Politik, Soziales
HANDWERK	and the second s
	Buchbinden, Krippenbau, Klöppeln, Spinnen u. Weben
LITERATUR & SCHREIBEN	
	Literatur verschiedenster Epochen und Gattungen.
	Gedichte, Kurzgeschichten, Erzählungen, Märchen oder
	Autobiographisches selber schreiben.
Shree Holluphic	.
	the A
	the production of

DESIGN FIRM | revolUZion

ALL DESIGN/PHOTOGRAPHER/COPYWRITER | Bernd Luz CLIENT | Volkshochschulheim Inzigkofen TOOLS | QuarkXPress, Adobe Photoshop PRINTING PROCESS | Four-color offset

In a small folder format, the brochure supports seminars for knowledge and creativity that are held in an old convent.

KREATIVITÄT Volkshockschulheim Ś ISSEN M FUR 351 KU

DESIGN FIRM | Charney Design ART DIRECTOR/DESIGNER | Carol Inez Charney PHOTOGRAPHER | Thomas Burke CLIENT | Integrated Composites TOOLS | QuarkXPress, Adobe Illustrator and Photoshop PAPER | Vintage Velvet PRINTING PROCESS | Four-color process offset

Intrigued by the unusual way the carbon fibers caught the light, Charney used photography to convey sophistication and to capture the fibers' unique visual qualities. The final piece could not be converted into a folder, so firm and client settled for a flap in the back to hold cut-to-fit sales sheets.

he Practical Application of Innovation

Service Brochures 133

DESIGNER | Mollie Kellogg Cirino ILLUSTRATORS | Mollie Cirino, watercolor; Michael Dawson, Photoshop PHOTOGRAPHER | John Gussman, still lifes COPYWRITER | Douglas Learman CLIENT | Trammell Crow Residential: Thorncroft Farms TOOLS | Macromedia FreeHand, Adobe Photoshop PAPER | Strathmore 80 lb. Americana cover; Vellum Gilclear flysheet; 100 lb. Book Lustro text PRINTING PROCESS | 4/4 plus metallic foil cover; 1/0 metallic PMS flysheet; 4/4 plus dull varnish pages

Price Learman's directions were to create a present to unwrap or a field diary. The designer's personal goal was to create a work that evoked the emotional responses of peace and harmony. She hand bound the brochure with a willow twig and copper wire to give it special appeal.

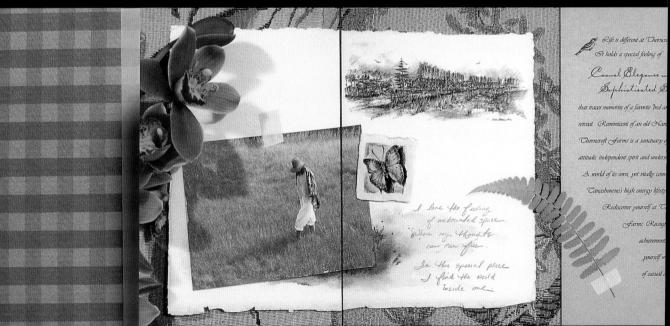

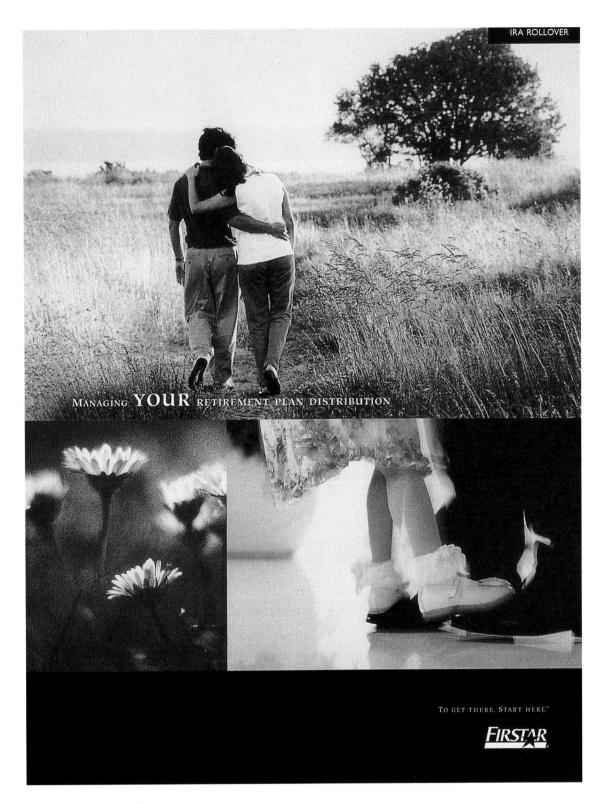

DESIGN FIRM | Tim Noonan Design DESIGNER | Tim Noonan COPYWRITER | Victoria Morrison CLIENT | Firstar Corporation TOOLS | QuarkXPress, Adobe Photoshop PAPER | Beckett Uncoated PRINTING PROCESS | Four-color process with spot color

The point of this brochure is to explain rollover options to clients of Firstar Corporation with IRA accounts. The design needed to tie in to the Firstar brand look.

DESIGN FIRM | Insight Design Communications ART DIRECTORS | Tracy and Sherrie Holdeman DESIGNER | Chris Parks CLIENT | Comcare TOOLS | Macromedia FreeHand, Adobe Photoshop

BROC

30

 \sim

SN

Mental-health professionals use art therapy as one of their tools in treating patients. This annual report incorporates actual art therapy illustrations and the treatment goals these illustrations represent to exemplify the services of the individual departments.

DESIGN FIRM | Morgan Design Studio, Inc. ART DIRECTOR | Michael Morgan DESIGNER | Kevin Fitzgerald PHOTOGRAPHER | Kara Brennan CLIENT | Atlanta Community Food Bank TOOLS | QuarkXPress PAPER | Coated on two sides PRINTING PROCESS | Four-color process

The client wanted a marketing campaign that would inspire families and people of all ages to join the Hunger Walk. The design team used four different photos to promote the event and to entice viewers to look, read, and participate.

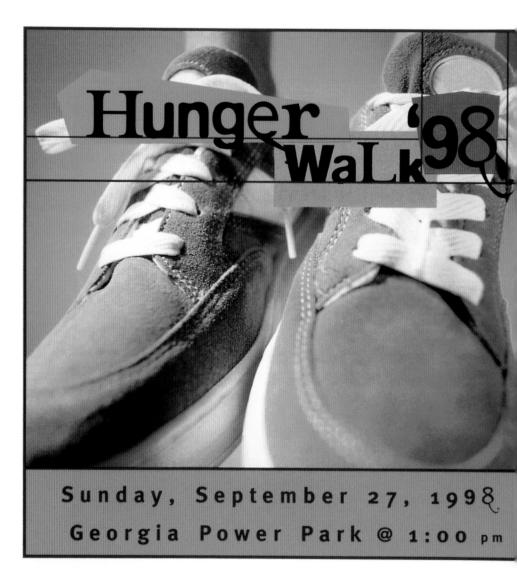

THE ENTERTAINMENT INDUSTRY

EXPANDS

1998 ELECTRONIC ARTS ANNUAL REPORT

DESIGN FIRM | The Leonhardt Group DESIGNERS | Ray Ueno, Jon Cannell PHOTOGRAPHERS | Jim Linna Photography, Jonathan Daniel—1994 World Cup Crowd CLIENT | Electronic Arts

Firmly in the driver's seat of interactive entertainment, Electronic Arts continues to expand and redefine its own industry. EA is now the world's top-selling publisher of interactive entertainment software. The Leonhart Group felt "expansion was a natural theme for EA in 1998."

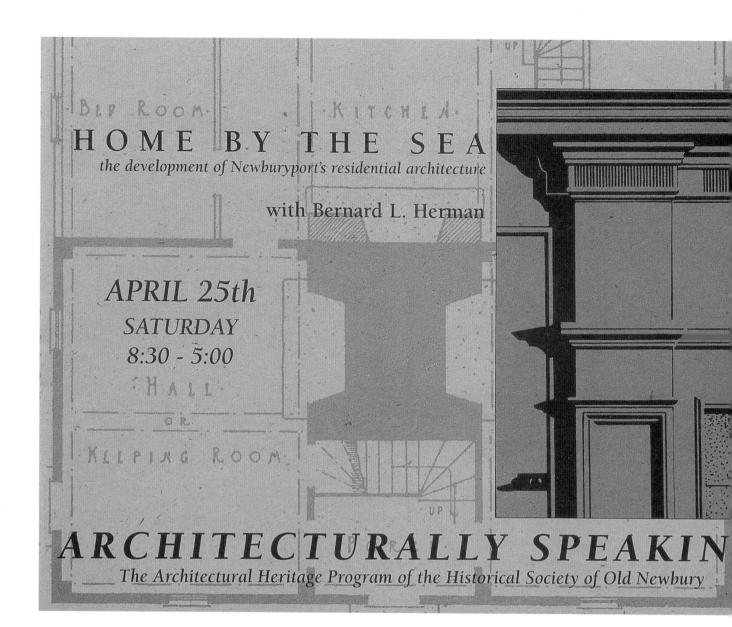

DESIGN FIRM | Johnson Graphics ART DIRECTOR/DESIGNER | Irene Johnson ILLUSTRATOR | Richard W. Johnson COPYWRITER | Adair Rowland CLIENT | Historical Society of Old Newb TOOLS | QuarkXPress, Adobe Photoshop PAPER | Desert Storm PRINTING PROCESS | One-color, black with

Johnson Graphics created a single-use, self-mailer advertising a seminar on hi The period architectural element place old floor plan on Kraft paper imparts the feeling the client desired. "Now that we have this expertise, staff and training, how do we meet new clients?"

DESIGN FIRM | Michael Courtney Design ART DIRECTOR/DESIGNER | Michael Courtney PHOTOGRAPHER | Stock COPYWRITERS | Susan Ruby, SMDS team CLIENT | Society for Marketing Professionals, Seattle chapter TOOLS | Macromedia FreeHand, Adobe Photoshop PRINTING PROCESS | Duotone

The objective was to design a distinctive announcement to draw a design literate group (marketing directors) to a professional seminar. The solution was to create an oversized piece with distinctive colors, stock photography, and a tickler reminder card.

Crafts National 30 Juried Exhibition Call For Entries 1996 (ENTRAL PENNSYLVANIA FESTIVAL THE RT (

DESIGN FIRM | Sommese Design ART DIRECTOR/ILLUSTRATOR | Lanny Sommese DESIGNER | Marina Garza COPYWRITER | Phil Walz CLIENT | Central Pennsylvania Festival of the Arts TOOLS | QuarkXPress PAPER | Cross Point Genesis PRINTING PROCESS | Offset lithography

The brochures needed to be individualized while retaining a consistent look that was harmonious with the graphics of the arts festival.

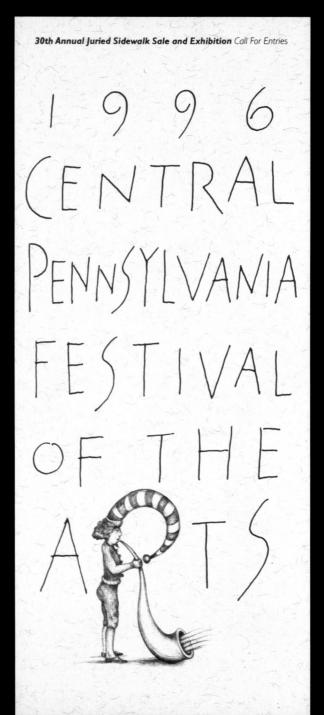

DESIGN FIRM | JOSEPH Rattan Design ART DIRECTOR | JOE Rattan DESIGNERS | JOE Rattan, Brandon Murphy ILLUSTRATOR | Michael Crampton CLIENT | Dallas Children's Theatre PAPER | Starwhite PRINTING PROCESS | Offset

This is a vehicle for the marketing communications firm to announce its name change and to provide its clients with a taste of its marketing and branding philosophies, in a format that commands attention.

A Record of Success

When it moved to Indiarupolis in 1917, Marian was a sometry college of 102 ordenes. It's enrollment has goints to your 1202 young nern and someta annually on its 14-acce campus in the heart of Indiarupolis, has experimed a remissione in neural years, so has diminin. It is many accomplishment stretch for its year has leep pase with that of Indiarupolis and yearent linking and how it has worke of Marian to beyer defined as the stretch of the Marian to beyer defined as the level as the Marian to beyer defined as the level as the Marian to be softwaren as the stret it is for Indiarupolis and the surrounding article level as the transformed size.

surrounding area. Banic accellence: The excellence of Martan Beeg reorgams, students, Ecoluty, and alumni how necessareal by the National Science Foundation. Fultheight Scholarship program, the American Colleges of Eacher Elicaciton, the American Association Calleges of Eacher Elicaciton, and other presi-ous constraintions. In Eccent North Central association Accorditation report discribed or an chocacitoral backet." Martan has also been feed in Mong magginen and U.S. Nens and Wind for for its calcacitored worth.

of the mind is strong. Relation access: Casched by staff who care about the whole proton. Marina nees atthétics as an extension of the classroom. Such an approach creates success. In addition to fielding highly competitive teams in filteren varing years. Marina was the Nortise and Collegates Erack Cycling Champsonhip in 1935-adecimage much larger, rankolskil, havan reads such as a claimena. Berkeley

Community outwork Insuvative on-campus and off-campus programs in service learning and metatoring now augment the clearoson experience in powerful, instructive ways by involving students in reaching our and becoming mentors to their campus peers and to youngsters in nearby communities.

embraced by our undergraduates. They are to harness the transforming power of educa human and social benefit, both in the India area and across national borders.

area and across national bolter. Promotion of public and arrive: A vietnat, ecumentical campus ministry vedcomes people of all tables. It is complemented by an active collaboratio bereven Maran and the Catoluk community in indiance of the tract tends to all the doceses of Industra. Marania commitment to acrose is further manifered in usy genoreding of the Catoluk. Driving Institute and purturbance and the control of programs and provide and potential formation programs.

Atrian has traditionally domain or program. Atrian has traditionally done much with little ato continue to prospec, critically important merovements in facilities and programs must be and now. The time has come for the commun or apport Marian College in its efforts to adam-a addiny to recenit, apport, and obtains stude-tion to effectively as possible while moments.

DESIGN FIRM | Held Diedrich, Inc. ART DIRECTOR | Dick Held DESIGNER | Megan Snow PHOTOGRAPHER | Larry Ladig COPYWRITER | Marian College CLIENT | Marian College TOOLS | QuarkXPress PAPER | Potlatch Vintage Velvet 80 lb. cover PRINTING PROCESS | Offset

DESIGN FIRM | Mires Design ART DIRECTORS | Scott Mires, Neill Archer Roan, Laura Connors DESIGNER | Miquel Perez ILLUSTRATORS | Jody Hewgill, Mark Ulriksen COPYWRITER | Neill Archer Roan CLIENT | Arena Stage TOOLS | QuarkXPress, Adobe Illustrator PAPER | 80 lb. Cougar Opaque PRINTING PROCESS | Web printing

It is a challenge to capture a whole season's worth plays in one piece and convince people to sign on t dotted line. The designer's solution was to highlight show with its own spread and personal reflections Arena's artistic director. Since this book's publicati Arena Stage's income has exceeded previous sales

We launch the 1998-99 season with a great American classic. I love this play; I am excited by the blood and the thunder and the sheer life vibrating through it. At its center is an unforgettable scene between Brick and Big Daddy. It is a scene about lies and mendacity; a theme that is always timely In Washington and which seems especially resonant the story of life triumphing over death, disappointment, betrayal and the past. This is my first production at Arena and Arena's first production of this play m.d.s

American dramas of all time. With it, the celebrated author of A Streetcar Named Desire immortalized his vividly drawn characters of Big Daddy, Big Mamma and Maggie the Cat. In the summer heat of a Mississippi cotton plantation, Big Daddy's family gathers to celebrate his 65th birthday. Passions rise with the temperature, as painful secrets are revealed, dreams are denied, and everyone tries, like today. At its heart, it tells "a cat on a hot tin roof," to hold on as long as they can.

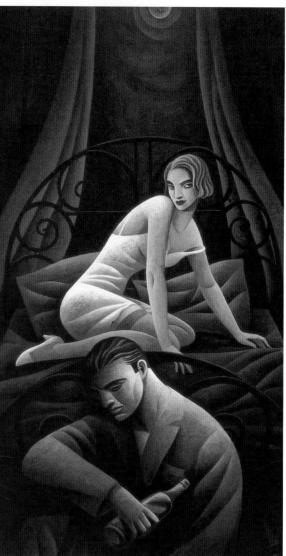

DESIGN FIRM | Lee Reedy Creative, Inc. ART DIRECTOR | Lee Reedy DESIGNERS | G. Patrick Gill, Heather Haworth ILLUSTRATORS | Bob, Rob and Christian Clayton COPYWRITER | Jamie Reedy CLIENT | The Art Directors' Club of Denver TOOLS | Adobe Photoshop, QuarkXPress PRINTING PROCESS | Six-color, stochastic, embossing, metallic inks

The design team's concept was to do a contemporary slant on the swing era. The firm has great creative talent to achieve the illustrations, and the copywriting captures the swing concept perfectly.

We have a responsibility to build the strongest nonprofit and philanthropic sector possible, through leadership with vision, management with accountability, and strategic planning with research. Sons Mindeer, Straten, INGPERDING SECTOR Mission

INDEPENDENT SECTOR is a national leadership forum, working to encourage philanthropy, volunteering, notfor-profit initiative, and citizen action that help us better serve people and communities.

INDEPENDENT SECTO 1996 Annual Repc

> DESIGN FIRM | Fernández Design Art director/designer | Tracy Ferná Photographer | Stock Copywriter | Elizabeth Rose Client | Independent Sector Tools | QuarkXPress PAPER | Mead Moistrite Matte, Gill Printing Process | Three-color offs

> This annual report was designed a ten business days on a minimal bu

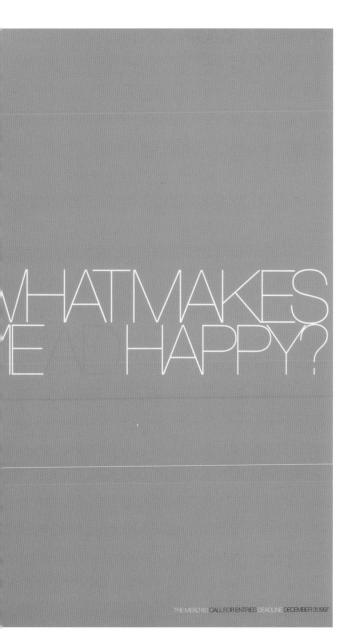

DESIGN FIRM | Pinkhaus Design ART DIRECTOR | Joel Fuller DESIGNER | Todd Houser PHOTOGRAPHER | Gallen Mei COPYWRITER | Frank Cunningham CLIENT | Mead 60: Call for Entries TOOLS | Adobe Illustrator and Photoshop PAPER | Signature Dull Mead 100 lb. cover PRINTING PROCESS | Four Color Process

This brochure was meant to stand out from the myriad entry forms that arrive on most designers' desks each week and to impress upon designers the prestige of winning Mead's award medal.

DESIGN FIRM | Muller and Co All design | Jeff Miller Illustrators | Jack Harris, Emory Au Photographer/copywriter | Alvin Ailey Client | Alvin Ailey Tools | Adobe Photoshop, QuarkXPress Paper | Strobe Printing process | Two-color offset

The biggest thrill for Muller and Co. was receiving their own brochures in the mail with all of the scratches, smears, and grime that come from mailing anything. This assignment made the design team feel as though they were participating in the world of dance rather than designing in a vacuum.

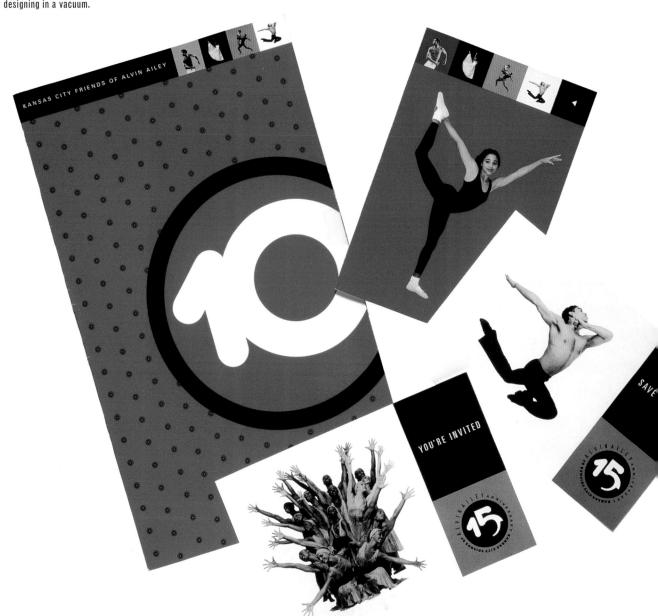

the quiet in the land

DAY LIFE, CONTEMPORARY ART and THE SHAKERS

Institute of Contemporary Art @ Maine College of Art IĈA

August 9 - September 21, 1997

Opening Reception, Saturday, August 9, 10am - 12pm

the shaker community at sabbathday lake: Sisters Frances A. Carr, Marie Burgess, June Carpenter, Minnie Greene and Brothers Arnold Hadd, Wayne Smith, and Alistair Bate

and artists:

Janine Antoni, Domenico de Clario, Adam Fuss, Mona Hatoum, Sam Samore, Jana Sterbak, Kazumi Tanaka, Wolfgang Tillmans, Nari Ward, and Chen Zhen.

conceived and organized by France Morin

exhibition at the ICA organized with Jennifer R. Gross and the Maine College of Art DESIGN FIRM | Sagmeister Inc. ART DIRECTOR | Stefan Sagmeister DESIGNERS | Stefan Sagmeister, Veronica Oh, Hjalti Karlsson PHOTOGRAPHERS | Adam Fuss, Wolfgang Tillmans, et al. COPYWRITER/CLIENT | France Morin TOOLS | QuarkXPress, Adobe Illustrator and Photoshop PAPER | 100 lb. matte coated PRINTING PROCESS | Offset

This brochure for an art project featured contemporary artists working at a Shaker Community.

DESIGN FIRM | Clarke Communication Design ART DIRECTOR/DESIGNER | John V. Clarke PHOTOGRAPHERS | John V. Clarke, students COPYWRITER | William Harris CLIENT | University of Illinois at Urbana—Champaign for the School of Art and Design TOOLS | QuarkXPress, Adobe Photoshop PRINTING PROCESS | Offset lithography

Entitled Positions Available, this was the first catalog done for an exhibition of graduate students' artwork. The budget was limited, so all photography was provided by the artists themselves. John Clarke shot additional black-and-white photos at a local exhibition of the students' work, to add visual impact to the catalog.

DESIGN FIRM | Illinois Wesleyan University ART DIRECTOR/DESIGNER | Sherilyn McElroy PHOTOGRAPHER | Kevin Strandberg CLIENT | Merwin School of Art, Wakeley Galleries TOOLS | QuarkXPress PRINTING PROCESS | Offset

The design goal was to create a brochure that could be used both as a gallery announcement and as a recruiting enticement for prospective students (the top vellum page can be removed for recruiting). McElroy's intent in the design was to unify disparate artistic techniques: differing styles, media, and sizes.

DESIGN FIRM | Bentley College, Communication and Publications ART DIRECTOR | Amy Coates COPYWRITER | Jennifer Spira CLIENT | Bentley College, Student Activities TOOLS | QuarkXPress, Adobe Photoshop PAPER | Zanders Mega Gloss 80 lb. text PRINTING PROCESS | Digital

To meet the client's deadline without sacrificing quality, the designer used digital printing, an inexpensive print method that delivers a four-color finished product in as little as four days.

cinéma danse musique documentaires émotions

DESIGN FIRM | Sonia Poirier ART DIRECTOR/DESIGNER | Sonia Poirier PHOTOGRAPHER | Georges Dufaux COPYWRITER | Suzie Koberge CLIENT | Tele-Quebec TOOLS | QuarkXPress, Adobe Photoshop PAPER | Rolland Supreme Dull PRINTING PROCESS | Two-color offset

This brochure promotes the two-month series of artistic programs translated as cultural weekends.

started with en The Joffrey niered *The Heart of* With that work unched its com program which program to he Silver y, has resulted in f dance, music 'theater.

r of The Heart o r of *The Heart of* was James Kudelka ist making the from his own dancer to that of a oher. The Heart of was a haunting werful emotional out people who ther but are never nnect.

g that James nould figure so tly in Hancher's th season.

DESIGNER | Ron McClellen Judith Hurtig ncher Auditorium be PageMaker and Photoshop, Macintosh ck Simpson Sundance Felt CESS | Offset

budget brochure was sent to dance patrons buyers to inform them on the connections e choreographer, the director, the company, esentations of dance at Hanch

> DESIGN FIRM | River City Studio ALL DESIGN | Jennifer Elliott COPYWRITER | Dennis Pruitt **CLIENT | Rick's Place** TOOLS | QuarkXPress, Adobe Illustrator and Photoshop PAPER | Starbrite, Opaque 80 lb. cover PRINTING PROCESS | Five PMS lithography

Rick's Place invitation booklet presented a two-fold problem; how to educate recipients about the foundation and convince them to attend a fundraiser. The designer's single solution was to make this invitation as exciting as the feel-good party of the summer!

on September 26.

Eight years later James Kudelka created *Cruel World* for American Ballet Theatre. There is no doubt that he has matured as a choreographer, but as he describes himself, he remains "the conscientious observer." still creating dances that are meditations on the classic themes of love, sex and death.

Eighteen dancers move in various forma-Eighteen dancers move in various forma-tions—solos, trios, large ensembles and pas-de deux. The emotional coloring is just as-varied as the dance formations. To a pas-stonate score by Tchaikovsky Souvenir of Florence), the dancers express joy and misery, desire and repulsion. There is sexual tension and partnerships are always uncasy. Emotions are telegraphed through movement that is almost dizzying in the variety of speeds, steps and images. variety of speeds, steps and images

Writing about Cruel World, The Toronto Globe and Mail critic concluded, "Kudelka's exploration of human relationships, in this and other ballets, is strikingly original. Traditionally, ballet is about balance. But in the hands of Camada's undisputed genius of the genre, ballet is given a whole new meaning. And that bodes well for the future of the art."

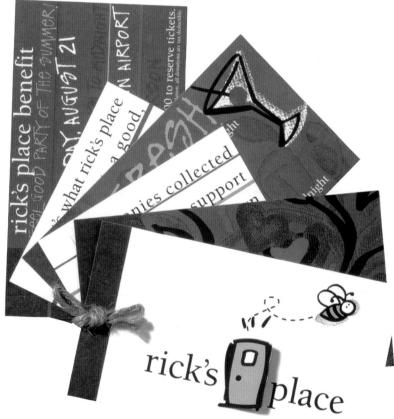

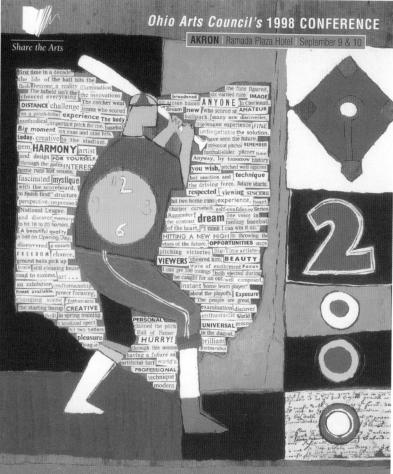

BATTING 2 Facing the Fastball of Change

REGISTRATION

OHIO ARTS COUNCIL BOARD MEETING

agenda Wednesday, September 9

WHAT'S YOUR PITCH?

DESIGN FIRM | Base Art Company

ILLUSTRATOR | Kirk Richard Smith

COPYWRITER | Charles Fenton, Editor CLIENT | Ohio Arts Council

TOOLS | QuarkXPress, Adobe Photoshop,

Macromedia FreeHand

according to their day of appearance.

PRINTING PROCESS | Four-color process plus two PMS

Themed Batting 2000: Facing the Fastball of Change, the

brochure/return registration form draws inspiration from

the obvious. Textural qualities of the cover illustration

backgrounds. Event speakers were displayed in line-ups

were retained throughout the piece in headers and

PAPER | Mohawk Navajo

ART DIRECTOR/DESIGNER | Terry Alan Rohrbach

BREAK 2:45-3 p.

BATTER UP!

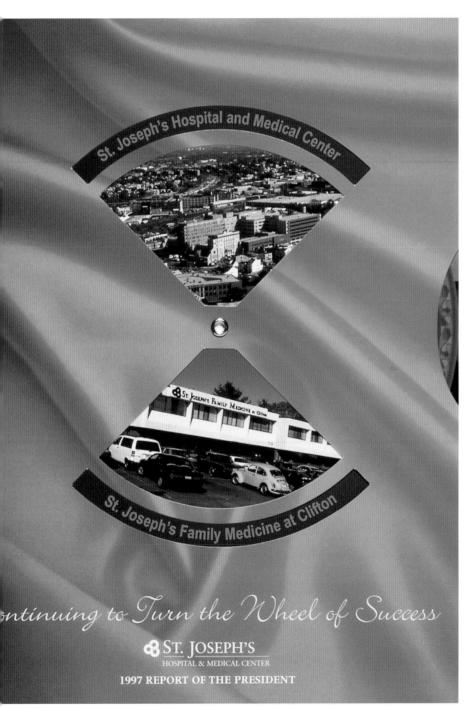

DESIGN FIRM | St. Joseph's Hospital ALL DESIGN | Ken Morris, Jr. PHOTOGRAPHER | Rich Green COPYWRITER | Sister Jane Frances CLIENT | St. Joseph's Hospital and Medical Center TOOLS | QuarkXPress, Adobe Illustrator and Photoshop PAPER | Warren Lustro Dull PRINTING PROCESS | Six-color process, spot and varnish

The cover design was inspired by the proportional scale artists use to resize artwork. The designer used this element to encourage viewers to interact with the design. Due to budget restraints, he was limited to four colors on the cover, but by enlarging the black-and-white photos to full pages and surrounding them with decorative color borders, he was able to add color to the inside pages.

Bettendorf Public Library

Information Center

DESIGN FIRM | Gackle Anderson Henningsen, In DESIGNER/ILLUSTRATOR | Wendy Anderson PHOTOGRAPHER | Mike Newell COPYWRITER | Greg Gackle CLIENT | Bettendorf Public Library TOOLS | QuarkXPress, Adobe Photoshop, Powell PAPER | Consolidated Productolith PRINTING PROCESS | Four-color process

This brochure was designed to be bold and ey like the newly renovated library it describes. faces accent the services provided, from the technology to the intimate café.

DESIGN FIRM | Hoffman & Angelic Design ART DIRECTOR/DESIGNER | Andrea Hoffman ILLUSTRATOR | Ivan Angelic HAND LETTERERS | Ivan Angelic, Michael and Suzanne Cohen CLIENT | Seattle Study Club TOOLS | Adobe Illustrator PAPER | Neenah Environment, UV Ultra II, Simpson Quest

PRINTING PROCESS | Offset and foil

The design team created an elegant manner with an approachable feel in this brochure by using bold zen-like brush illustrations, hand-lettered quotations, and the juxtaposition of textures against matte uncoated stock. Speckled UV fly sheets revealed bold illustrations beneath. The natural, serene color scheme of sand, sage, and terra-cotta, and the square and circle elements, balanced harmoniously and elegantly.

Arts Jazz Series: Club of Chicago presents our eighth annual Landmark Jazz Series: CCTECTICA	is with gran prote at we open this accon with planist die Omstann. This levong south- ter, Oristian has pritter best of marany, recording that par grans Stan et Diese Young, deman Hawkins, def Die that weit weither Hawkins, def Die that weit weither Hawkins, def Die that weit weither Hawkins, souther Hawkins, s	Karl Montzka hongs his Flammond organ and his innorative quarter for an evening of smooth and swinging jaz. Montzka is emerging on the local scene as a glitted hand leader, organist, arranger and compare, exploring everything from street beat groover to bright swing loining Montzka in the quarter are his brother Eric on draws, spitanst John McLann and Ryan Schutz on hass transper.	This acoustic jazz quartet delivers what Lovd Sacks of the Chicago SurTimes calk*"hard-bopping deliphts and flowing medifations by a band that desarves to go piace." Leaders Bran Gephart to go piace." Leaders Bran Gephart Soxophoro, and Bob Long (piano) are pioned by Ken Haehach on thas and Mark Octo on thans. All of these artics have constanding reputations for their work both locality and nationality, and togsther they deliver an evening of extraordinary jazz.	briAn gePhart bOb long quarTet March 24, 1999	Recipient of the 1998 Back avard for pussanding acti- autory Norrs graces lands with the cutstanding vecal panno uterns. The former or legendry London House, N audRefy montal field the inAcuse of legendry London Long, N audRefy montal legendry autors and the inAcuse of legendry London Long, N autors and the inAcuse of legendry montal legendry autors and the result autors
--	--	---	--	---	---

DESIGN FIRM | WATCH! Graphic Design DESIGNER | Carolyn Chester CLIENT | The Three Arts Club of Chicago TOOLS | Adobe Illustrator, QuarkXPress PAPER | Cougar PRINTING PROCESS | TWO PMS plus black

Landmark Jazz is a bimonthly series featuring live performances by Chicago's most distinguished jazz artists. The design is inspired by early jazz albums. WITH MUSIC, GREATNESS SEEMS LIKE IT'S RIGHT AROUND THE CORNER." Freedom Middle School

N D NUAL DONATION ation for a solic aluable life exp

NT FUND

15

MUS

D Quan

DESIGN FIRM | 1049 Design

K YOU FOR YOUR GENEROUS COMMITMENT TO WISCONSIN YOUTHI ART DIRECTOR | Rachel Lom, Wisconsin Foundation for School Music (WFSM)

DESIGNERS/ILLUSTRATORS | Mary Kay Warner, 1049 Design PHOTOGRAPHERS | Rick Trummer, Don Christensen COPYWRITERS | Rachel Lom, Linda Peterson, WFSM

- **CLIENT** | Wisconsin Foundation for School Music
- TOOLS | QuarkXPress, Adobe Illustrator
- PAPER | 80 lb. Productolith Gloss cover; 100 lb. Productolith Gloss text

To achieve a creative, rich design on a two-color budget, textures, duotones, and many different screens were used. Photos and quotes from kids provided a personal connection to their music.

WFSM DONOR PLEDGE FORM

DESIGN FIRM | Sayles Graphic Design ALL DESIGN | John Sayles COPYWRITER | Kristin Lennert CLIENT | National Society of Fund Raising Executives PAPER | Astro Brite Goldenrod PRINTING PROCESS | Offset

Professional fundraisers group wanted an attention-getting campaign package for its 1998 regional gathering. When the initial design (themed: Raising Dough: Recipes for Success) was presented at the 1997 annual meeting, each attendee received a bakery bread bag printed with the theme and filled with a fresh loaf of bread. The later mailing included a wooden spoon tied inside the box and an informational brochure.

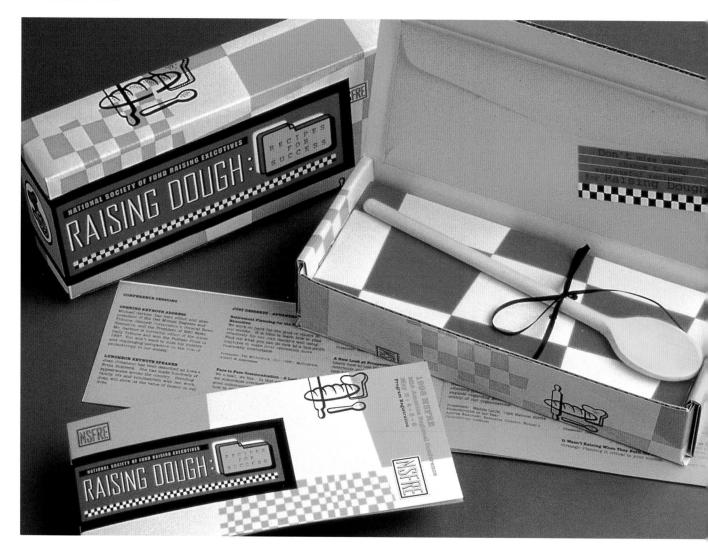

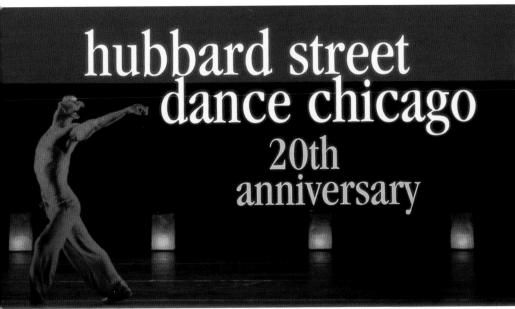

APRIL 14 THROUGH MAY 3, 1998 auditorium theatre

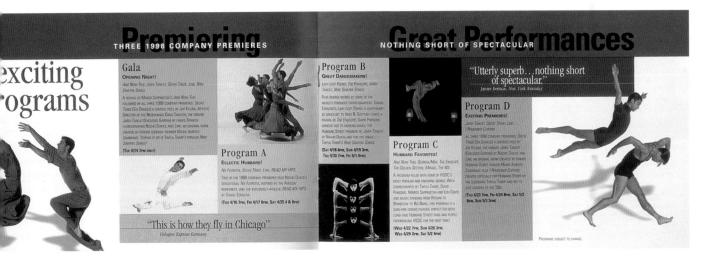

Fernández Design ESIGNER | Tracy Fernández | Lois Greenfield, Gert Krautbauer Michael Pauren ard Street Dance Chicago XPress a I ss | Four-color offset

was designed and produced within e design goal was to create an interesting ece that is easy to follow DESIGN FIRM | Solar Design ART DIRECTOR | Jennifer Schmidt DESIGNERS | Jennifer Schmidt, Susan Russellu COPYWRITER | Bill Watson CLIENT | Maryville City of Youth TOOLS | QuarkXPress, Adobe Photoshop PAPER | Neenah Classic Crest 80 Ib. cover PRINTING PROCESS | Four-color offset

This brochure promotes the Chicagoland Sports Hall of Fame facility.

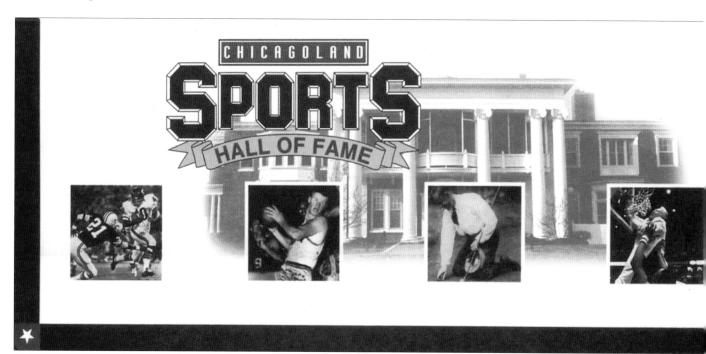

Twentieth Anniversary Album

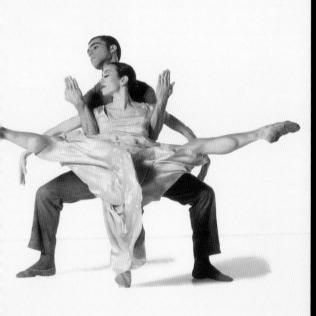

HUBBARD STREET DANCE CHICAGO

DESIGN FIRM | Fernández Design ART DIRECTOR/DESIGNER | Tracy Fernández PHOTOGRAPHERS | Lois Greenfield, Reudi Hoffman COPYWRITER | Michael Pauken CLIENT | Hubbard Street Dance Chicago TOOLS | QuarkXPress PAPER | Mead Signature Gloss 100 lb. text and cover PRINTING PROCESS | Four-color plus one PMS plus aqueous coat

The objective was to have an attractive piece that would celebrate the 20th anniversary season of the company and that could also be sold as a souvenir at performances. Photos were taken with a telephoto lens at performances. The production time was two weeks, and the budget was minimal.

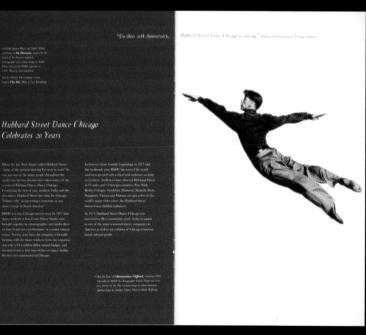

DESIGN FIRM | GAF Advertising/Design ALL DESIGN | Gregg A. Floyd PHOTOGRAPHER | David Obar COPYWRITERS | Gregg A. Floyd, Linda Bryza CLIENT | Ft. Worth Housing Authority: Amaka Childcare Center TOOLS | QuarkXPress, Adobe Illustrator and Photoshop PAPER | Confetti, cover; Productolith, text PRINTING PROCESS | 1/1 spot, cover; 4/4 process, text

A revitalization program was created to build a day-care center in a low-income development. The logo concept and brochure had to reflect the name of the center and the theme of investing in the future.

CHILD CARE CENTER

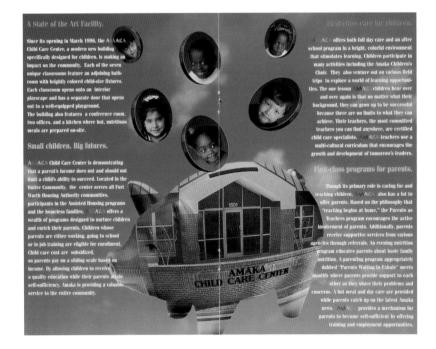

WILIJAH WILL BE WANTED, TOO.

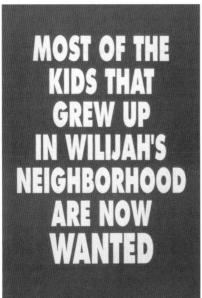

DESIGN FIRM | GAF Advertising/Design ART DIRECTOR/DESIGNER | Gregg A. Floyd PHOTOGRAPHER | Ken Brock COPYWRITER | Gregg A. Floyd CLIENT | St. Philip's School and Community Center TOOLS | QuarkXPress, Adobe Illustrator and Photoshop PAPER | Genesis PRINTING PROCESS | 2/2 spot color

This brochure was created to generate underwriting for low-income students' tuition. The design succeeded by increasing awareness and participation in the program. DESIGN FIRM | GAF Advertising/Design ART DIRECTOR/DESIGNER | Gregg A. Floyd ILLUSTRATORS | *The Wall Street Journal* Art Department, Gregg A. Floyd PHOTOGRAPHERS | Jess Hornbuckle, David Obar, Linda Bryza, Alice Sykes, Kelly Buizch COPYWRITER | Gregg A. Floyd CLIENT | Dallas Housing Authority TOOLS | QXD, Adobe Illustrator and Photoshop PAPER | Environmental PRINTING PROCESS | 1/1 spot color

This biennial report's theme reflects the mission of using education and DHA programs as the equation to move low-income people towards self-sufficiency. The design incorporates a community newspaper style to describe program and individual successes.

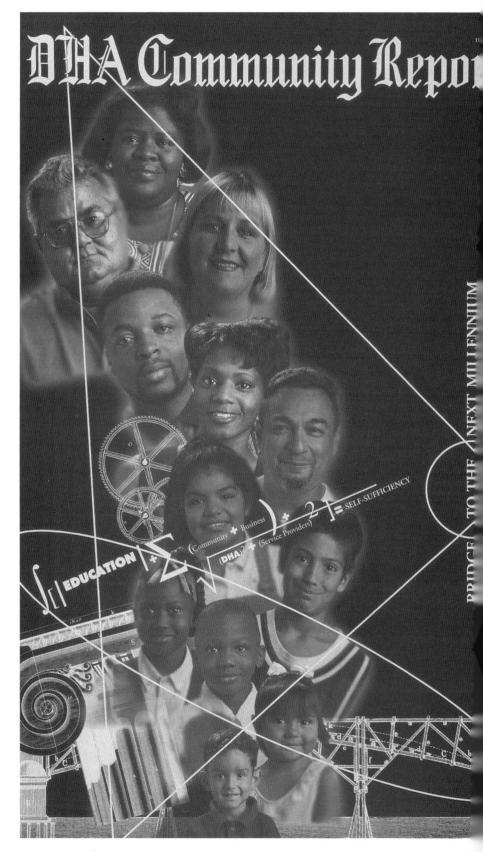

DESIGN FIRM | Sayles Graphic Design ALL DESIGN | John Sayles COPYWRITER | Jack Carey CLIENT | Des Moines Parks and Recreation Department PAPER | Crown Vintage Antique White PRINTING PROCESS | Offset

A series of activities meant a versatile invitation was needed, since not all guests would attend each event. Sayles' solution was an elegant collection of cards, each printed with the time and location for individual events. Copper and black ink are used on cream paper; the hand-tied ribbon references the ribbon cutting and adds an unexpected touch. The trimmed cards fit into a black #10 envelope that can be mailed with one postage stamp. To commemorate the event, each invitation included an oversized Lucite lapel pin printed in metallic copper and silver inks.

public

A sense of community. Of what has come before. Of what is. Of what can be.

This is public art.

DESIGN FIRM | Greteman Group ART DIRECTOR | Sonia Greteman DESIGNER | Craig Tomson COPYWRITER | Deanna Harms CLIENT | Public Art Advisory Board PAPER | Warren Lustro Dull Cream PRINTING PROCESS | Four-color process

This brochure serves to educate a broad audie government leaders, potential donors, artists, and the general public. It educates aptly throu photography, art elements, and engaging copy.

The Master of Fine Arts in Graphic Design is a two to three-year program which provides students with an opportunity to pursue in-depth investigation in specific areas of visual communication. The program's primary goal is to strengthen practical, conceptual, and theoretical knowledge as it applies to the design process and its product-communication of a message. The focus is not only on the development of design solutions. but on how and why design problems are addressed. In light of emerging technologies and the shift to digital communication, students are encouraged to critically examine current practices while exploring the relevance of traditional design approaches. By encouraging students to intelligently look forward while expanding their knowledge of current communication, the program provides a forum in which to interpret the role designers play in the unfolding and shaping of information.

The program is intended neither as a replacement for an undergraduate design education, nor as merely an extension of the undergraduate experience. Rather it is a highly individualized course of study which allows students to further their own personal design career goals. Therefore, professional design experience, maturity, and inquisitiveness often serve as catalysts to motivate the most successful candidates.

The Glaph Delign Hogsen provide 4 biolosis todo with individual and submitted with individual and submitted with the submitted with the submitted with the Delign registers the submitted with a submitted with the submitted with

the Link Gallery, a large exhibition area and public lounge with entry into the University's Krannert Art Museum and Graduate students have 24 hour access to the School's Center for students in the theory and practical Graphic Technologies (CGT), a state of the art computer facility, operated by a professional technology staff and supervised by a team of graduate tion process. Courses and independ study experiences concentrate on the role of typography and image making its assistants. The Center consists of five personal research and focused invest gations of individually selected design topics culminating in a final graduate publication, imaging, and multimedia software, black and white and color project. Students work closely with laser printers. Slatbed and slide scanthe graduate adviser and other faculty ners, zin drives, and sonhisticated video project advisers. Progress toward the MA degree is subject to periodic review by the faculty. In the final year of study. mores with a wide range of accompagroup MFA exhibition at Krannert Art annual exhibition with graduating eniors at I Space. In addition, a docu-

Although digital technology is the workhorse of contemporary design and production, a more traditional letterpress (aboratory also awaits interested graduate students

and a public preventation during their final sevenities are required for the MIA degree During their second year, gradua are students have the opportunity to neach bragenoing design courses in the undergraduate Graphic Design Program.

approved by the student's committee

23 GRAPHIC DESIGN

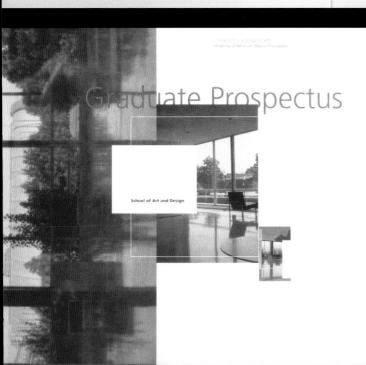

Pros

New Views of Depression for Older Adults

How to Recognize Depression, Get Help, and Be Well Again

It is estimated that 15% of adults over age 65 may suffer from depression.

Program Coordinator's Guide

ENLIGHTEN A New Light on Depression in Older Adults

How to Talk to Your Doctor About Depression...

and Be Well Again

ENLICHTEN Area tatic on Depression in Other Adult

DESIGN FIRM | Malik Design ART DIRECTOR/DESIGNER | Donna Malik ILLUSTRATOR | Jeff Cornell COPYWRITER | Polly Edelson CLIENT | Eden Communications: Pfizer, Inc. TOOLS | QuarkXPress PAPER | Plainwell

ENLIGHTEN

This brochure series was developed to educate senior citizens that depression is a medical condition, not just a part of aging. Text size was a key design issue: it had to be large enough for older people to read easily.

DESIGN FIRM | Punto e Virgola S.A.S ART DIRECTOR/DESIGNER | Anna Palandra COPYWRITER | Andrea Tinti CLIENT | Polygram Italia TOOLS | QuarkXPress, Adobe Photoshop, Macromedia FreeHand PAPER | Recycled paper PRINTING PROCESS | Offset

This brochure was ordered by Polygram Italia to present their artists in a thirty-two-page promotional magazine. The client wanted a design with modern, legible graphics.

Estate Polydor

polydo

Institutional and Organizational Brochures 173

DESIGN FIRM | Punto e Virgola S.A.S. ART DIRECTOR | Anna Palandra COPYWRITER | Andrea Tinti CLIENT | Commune of Bologna: Zero in Condotia TOOLS | QuarkXPress, Adobe Photoshop PAPER | Newspaper Type PRINTING PROCESS | Daily newspaper processes

This brochure was ordered by the Commune of Bologna to promote the musical festival Scandellara Rock. The format and paper were chosen to create an aggressive marketing piece for young audiences. With a budget of 5,000,000 lire, the client needed a simple format and minimal color.

Teaching or Intelligence

The Fourth

A Gathering for the Millennium April 21–26, 1998 Marriott Marquis Hotel 45th and Broadway New York, NY

> DESIGN FIRM | B² Design ART DIRECTOR/DESIGNER | Carol Benthal-Bingley COPYWRITER | Linda Fuller CLIENT | International Renewal Institute TOOLS | Adobe PageMaker and Photoshop

This conference program was designed for an Educators Conference in New York City.

DESIGN FIRM | Greenzweig Design ART DIRECTOR/DESIGNER | Tim Greenzweig PHOTOGRAPHER | JASON JONES COPYWRITER | Mary Curran CLIENT | Stamats Communications, Inc. TOOLS | QuarkXPress, Adobe Photoshop PAPER | Mohawk 50/10 PRINTING PROCESS | Four-color process, offset

This is one in a series of informational broch reflects the effects of Lake Superior and its on the students at the University of Minnesot

"We place a heavy emphasis on real-world next, opportunities, so our undergraduates are better propared than much athers. Some have oppared sof 500 hours of experience in clinical and school settings." — H. Mitzi Deame, Deam, CENSP

CEHSP

De ofriends turn to you when school—or life—seems complicated? by our otten find yourself leading a team effort to helping others solve a problem, explore an issue, or reach a gal? You may be a natural for UMD's College of Education and Human Service Professions. At CEHSP, we're committed to developing well-prepared, **karnerand client-sensitive professionals** sho foces on meeting the needs of the people they serve. Whether your future arena is the classroom, the gam, a human service agents, or a corporate conference room, you'l find the preparation you need in the program we offer. We have a service agents, or a corporate conference room, you'l and find the preparation you need in the program we offer. We have a service addent, you'll combine broad-ranging classes in the liber all within the optication you are a of interest, whether it's early childhood, adult psychology, or anything in between. You'll ado receive rigroover training in the preactice of your chones profession and in the "people skills" that will chanace your effectiveness. In every department of the college, you'll gain a profound respect for cultural diversity, We're home to UMD's American Indian Learning Resource Center, and one of our Native American faculty members holds the nation's first endowed chair in American Indian education. Through seminars, conferences, and classroom experiences, the Anishimabe people in our community are helping everyone develop a better understanding of how cultural differences enrich he human family.

everyone develop a better understanding of now cultural utilizences entret the human family. In class and through volunteer service, practicums, and internships, you'll discover much more—**how to collaborate** with other professionals, **how to reflect upon** your goals and take charge of your own learning, **how to empower** yourself and others by taking action in the real world. By the time you graduate, you'll feel well equipped to start your career or to enroll in graduate or professional studies.

"I work at the Yi program, and I'v mentary schools It's really good pi teaching."

Worldstar Design esigner | Greg Guhl Greg Guhl

kXPress, Adobe Illustrator and Photoshop ss | Four-color offset

oncept supported the convention's slogan, s of Trust. Images of architects and with a bridge created a unique design. lors were selected for each brochure.

DESIGN FIRM | Insight Design Communications ART DIRECTORS | Tracy and Sherrie Holdeman DESIGNERS | Sherrie Holdeman, Chris Parks ILLUSTRATOR | Chris Parks PHOTOGRAPHER | Dimitris Skliris CLIENT | City Arts TOOLS | Macromedia FreeHand

Since this art event took place in a partially finished gallery, where actual construction was taking place, the brochure took on a functional construction theme. Aside from developing construction icons, the pages assemble into a functional blueprint layout of the building and gallery itself.

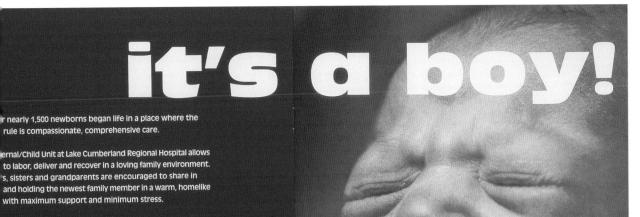

en some newborns require intensive care, our Special Care Is certified to handle all but the most critically ill babies.

A Report to the Community

DESIGN FIRM | Kirby Stephens Design ART DIRECTOR/DESIGNER | Kirby Stephens PHOTOGRAPHER | William Cox, stock COPYWRITER | Kirby Stephens CLIENT | Lake Cumberland Regional Hospital TOOLS | Macromedia FreeHand, Adobe Photoshop PAPER | Repap Matte PRINTING PROCESS | Five-color spot, offset

To help mend a local hospital's waning reputation, new management gave the designers specific areas to address in this direct, to-the-point, report to the community.

GHA wanted a commemorative book featuring twelve articles written by Dr. Underwood. Guhl designed a title page for each article that features the article name, a quote or quotes, a supporting photo, and the issue of the publication that had featured the article.

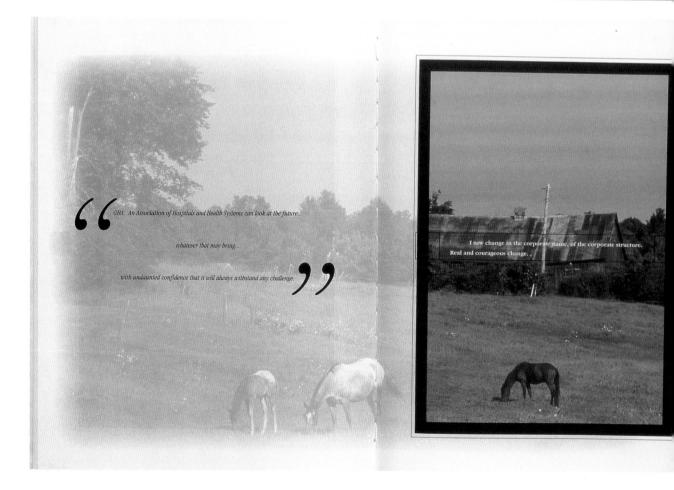

20 Year Class Reunion June 8th-9th, 1996 - Atlanta, Georgia

DESIGN FIRM | Worldstar Design ART DIRECTOR/DESIGNER | Greg Guhl CLIENT | Henderson High School TOOLS | Adobe Illustrator and Photoshop, QuarkXPress PRINTING PROCESS | One-Color

Posterized effects applied to photos of cougars, and the creation of a 20th anniversary logo, gave this reunion invitation its snap.

DESIGN FIRM | Sayles Graphic Design ALL DESIGN | John Sayles COPYWRITER | Annie Meacham PAPER | Terracoat Gray PRINTING PROCESS | Offset

This one-color invitation uses storytelling graphics: a shower on the front and an airplane hopping from one home to the next. The piece folds out to reveal the recipient of the baby shower—an adopted kitten named Sascha B.

DESIGN FIRM | Kan & Lau Design Consultants ART DIRECTOR/DESIGNER | Lau Siu Hong TOOLS | Adobe PageMaker, Macromedia FreeHand, Adobe Photoshop

The artwork in the Works of Message were inspired by books but without words.

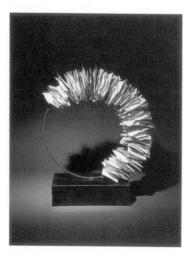

As a protectional designer amateur arrist, Lau's "amat welk" in recent years might comparable to the work of ma professional "arrists" concepts and the details of design works, which I have as testify to his mastery of des incabalary as well as the clan and variety of his ideas, it incretore all the more striking he should be so single-minded the thoice of content and form

DESIGN FIRM | KMPH Fox 26 DESIGN DIRECTOR | Rebecca M. Barnes COMPUTER PRODUCTION | Mullins and Son PRINTING PROCESS | Four-color process

The designers began with the traditional folder to present an annual sports package designed to help their Marketing Department with client presentations. A separate one-sheet insert is held inside the folder, so the folder can be used throughout the year. DESIGN FIRM | Roslyn Eskind Associates Limited ART DIRECTOR | Roslyn Eskind DESIGNERS | Roslyn Eskind, Heike Sillaste, Gary Mansbridge COPYWRITER | Roslyn Eskind CLIENT | Services Group of America TOOLS | QuarkXPress, Adobe Illustrator and Photoshop PAPER | Horizon 8pt. cover dull PRINTING PROCESS | Heidelberg (direct to plate)

Contact	Roslyn Eskind As	sociates Limited
		471 Richmond Street West Suite 200 Toronto, Ontario M5V 1X9
		Graphic Design Consultants
	fax 41	6 504 6075 6 504 6085 coslyneskind.com

Cartazes

João Machado

DESIGN FIRM | JOão Machado, Design Lda. All design | João Machado Tools | Macromedia FreeHand, QuarkXPress

hink of your corporate brand the same way. If you can cre

are service. But if you neglext your corporate brand, you must opportunity to nurrare the powerful bond that it creates.

* From the brand up

cor In many ways, developing a brand is like assembling a live breaching creature. Bring together diverse marketing eler unch them together, researcare with your company, imculture, then watch the thing come to life. Like somethin organic, the brand will even evolve over time, adapting to constantly changing environment.

A branding campaign should integrate all of your market communications into a cohesive package. Once you creat to come and your determine the control the come of your organization, you can apply the brand no print collaterals, product packaging. Web sites, multimedia presentations and physical environments such as trade show displays or store breasts.

Corporate identity: The sum of it a

Taken sogether, all of the components of a branding campaign characterize the identity of your company. A successful image engages comments — intellectually and emotionally then lingers in their memory. Only then can you begin to former most.

Prbit Integrated specializes in helping organizations define and evelop their brands. If you're in need of a little brand-aid, ann use us.

DESIGN FIRM | Orbit Integrated ART DIRECTOR/DESIGNER | JACK HARRIS ILLUSTRATORS | JACK HARRIS, EMORY AU COPYWRITER | William Harris CLIENT | Orbit Integrated TOOLS | QuarkXPress, Adobe Illustrator and Photoshop PAPER | 80 lb. Mohawk Poseidon Cover PRINTING PROCESS | FOUR-COLOR OFFSET

This is a vehicle for the marketing communications firm to announce its name change, and to provide its clients with a taste of its marketing and branding philosophies, in a format that commands attention.

revolution

DESIGN FIRM | Mires Design ART DIRECTOR | John Ball DESIGNER | Gale Spitzley ILLUSTRATORS | Miquel Perez, Jeff Samaripa COPYWRITER | Brian Woosley TOOLS | QuarkXPress, Adobe Illustrator

PAPER | Zanders Mirricard silver, cover; 12 pt. Zanders Chromolux Vario Cover, red, interior

PRINTING PROCESS | Four-color offset

The Mires Design identity book is used to present their work to potential clients, both in person and via direct mail. The designer used a mirror-like cover stock to reflect the firm's philosophy on corporate and brand identity.

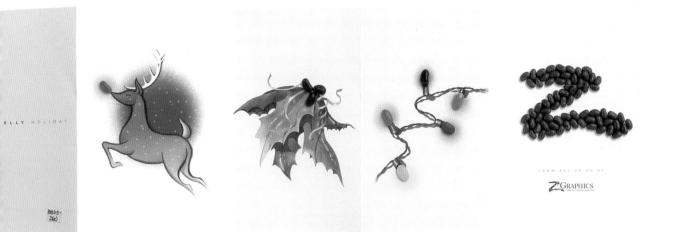

DESIGN FIRM | ZGraphics, Ltd. ART DIRECTOR | JOE ZEller DESIGNER | Gregg Rojewski ILLUSTRATOR | Paul Turnbaugh

Jelly beans for the holiday season! What could be more yummy? ZGraphics' greeting card emphasizes the jelly bean theme by using photos of actual jelly beans in conjunction with illustrations of the holiday season.

DESIGN FIRM | Muller and Co. ART DIRECTORS | John Muller, Joann Otto DESIGNER | Joann Otto PHOTOGRAPHER | Steve Curtis COPYWRITER | Pat Piper TOOLS | Adobe Photoshop, QuarkXPress PAPER | Strobe Silk PRINTING PROCESS | Four-color process plus dull gloss dry-trap varnish

To show prospective clients that advertising and design can work together with incredible results, the designer literally divided up the brochure into the two disciplines for an interesting presentation.

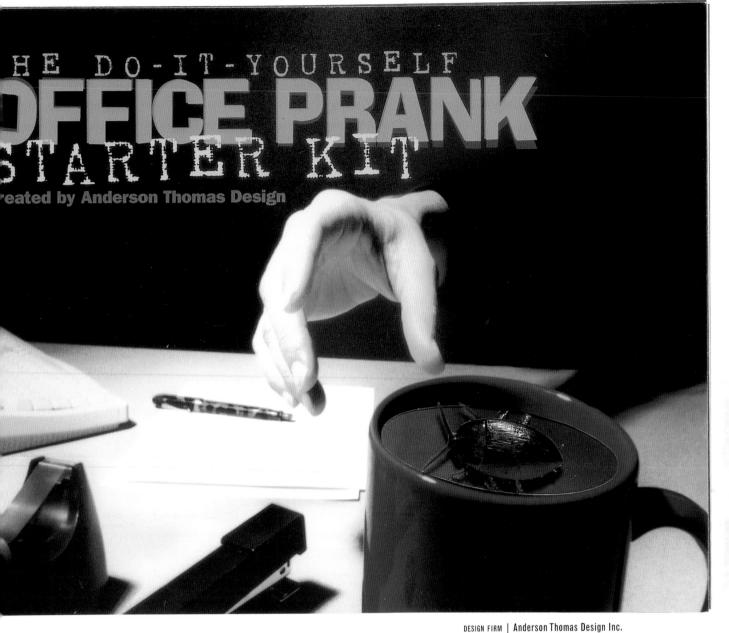

ART DIRECTOR | Joel Anderson DESIGNERS | Joel Anderson DESIGNERS | Joel Anderson, Abe Goolsby, Susan Browne, Roy Roder, Jay Thatcher, Jay Smith ILLUSTRATOR | Kristi Carter PHOTOGRAPHER | Scott Thomas TOOLS | QuarkXPress, Adobe Illustrator and Photoshop PAPER | Domtar: Excellence gloss, Sandpiper oat, Fusion ivory and goldenrod

PRINTING PROCESS | Four-color process plus fluorescent PMS plus spot varnish

The design process involved conceptual meetings from which the idea and the gags originated. From there, groups of designers were assigned to design and execute the different sections, thus showcasing their different creative styles.

VOIT SPORTS THE ORB BASKETBALL

IT'S A WHOLE NEW KIND OF BASKETBALL, A DIMPLED PRACTICE BALL DESIGNED TO HELP AVERAGE-SIZED HANDS PLAY MORE LIKE NBA-SIZED HANDS. IN ADDITION TO NAMING THE PRODUCT, WE CREATED A UNIQUE IDENTITY AND PACKAGING THAT GIVES CONSUMERS AN INSTANT GRIP ON WHAT THIS BALL'S ALL ABOUT.

Mires Design | Jose A. Serrano |eborah Hom, Gale Spitzley John Kuraoka, Brian Woosley kXPress =ss | Four-color offset

on was created to showcase Mires Design's ging projects.Their strategy was to present a format that made use of corrugated board

DESIGN FIRM | Architectural Brochures Art Director | Liza Bachrach All Design | Liza Bachrach Tools | QuarkXPress, Adobe Illustrator Paper | Gilclear, Oxford, white 28 lb. Printing Process | Four PMS colors

The firm wanted a brochure that would demonstrate to the public all the wonderful design options there are for brochures: color, unique paper, emboss, dye cut, score, fold, and bleed. They created a design that coordinates well with their letterhead, and is simple, yet elegant.

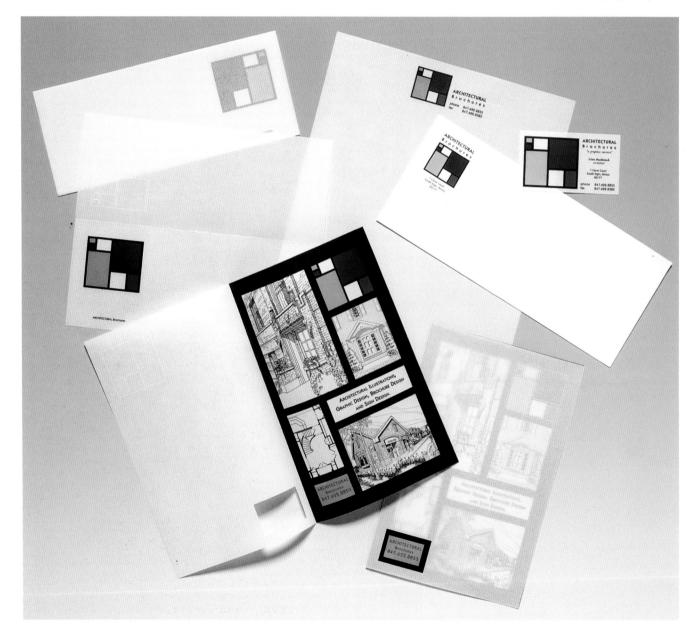

DESIGN FIRM | Solar Design ART DIRECTOR | Jennifer Schmidt DESIGNERS | Jennifer Schmidt, Susan Russell TOOLS | QuarkXPress, Adobe Illustrator and Photoshop PAPER | Cover: Fox River Confetti; interior: Neenah Classic Crest PRINTING PROCESS | Black thermography, cover; two-color PMS, interior

This brochure educates the reader on the process of design and is one component of the firm's presentation folder. Sun facts are included to reinforce the firm's goal: to give each client Solar's energy!

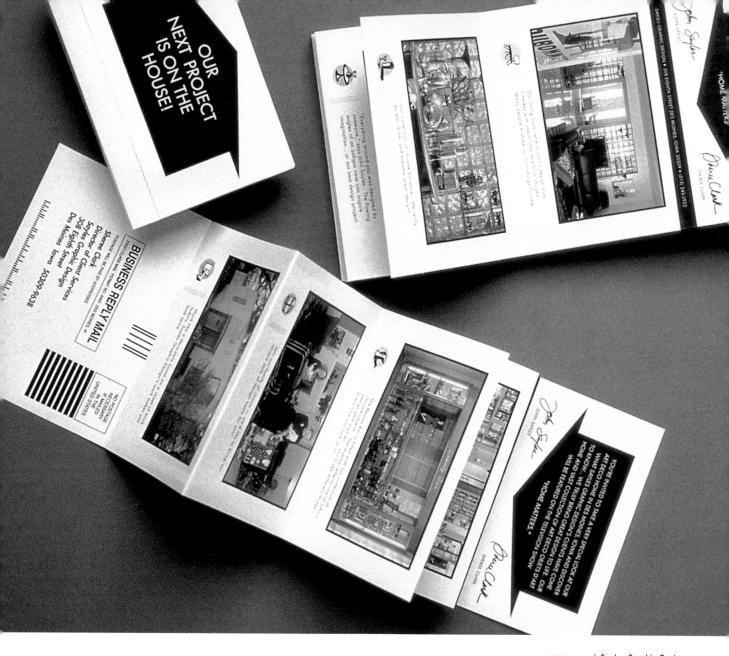

DESIGN FIRM | Sayles Graphic Design ART DIRECTOR/DESIGNER | John Sayles PHOTOGRAPHER | BIII Nellans COPYWRITER | Wendy Lyons PAPER | Crown Vantage Terracoat Gray PRINTING PROCESS | Offset

Sayles and Clark commemorated the airing of a TV show with a special announcement. The ac mailer, appropriately titled Our Next Project I House, is reminiscent of a wallet full of photo detailed shots display their eye-catching colle showcasing their appreciation for the elegand of the Art Deco era.

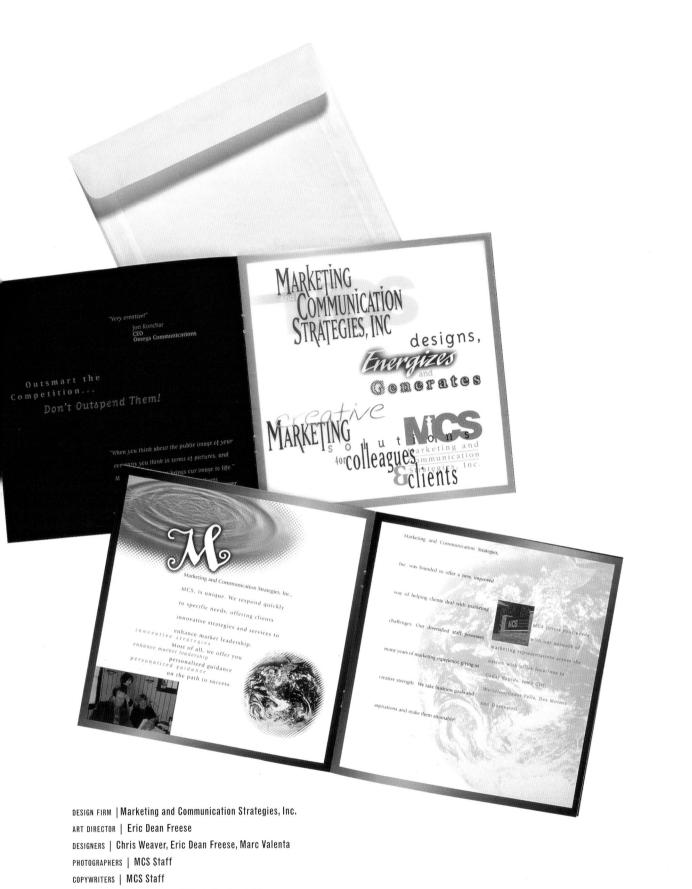

- TOOLS | Adobe Photoshop and Illustrator, QuarkXPress
- PAPER | Evergreen 100 lb. cover, Utopia 2 Dull, Glama
- PRINTING PROCESS | Two-color plus spot varnish on cover

FACTOR DESIGN	FACTOR DESIGN	

Tja, das war er, der erste Eindruck, für den es keine zweite Chance gibt. Wir hoffen, wir konnten Sie ein bißchen neugierig machen. Da hätten wir dann nämlich schon eine gemeinsame Basis. Wir sind neugierig. Ganz enorm sogar. Und ganz besonders darauf, was Sie jetzt wohl über uns denken. Rufen Sie uns doch mal an und erzählen Sie es uns. Sprechen wir über Details.

Well, that was it-the first impression. There's no second chance. We hope we've made you a bit curious. Then we already have something in common. Because at Factor Design, we're extremely curious. For example, right now we're wondering what you think of us. Why not give us a call and let us know?

BILDTAFEL/PLATE OF LEUKOEVTEN

13

DESIGN FIRM | Factor Design ART DIRECTOR | Olaf Stein DESIGNER | Eva Ralle ILLUSTRATOR | Stock PHOTOGRAPHER | Frank Stockel COPYWRITER | Hannah S. Fricke TOOLS | Macromedia FreeHand, QuarkXPress PAPER | Romerturn Esparto PRINTING PROCESS | Four-color offset

This brochure is part of Factor's self promotional piece that tells clients about the firm's general philosophy on graphic design.

IDEA BOOK 4.0

DESIGN FIRM | Caesar Photo Design, Inc. Art director | Caesar Lima Designers | Caesar Lima, Pouane Dinso Photographer | Caesar Lima Copywriter | Jennifer Castle Printing Process | 5/5 colors

Since Caesar Photo Design is a 100% digital photo studio, they wanted to display a futuristic image to potential clients. This brochure eliminated the need to send portfolios of their photographic work, because it speaks for itself: big images and few words are key elements of its success.

Beyond the hum of the computer, beyond the glare of the screen... There is always the art. Software can not generate creativity. Without the idea, there is no image Without the idea, there is nothing...

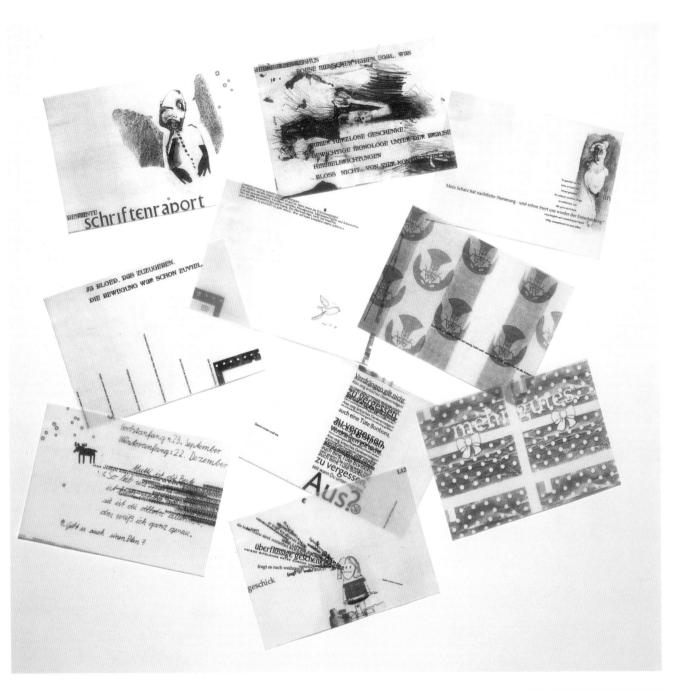

DESIGNERS/ILLUSTRATORS | Doreen Kiepsel and Marlena Sang Copywriters | Doreen Kiepsel and Marlena Sang PRINTING PROCESS | Inkjet and photocopier

Ten sheets were put together in one piece to create Christmas greetings that use the designers' own illustrations, texts, forms, and fonts. The recipient can pick the one he or she likes best and just enjoy it.

U S WEST COMMUNICATIONS "Ain't It Grand" was one of a series of , , internal sales promotions that operated under an overall communications strategy of "Making Music Together". This campaign included

DESIGN FIRM | Vaughn Wedeen Creative ART DIRECTORS/DESIGNERS | Rick Vaughn, Steve Wedeen ILLUSTRATOR | Kristi Carter Photographers | Dave Nufer, Michael Barley COPYWRITER | Steve Wedeen Tools | QuarkXPress, Adobe Photoshop, Macromedia FreeHand

1049 DESIGN 1603 Cypress Trail Middleton,WI 53562 608-232-1049

ADELE BASS & CO. DESIGN 758 E. Colorado Boulevard Suite 209 Pasadena, CA 91101 626-304-0306

ALAN CHAN DESIGN COMPANY 2/F Shiu Lam Building 23 Luard Road Wanchai, Hong Kong 852-2527 8228

ANDERSON THOMAS DESIGN INC. 110 29th Avenue North Suite 100 Nashville, TN 37203 615-327-9894

ARCHITECTURAL BROCHURES 7 Clove Court South Elgin, IL 60177 847-622-8855

ATELIER GRAPHIQUE BIZART 20 Rue J. P. Beicht L-1226 Luxembourg 00352 462255 1

AWG GRAPHICS COMUNICAÇÃO LTDA R. Maestro Cardim, 377 8 and Saspualo Sao Paulo, Brazil 55 11 289 0099 R29

B² DESIGN 220 South 5th Street Dekalb, IL 60115 815-748-5876

BARBARA FERGUSON DESIGN 10211 Swanton Drive Santee, CA 92071 619-562-5078 BASE ART COMPANY 209 South High Street, #212 Columbus, OH 43215 614-280-9369 BELYEA DESIGN ALLIANCE 1809 7th Avenue, #1007 Seattle, WA 98101 206-682-4895

BENTLEY COLLEGE 175 Forest Street, LEW-205 Waltham, MA 02452 781-891-2241

BIG EYE CREATIVE, INC. 1300 Richards Street Suite 101 Vancouver, BC V6B 366 Canada 604-683-5655

BLACK CAT DESIGN 637 3rd Avenue West #412 Seattle, WA 98119 206-270-8758

BRABENDERCOX 2100 Wharton Street Pittsburgh, PA 15203 412-488-6400

BULLET COMMUNICATIONS, INC. 200 South Midland Avenue Joliet, IL 60436 815-741-2804

CAESAR PHOTO DESIGN 21358 Nordhoff Street #107 Chatsworth, CA 91311 818-718-0878

CHARNEY DESIGN 1120 Whitewater Cove Santa Cruz, CA 95062 831-479-4675

CLARKE COMMUNICATION DESIGN 1608 Bentbrook Court Champaign, IL 61822 217-244-8539 COMMUNICATION ARTS COMP 129 East Pascaquola Street Jackson, MS 39201 601-354-7955

CREATIVE CONSPIRACY INC. 110 East 9th Street Durango, CO 81301 970-247-2262

THE CREATIVE RESPONSE CO 217 Nicanor Garcia Street Bel-Air II, Makati City Philippines 632-896-1535

DAMEON HICKMAN DESIGN 1801 Dove #104 Newport Beach, CA 92660 949-261-7857

DENISE KEMPER DESIGN 505 Wintergreen Drive Wadsworth, OH 44281 330-335-5200

DESIGN GUYS 119 North Fourth Street, #40 Minneapolis, MN 55401 612-338-4462

DIA Central House, Alwyne Road London JW19 7AB United Kingdom 0181 879 7090

DIGITAL GIRAFFE PO Box D-1 Carmel, CA 93921 831-624-1833

ELTON WARD DESIGN PO Box 802, Parramatta NSW 2124, Australia 61-2 9635 6500

FACTOR DESIGN Schulterblatt 58 20357 Hamburg Germany 49 40 432 571 0

0610 ,

ERSON HENNINGSEN INC. nth Street A 52722

ISING DESIGN III Drive

231 7

RÁFICO ena 431-4 F Aires

1

D ASSOCIES MUNICATION treet

6 H2T 2H1

1

G DESIGN 19th Street 98103 1

GROUP y

67202 14 SIGN

, IL 61701 5

ICH, INC. th Street

s, IN 46205-4613 31 HOFFMAN AND ANGELIC DESIGN 317-1675 Martin Drive Surrey, BC V4A 6E2 Canada 604-535-8551

HORNALL ANDERSON DESIGN WORKS, INC. 1008 Western Avenue Suite 600 Seattle, WA 98104

BARRY HUTZEL 2058 Breeze Drive Holland, MI 49424

ILLINOIS WESLEYAN UNIVERSITY 302 East Graham Street PO Box 2900 Bloomington, IL 61702-2900 309-556-3048

INLAND GROUP, INC. 22A North Main Edwardsville, IL 62025 618-656-8836

INSIGHT DESIGN COMMUNCATIONS 322 South Mosley Wichita, KS 67202 316-262-0085

INTEGRATED MARKETING SERVICES 279 Wall Street Princeton, NJ 08540 609-683-9055 JANICE AITCHISON 25 Slocum Avenue Tappan, NY 10983 914-365-8607

JD THOMAS COMPANY 820 Monroe #333 Grand Rapids, MI 49503 616-235-1700

JEFF FISHER LOGO MOTIVES PO Box 6631 Portland, OR 97228-6631 503-283-8673 JOAO MACHADO DESIGN LDA Ria Padre Xavier Coltinho, No. 125 4150 Porto Portugal 351 2-6103772 16203778

JOHNSON GRAPHICS 2 Riverfront Newbury, MA 01951 978-462-8414

JOSEPH RATTAN DESIGN 5924 Pebblestone Lane Plano, TX 75093 972-931-8044

JULIA TAM DESIGN 2216 Via La Brea Palos Verdes, CA 90274 310-378-7583

KAN & LAU DESIGN CONSULTANTS 2817 Great Smart Tower 230 Wanchai Road, Hong Kong 852-2574-8399

KEN WEIGHTMAN DESIGN 7036 Park Drive New Port Richey, FL 34652 727-849-8166

DOREEN KIEPSEL AND MARLENA SANG Lornsenstr. 36 22767 Hamburg Germany 0049-40-3800-690

KIRBY STEPHENS DESIGN 219 East Mt. Vernon Street Somerset, KY 42501 606-679-5634

KMPH FOX 26 5111 East McKinley Avenue Fresno, CA 93727 209-255-2600 LEE REEDY CREATIVE, INC. 1542 Williams Denver, CO 80218 303-333-2936

white a

THE LEONHARDT GROUP 1218 3rd Avenue #620 Seattle, WA 98101

LOUISA SUGAR DESIGN 1650 Jackson Street Suite 307 San Francisco, CA 94109 415-931-1535

MALIK DESIGN 88 Merritt Avenue Sayreville, NJ 08879-1955 732-727-4352

MARKETING AND COMMUNICATIONS STRATEGIES, INC. 2218 1st Avenue NE Cedar Rapids, IA 52402 319-363-6005

MCGAUGHY DESIGN 3706-A Steppes Court Falls Church, VA 22041 703-578-1375

MELISSA PASSEHL DESIGN 1275 Lincoln Avenue #7 San Jose, CA 95125 408-294-4422

MENDIOLA DESIGN STUDIO Calle 37 No. 523 Mercedes Buenos Aires, Argentina 54-324-33469

MERVIL PAYLOR DESIGN 1917 Lennox Avenue Charlotte, NC 28203 704-375-4444

MICHAEL COURTNEY DESIGN 121 East Boston Seattle, WA 98102 206-329-8188

MIRES DESIGN 2345 Kettner Boulevard San Diego, CA 92101

MODELHART GRAFIK-DESIGN DA Ing. Ludwig Pech Strasse 1 A-5600 St. Johann Austria 43-6412-4679

MORGAN DESIGN STUDIO, INC. 345 Whitehall Street Southwest Suite 106 Atlanta, GA 30303 4-584-0746

MULLER AND COMPANY 4739 Belleview Kansas City, MO 64112 816-531-1992

NESNADNY & SCHWARTZ 1080 Magnolia Drive Cleveland, OH 44106 216-791-7721

ORBIT INTEGRATED 722 Yorklyn Road Hockessin, DE 19707 302-234-5700, x25 PENSARE DESIGN GROUP LTD. 729 19th Street Northwest Second Floor Washington, DC 20005 202-638-7700

PEPE GIMENO, SL C/Cadirers, SN 46110 Godella Valencia, Spain 34-963904074

PHILLIPS DESIGN GROUP 25 Drydock Avenue Boston, MA 02210 617-423-7676

PINKHAUS DESIGN 2424 South Dixie Highway Suite 201 Miami, FL 33133 305-854-1000

PRICE LEARMAN ASSOCIATES 737 Market Street Kirkland, WA 98033 425-803-0333

PUNTO E VIRGOLA S.A.S. Via Battindarno 177 40133 Bologna Italy 0038-051-56.58.97

Q DESIGN Neuberg 14 65193 Wiesbaden Germany 0045-611-1S1310

RAMONA HUTKO DESIGN 4712 South Chelsea Lane Bethesda, MD 20814 301-656-2763 RENATE GOKL 803 South Coler Avenue, #5 Urbana, IL 61801 217-367-7124

REVOLUZION Uhlandstrasse 4 78579 Neuhausen ob Eck Germany 011-49-7467-1467

THE RIORDON DESIGN GROUF 131 George Street Oakville, Ontario L68 3B9 Canada 905-339-0750

RIVER CITY STUDIO 116 West 3rd Street Kansas City, MO 64105 816-474-3922

ROSLYN ESKIND ASSOCIATES 471 Richmond Street West Toronto, Ontario MSV 1X9 Canada 416-504-6075

SAGMEISTER INC. 222 West 14 Street New York, NY 10011 212-647-1789

ST. JOSEPH'S HOSPITAL 703 Main Street Paterson, NJ 07503 973-754-2874

SAYLES GRAPHIC DESIGN 308 Eighth Street Des Moines, IA 50309 515-243-2922 SHIELDS DESIGN 415 East Olive Avenue Fresno, CA 93728 ES INC. Iy

10010

N kton Street ghts, IL 60004

SIGN ad , PA 16803

IT nue, #500 8101-3423

IGN treet 2210 }

BROADCASTS LIMITED r Water Bay Road g Kong 38

DESIGN rospect Avenue VI 53202 I

R, INC. Road 06903 5

ESIGN amelech Street 12

972-3-5239361

VAUGHN WEDEEN CREATIVE, INC. 407 Rio Grande NW Albuquerque, NM 87104 505-243-4000

VISUAL MARKETING ASSOCIATES, INC. 322 South Patterson Boulevard Dayton, OH 45402 937-223-7500

WATCH! GRAPHIC DESIGN 3447 N Lincoln Chicago, IL 60657 773-665-2292

WITHERSPOON ADVERITISING 1000 West Weatherford Street Fort Worth, TX 76102-1842 817-335-1373

W00D DESIGN 1775 York Avenue 326 New York, NY 10128 212-490-2626

WOOD DESIGN AND ART STUDIO 15371 Locust Street Omaha, NE 68116 402-431-0419

WORLDSTAR DESIGN 4401 Shallowford Road, #192 Roswell, GA 30075 404-330-7827 X DESIGN COMPANY 2525 West Main Street, #201 Littleton, C0 80120 303-797-6311 Z GRAPHICS LTD. 322 North River Street East Dundee, IL 60118 847-836-6022

ZYLSTRA DESIGN 5075 W 220th Street Fairview Park, OH 44126 440-734-1704

Adele Bass & Co. Design 116 Alan Chan Design Company 32, 35, 48 Anderson Thomas Design Inc. 62, 70, 191 Architectural Brochures 194 Atelier Graphique Bizart 108 AWG Graphics Comunicação LTDA 28, 51, 79 B² Design 86, 175 Barbara Ferguson Design 131 Barry Hutzel 66 Base Art Company 156 Belyea Design Alliance 42 Bentley College—Communication and Publications 153 Big Eye Creative, Inc. 39, 88, 117 Black Cat Design 125 Brabendercox 43 Bullet Communications, Inc. 110 Caesar Photo Design, Inc. 199 Charney Design 133 Clarke Communication Design 152 Communication Arts Company 29, 36, 50, 61 Creative Conspiracy, Inc. 81 The Creative Response Co., Inc. 19, 21, 22, 52 Dameon Hickman Design 105 Denise Kemper Design 13 Design Guys 80, 96 DIA 93 Digital Giraffe 121 Elton Ward Design 111

Fernández Design 148, 163, 165 Louisa Sugar Design 95 Gackle Anderson Henningsen Inc. 158 GAF Advertising/Design 166, 167, 168 GN diseño gráfico 122 Goodhue & Associates Design Communication 24, 67, 104 Greenzweig Design 176 Greteman Group 99, 127, 170 Griffin Design 115 Held Diedrich, Inc. 145 Hoffman and Angelic Design 159 Hornall Anderson Design Works, Inc. 20, 56, 60, 78, 91, 123 Illinois Wesleyan University 153 Inland Group, Inc. 104 Insight Design Communications 45, 136, 137, 178 Integrated Marketing Services 112 Janice Aitchison 82 JD Thomas Company 15 Jeff Fisher Logo Motives 34 João Machado Design LDA 186 Johnson Graphics 140 Joseph Rattan Design 69, 144 Julia Tam Design 33 Kan & Lau Design Consultants 18, 75, 184 Ken Weightman Design 89 Doreen Kiepsel and Marlena Sang 200 Kirby Stephens Design 179 KMPH Fox 185 Lee Reedy Creative, Inc. 40, 76, 100-101,

147

Factor Design 97, 198

Malik Design 172 Marketing and Communicatio Strategies Inc., 41, 120, 197 Marlena Sang 200 McGaughy Design 16 Ron McClellen 155 Melissa Passehl Design 53, Mendiola Design Studio 54 Mervil Paylor Design 49 Michael Courtney Design 59 Mires Design 23, 72-73, 146 192 - 193Modelhart Grafik-Design DA Morgan Design Studio, Inc. Muller and Company 92, 150 Nesnadny & Schwartz 55, c 1049 Design 161 Orbit Integrated 187 Pensare Design Group LTD. Pepe Gimeno, SL 10-11, 65 Phillips Design Group 71 Pinkhaus Design 57, 77, 102 Price Learman Associates Punto e Virgola S.A.S. 129, Q Design 12 Ramona Hutko Design 43 Renate Gokl 103, 171 revoLUZion 102, 128, 132 The Riordan Design Group,

G D E S E R T P R E S

The Leonhardt Group 58, 139

tudio *155*

nd Associates Limted 186

Inc. 151

hic Design *63, 162, 169, 6*

ign *84, 118*

'es 27, 98

n *164, 195*

esign *142-143*

r 154

it 47

Hospital 157

ign *14*

roadcasts Limited 26, 37

Design *135*

, Inc. *38, 74*

esign *64*

leen Creative *44,* , *201*

eting Associates 83, 85

phic Design *31, 160*

n Adveritising *68*

n *30, 113*

n and Art Studio 126

Jesign 177, 180, 181

ompany *106, 119*

Ltd. 25, 189

ign *13*

tural Heritage Progr